MW00621033

BOULDER CITY

The Town that Built the Hoover Dam

PAUL W. PAPA

THE
History
PRESS

Published by The History Press
Charleston, SC
www.historypress.net

Front cover, top: courtesy of Boulder Dam Museum. Union Pacific Railroad Collection; *bottom*: courtesy of Bureau of Reclamation.
Back cover, top: courtesy of Boulder Dam Museum; *bottom*: courtesy of Bureau of Reclamation.

First published 2017

Manufactured in the United States

ISBN 9781467137157

Library of Congress Control Number: 2017931810

Notice: The information in this book is true and complete to the best of our knowledge. It is offered without guarantee on the part of the author or The History Press. The author and The History Press disclaim all liability in connection with the use of this book.

CONTENTS

Acknowledgements 5
Introduction 7

1. "To Convert a Natural Menace into a National Resource" 9
2. A Tale of Three…or Four…Cities 39
3. Building Boulder City 91
4. Life in Boulder City 132
5. So Hoover Dam Was Built…Now What? 168

Appendix: Visiting Dignitaries and Celebrities 185
Bibliography 189
About the Author 192

ACKNOWLEDGEMENTS

Anyone having been associated with the Boulder Canyon Project should be proud of the part he or she played, whether in planning, design or execution, including those in the field of industry who furnished construction materials, plant and equipment; in many instances of unprecedented type or size.
—*Construction engineer Walker R. Young*

First and foremost, I'd like to thank Shirl Naegle, the collections manager at the Boulder City Hoover Dam Museum, without whom this book would not have been possible. Thank you for tirelessly answering my questions, locating the hard-to-find photos and hunting down all those stories that seemed destined to remain hidden. Every time I needed something, you found it. You are simply amazing! Thanks also to Dennis McBride, director of the Nevada State Museum, for giving me some direction at the start of the book and helping to locate those rocks that needed to be overturned. Thanks goes out to Lara Godbey Smith, her sister Ila Godbey Clements-Davey and Alice Dodge Brumage, who patiently sat with me and told me their stories. A special thanks goes out to Artie Crisp at The History Press for working with me until just the right project came along—this one was definitely it—and to my editor, Rick Delaney, for his efforts to make this the best book it could possibly be. Last but not least, I'd like to thank the 31ers—the men and women who built the Hoover Dam and Boulder City—who spoke to me from their graves, telling their stories through firsthand accounts, and to the people wise enough to capture those stories while the 31ers were still with us.

INTRODUCTION

Until the final yard of concrete could be poured into the completed dam the
Colorado River would be a menace to tens of thousands of people and hundreds
of thousands of acres of fertile land.
—*George A. Pettitt*

Boulder City is not supposed to be there—well, most of it anyway. More
than two-thirds of it was supposed to have returned to the desert from
whence it came when the dam was completed in 1935, but it never did.
Boulder City is, and always has been, resilient. I have wanted to write this
book for quite some time, because from the moment I moved into the valley,
I have been drawn to this unique and industrious town. The more I learned
about Boulder City, the more fascinated I became. I started out writing what
I thought was a book about Boulder City, but somewhere along the line
something special happened. It was never my intent to tell the story of the
Hoover Dam—there are plenty of great books that address that topic. My
desire instead was to tell a story little known, the story of the town created
for the construction of the dam—the town that began just as the dam was
underway and was completed long before the last cement was laid in the
Black Canyon below.

But then everything changed. I stumbled upon a cache of history;
interviews that had been thoughtfully recorded many years ago. These
were oral histories of the men and women who lived in Boulder City and
who built the dam. As these people told me their stories—literally from the

grave—I began to get a picture of what it was like to live in Boulder City as it was being built. It was this story that I knew must be told. It was this story that those 31ers, as they were called, wanted known. So I changed my initial plans and, instead, was determined to tell the story of the men and women who formed this unique little town into a community. After reading their stories (they were made into transcripts and bound into books), I started to fall even more deeply in love with Boulder City, understanding now how it came to be and what it took to get it there—what it took to survive.

This is a story of pioneers. Of men and women who never gave up or in. Of people who would rather travel across the country in search of work than to stay where they were and wait to be saved. These were a hardy folk, people who didn't want a handout, just a chance to put food on their tables. People of another time. I have tried to give you an overall flavor of the town they created, instead of worrying too much about chronological order. I hope that in doing this, you can come to understand, as I have, just how special Boulder City truly is. I also hope that by reading this book, you'll take the time to visit Boulder City and, as the 1935–36 tourist guide says, "[Go to the] main business section, park [your] car and visit the city's public buildings; the attractive stores, dine in its cafes and 'rub elbows' with its citizenry." If you do not, you will indeed miss something very special.

"TO CONVERT A NATURAL MENACE INTO A NATIONAL RESOURCE"

The Lord left that dam site there. It was only up to man to discover it and to use it.
—*Hoover Dam construction engineer Walker R. Young*

In a cramped office of the U.S. Bureau of Reclamation in Denver, Colorado, on the morning of Wednesday, March 4, 1931, gathered a group of men with a common interest. Pressed into the room deep with newspaper reporters were contractors, machinery and materials agents, insurance brokers and anyone else who managed to squeeze into the packed room. At around 10:00 a.m., Bureau of Reclamation chief engineer Raymond Walker, envelopes in hand, made his way to the front. So many had dreamed of placing—and winning—a bid, but when it came right down to it, Walker was holding only five envelopes; only five companies had placed bids, and even fewer would be able to come up with the $2 million bond required for the bid to be accepted.

In the 1930s, a man's word was his bond. Many people were reluctant to sign paperwork in those days, operating under the theory that if you couldn't trust a man's word, you certainly couldn't trust his signature. For this reason, many companies didn't see the need to post a bond. The U.S. government, however, did not see things the same way. A man's word was all well and good, but it held no weight with the insurance companies that would be asked to gamble on a project of the scale required to build a dam.

When Walker opened the first envelope and began to read the contents aloud, he was met with subdued chuckles that quickly turned to outright

laughter. "$80,000 less than the lowest bid you get" was written on the paper submitted by Edwin A. Smith of Louisville, Kentucky. The bid was accompanied by a brief family history and several character references. What it wasn't accompanied by was the $2 million bond, leaving Walker with little choice but to declare the bid invalid. The second bid was no better: $200 million or "cost plus 10 percent." This bid, from the John Bernard Simon Company of New York, was also missing the required bond and, like the first bid, ruled invalid.

The third bid came from one of the giants in the construction industry on the East Coast. The Arundel Corporation of Baltimore, Maryland— in association with Lynn H. Atkinson of Los Angeles—put in a bid of $53,893,878.70. This bid was the first of the five to contain the required bond and was enough to quiet the crowd. The next two bids would also contain the required bond. The Woods Brothers Corporation of Lincoln, Nebraska—in association with A. Guthrie & Company of Portland, Oregon—bid $58,653,107.50. Six Companies Incorporated out of San Francisco, California, placed the winning bid of $48,890,955.50—almost $10 million lower than the highest bidder.

The crowd erupted in cheers as the winning bid was read. Reporters scurried to get the news out to their respective papers as fast as humanly possible. The only thing left for Walker to do was examine the figures before the contract could be signed. That would occur seven days later, on March 11, 1931, when Secretary of the Interior Ray Lyman Wilbur signed the acceptance "with an old-fashioned pen, which he prefers for signatures on the most important documents submitted to him," reported the *Los Angeles Times*, adding, "Dr. Mead, commissioner of reclamation, smiled broadly as did Senator Johnson and Representative Swing, co-authors of the Boulder Dam Act, and other officials present at the signing."

BOULDER CANYON OR BLACK CANYON

It was incomprehensible how they could possibly build a dam in there.
—Las Vegas resident Dean Pulsipher

From almost the time of its inception in 1902, the U.S. Bureau of Reclamation (then known as the Reclamation Service) had thoughts of taming the Colorado River. In 1905, Joseph Barlow Lippincott was dispatched to the

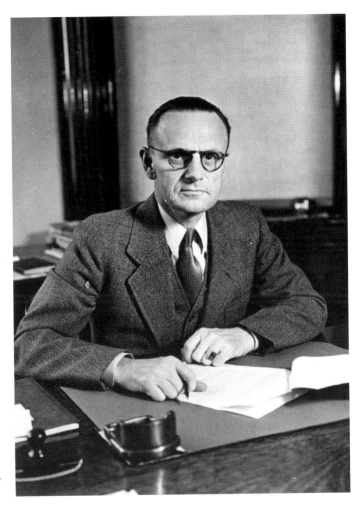

Construction engineer Walker R. Young. *Courtesy of Boulder Dam Museum.*

lower part of the river to make an assessment. "Nothing was done at that time," said Walker Young, "but later they got to thinking about irrigation, flood control, demands for power, domestic water supply." Thirteen years later, "the project became involved again in the minds of the Bureau of Reclamation when Dr. Arthur P. Davis, who was then the commissioner of reclamation, got the idea that the storage, a large storage, should be provided for the lower Colorado River near the point of use," said Young.

Davis's idea served to narrow down the location of the dam from the many that had been scouted over the years. "It takes a long time to get there," said Young about the water flowing downstream. "The water being released from the upper reservoirs of the Colorado River basin would not

reach the point of use for weeks. That would not be an economical use of the Colorado. You could never judge what release would be required three weeks away or so." The solution: build a dam to create a reservoir closer to the lower basin. Davis suggested that a reservoir was needed about three hundred miles from the point of use. "That reason was because at that time the transmission of the electric energy would not be practical for distances longer than 300 miles," explained Young.

It just so happened that there were two canyons about three hundred miles from the point of use: Boulder Canyon and Black Canyon. Homer Hamlin, a geologist for the Bureau of Reclamation, and his assistant E.T. Wheeler, were sent down to investigate. Hamlin recommended Boulder Canyon but stated that the Black Canyon would be a legitimate substitute if the former proved incompatible. Surveys were made, and cores were taken with diamond drilling—Boulder Canyon was looking like the right place to put the dam. So much so that when Congress proposed the bill that would allow the building of the dam, they called it the Boulder Canyon Project Act.

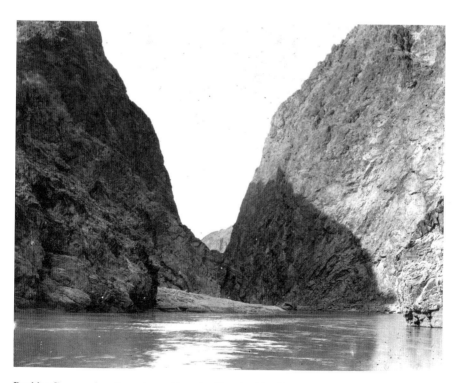

Boulder Canyon view downstream from the Nevada side. *Courtesy of Bureau of Reclamation.*

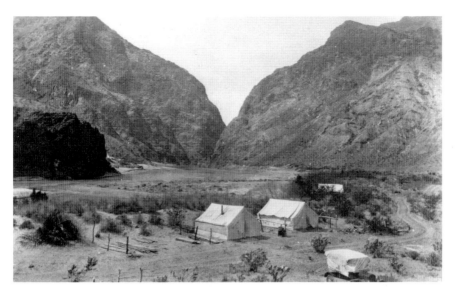

U.S. Diamond Drilling Camp at the entrance of Boulder Canyon. *Courtesy of Boulder Dam Museum. Cragin Collection.*

Long before Six Companies was awarded the largest bid in U.S. history, Walker R. Young was brought on board and placed in charge of the Colorado River Commission, which was tasked with investigating the feasibility of building a dam at Boulder Canyon. Young had graduated from the University of Idaho with an engineering degree. It was there that he was given the nickname "Brigham," which was eventually shortened to "Brig." The reference was to Brigham Young, the one-time president of the Church of Jesus Christ of Latter-day Saints with whom he shared a last name. It was also while living in Idaho that he married Marguerite Bush and went to work for the Bureau of Reclamation as the assistant engineer on the Arrowrock Dam project in Idaho—a move that would set the course for his professional career.

"Walker Young was a man that was a stickler for detail," said dam worker Bob Parker.

> *The day after I went to work, I had a letter from Walker Young. It told me what my duties were, who my boss was, and who I was to see if I had any problems. That detail you don't find in a man that's the head of a project as big as this. He knew every man that worked down here. I think before the job was done, he knew most of the Six Companies employees.*

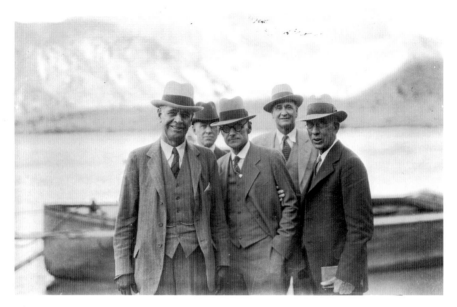

Representatives of the Colorado River Commission at the Colorado River. Walker R. Young is at front center. *Courtesy of Boulder Dam Museum. W.A. Davis Collection.*

Although Boulder Canyon was composed mostly of granite—very desirable for supporting a dam—it had some significant drawbacks. First, the walls of the canyon were extremely high—the dam would have to be close to seven hundred feet tall just to create the reservoir. And if that wasn't daunting enough, the canyon had little to no accessibility. If you're going to build a dam, you'll need to be able to get workers and equipment to the site. That wasn't going to be easy at Boulder Canyon. Faced with these obstacles, Young "thought it would be better to investigate a dam site at the upstream end of the canyon." Young and his crew had no better luck at this second site: they discovered it had a fault line running right through it, something that could spell disaster no matter how well the dam was built.

So Young, drilling expert George Hammond and old-time river man Harry Armisted (and his dog Baldy) went twenty miles downriver to the Black Canyon. "It looked to us that the lower canyon, the lower dam site that was suggested by Homer Hamlin, was the best site," recalled Young. This site would prove to be the better choice for several reasons. First, there was already a bit of a water storage capacity where the river widened at Hemenway Wash in the Las Vegas Wash basin between the two canyons. Second,

as Young explained, "By moving downstream twenty miles, you lose considerable depth, so you see, the dam could be higher, providing the river channel remains consistent in cross section." By higher, Young meant the bottom of the dam could be started at a much higher elevation than would be the case at Boulder Canyon, actually allowing the dam to be shorter in overall height. Third, there was a place to build a spillway on both the Nevada and the Arizona sides of the dam— eliminating the need to run water over the top of the dam itself. This benefit would also allow a powerhouse to be built downstream without worry of it interfering with the spillway.

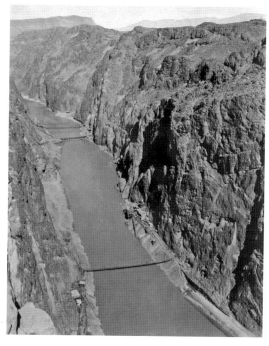

Looking upstream at Black Canyon. The dam would be located just up from the footbridge at the bottom of the picture. *Courtesy of Bureau of Reclamation.*

Still, building a dam in the Black Canyon was a daunting task. "Even today, with all the advanced equipment and methods," wrote dam worker Marion V. Allen, "one look at Black Canyon would be enough to chill the most enthusiastic. It had perpendicular walls, and not even a flat spot on top from which to start operations." But as with everything else, money turned out to be the deciding factor. "Because of inaccessibility between the two sites, it turned out it was less expensive to build a dam of that storage capacity in Black Canyon rather than Boulder Canyon," said Young. "The thing that turned the tide over was the fact that one day when I was trying to find out whether we could reach the dam site from the top—we'd already reached it from the bottom—I discovered it [was] equipped to actually build a railroad from the main line Las Vegas to Los Angeles to the top of the dam site. I mean right on top." Black Canyon was clearly the better choice. As Young put it, "The site appeared to exactly meet the requirements for design and also construction."

Though Black Canyon was eventually settled on as the dam site, a bill titled the Boulder Canyon Project Act had already been introduced into Congress early in the process of determining the best location for the dam. While the site of the dam had been narrowed to the two canyons, the bill had been proposed before the final surveys were completed and the best place to locate the dam was determined. Even when Black Canyon was finally chosen as the site, the word "Boulder" was already in the lexicon—the name stuck. While the dam would be built in Black Canyon, it, along with the city that housed its workers, would bear the name "Boulder."

Taming the Mighty Colorado

Nobody knew just what the thundering Colorado would do when puny human beings tried to put a bit between its teeth and a saddle on its back.
—*George A. Pettitt*

Named Rio Colorado by Spanish priest Francisco Garcés in 1776, the Colorado River is the largest river in the southwestern United States. It flows 1,750 miles from its headwaters at fourteen thousand feet above sea level in the Central Rocky Mountains to the Sea of Cortez in northwestern Mexico. The river passes completely through or borders seven states on its journey from the mountains to the sea. Along the way, it transverses sharp, jagged mountain ranges, flows down through high plateaus and eventually heads across the hot, arid plains. Its waters are so strong that it has been able to carve its way through solid rock, leaving several canyons in its wake—one of which is considered grand.

The strength of the river is due in large part to the amount of yearly snowfall the Rocky Mountains receive or, more precisely, the amount of runoff that occurs as a result of that snowfall. In the 1920s, the Colorado was proving to be not only unreliable, but unpredictable as well. In some months—typically May and June—the river might discharge as much as 200,000 cubic feet of water per second. In other months—usually August through October—that level could drop to as low 1,300 cubic feet per second. When the runoff was high, the lower river became a swift-moving body of water that was described in one government report as a "raging torrent."

In the 1900s, the Colorado was a main source of water for the many towns and villages located in the areas through which it ran, but it was proving

difficult to consistently rely on that river as a source for water. In the rainy season, water levels in the river's tributaries—especially Arizona's Gila— would rise so high as to rival the Colorado itself. Additionally, the running waters of the Colorado tended to produce a great deal of fine sand or clay, called silt. In fact, it produced an average of two hundred million tons of silt, which was deposited as sediment along or near its banks. The deposits of silt built up the banks, forcing the water toward the center of the river and causing the level to rise until there was a legitimate fear the Colorado could overflow its banks and either flood the surrounding area or create a new channel on lower ground. This was especially worrisome in places such as the Imperial Valley, because it was below sea level.

While silt might not seem like a significant issue, it can have life-altering consequences. Mississippi's vast delta was created by the 1 cubic foot of silt the Mississippi River carried with each 1,500 cubic feet of water. The Nile River made Egypt an empire, allowing it to build huge monuments because the river moved 1 cubic foot of silt with every 1,900 cubic feet of water. In contrast, the mighty Colorado River moves 1 cubic foot of silt for every 277 cubic feet of water. "During the course of a year, on the average, enough water flows down [the Colorado River's] channel to bury 17,300,000 acres of land a foot deep; and with that water comes approximately 170,000,000 tons of silt," wrote George A. Pettit in *So Boulder Dam Was Built*, a book he authored for Six Companies, Inc. That's enough silt to cover 105,000 acres 1 foot deep. In two years, it would be enough silt to replace "all of the rock and dirt that was removed in digging the Panama Canal," wrote Pettit. He added, "For countless centuries the Colorado River has been engaged in moving the surface of Utah, Wyoming, New Mexico, Colorado, Arizona, and Nevada down to the sea."

In an attempt to control the waters of the Colorado, a vast system of embankments, called levees, had been built along the river. The purpose of these levees was to prevent the river from overflowing. The only problem was that all of these levees were in Mexico; even though they were located in another country, they had been built and were being maintained by U.S. dollars. In 1924 alone, the United States—in conjunction with the Southern Pacific Company and the Imperial Irrigation District—spent more than $10 million maintaining the levee system.

If the expenditure in a foreign country wasn't bad enough, the levees themselves weren't a reliable means of containing the Colorado. Breaks in the levee system occurred with some frequency; in 1905, one such break sent the Colorado on an alternate path—one it had abandoned centuries

earlier. It was a path that would take two years to correct. That year, the river caused three flash floods, something that, according to available records, hadn't happened for some twenty-seven years. If changing its path wasn't bad enough, the river's width more than doubled, from 60 to 150 feet, causing it to flood its banks.

Because they cause the water level to rise, silt deposits also had an effect on the levee system itself, which had to be routinely raised in some areas to strengthen the ever-rising flood levels. A 1924 report to the Department of the Interior on the problems of the Colorado River basin stated: "In its current state of partial development; however, the river is a menace no less than it is a benefit." The same report also concluded that "river regulation, flood control, and storage for irrigation can be best and most economically obtained at Boulder Canyon with a dam at Black Canyon."

THE LONG ROAD TO AN AGREEMENT

While sites had been scouted and a bill presented in the House, one man was determined to make the dam a reality. Still, Secretary of Commerce Herbert Hoover knew it was one thing to want to build a dam and quite another to actually get it done. The secretary had a sole purpose in mind when he met with representatives of each of the seven states—Arizona, California, Colorado, Nevada, New Mexico, Utah and Wyoming—through which the river ran. His goal was to bring the states to an accord on how best to allocate the water once a dam was built to tame the mighty Colorado. With the river running through or being fed by tributaries in each state, coming to an agreement that benefited all parties was a tall task indeed, but it was one Hoover intended to accomplish. That wasn't going to happen easily. Although he managed to get representatives from all seven states to meet in one place, the 1921 meeting did not go as well as Hoover expected, and after nine such meetings, an accord could still not be reached.

Ray L. Wilbur Jr., son of the man who would eventually become the secretary of interior, wrote:

> *To properly appreciate the complicated problem which the Colorado River presents there must be some realization not only of the physical features of the river but also of the political complications arising from the fact that the seven states of the Colorado River Basin are not only interested but*

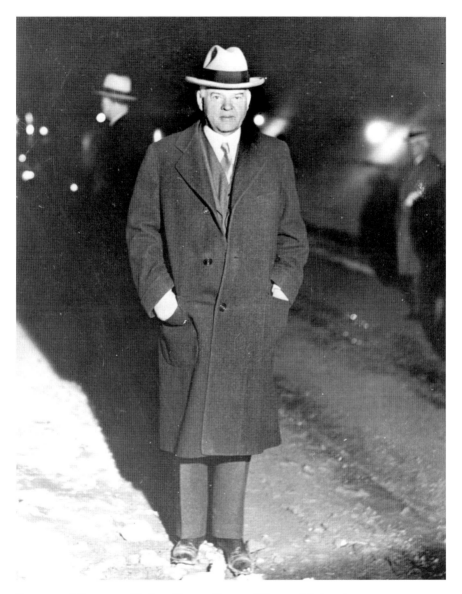

Secretary of Commerce Herbert Hoover. *Courtesy of Bureau of Reclamation.*

vitally concerned in this great natural resource. To work out a reasonable comprehensive scheme for development of the river is an undertaking of great magnitude.

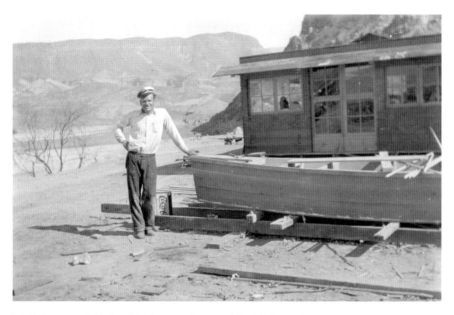

Murl Emery and his hand-built boat. *Courtesy of Boulder Dam Museum.*

Secretary Hoover had already scouted out the two sites where a dam might be placed. "He had been down there several times," said Las Vegas resident Dean Pulsipher, speaking of the future president. Hoover had enlisted the help of a red-headed, bearded man named Murl Emery who lived near the river. "Murl was the only one who had a boat down there," said Pulsipher. Emery would later be one of the men who ferried the surveyors to both the Boulder and Black Canyons whenever they needed to go. "Murl Emery was an old river rat," recalls Young, "a man with an amazing knowledge of the river, knew all the problems, knew how to live in the desert."

Emery got his experience running a ferry from Arizona to Nevada. "I developed the ability of navigating on the Colorado River," he said. "I became the expert at it." Emery was an educated man, but not by much. "I had been to school," he recalled. "I learned to read and write and I could count to a hundred, and I said that's enough. I didn't need to know anymore. I never had anything over a hundred dollars, and so if you could count to a hundred, why you had the whole thing done."

In a final attempt to come to an agreement, on November 9, 1922, representatives from the seven states met once again, this time in Santa Fe, New Mexico. The town was chosen because it had earned a reputation as the "peace city" of the nation. After a fifteen-day session, on November

24, the representatives created the Colorado River Compact. The route of the Colorado River was divided into two basins, with the split occurring at Lee Ferry in Arizona near the Utah/Arizona border. According to the compact, the states of the upper basin—Colorado, New Mexico, Utah and Wyoming—agreed to never let the flow of the Colorado drop below 75 million acre-feet for ten consecutive years. Additionally, all water stored in the upper basin that was not designated for beneficial use had to be allowed to flow to the lower basin states of Arizona, California and Nevada.

While all seven states had a hand in creating the compact, Arizona was reluctant to ratify it. Regardless, less than a month later, on December 21, 1928, President Calvin Coolidge signed the Boulder Canyon Project Act (later known as the Swing-Johnson Bill), which provided for "the construction of works for the protection and development of the Colorado River basin." Even with the passage of the bill, Arizona still refused to ratify the compact; its reluctance proved a stumbling block for the next five years. The holdup was due to the state's desire to have the waters of the Gila River—a tributary of the Colorado—be exempt from the "demands of Mexico or the Imperial Valley." Arizona had no intention of signing until it got that exemption.

By 1929, Arizona's refusal to sign was creating quite a controversy. So much so that in February of that same year, delegates from Nevada, California and Arizona were ordered by their respective governors to meet at a Tri-State Colorado River Conference and reach an agreement. The conference, which was once again held in Santa Fe, was chaired by William J. Donovan, assistant to the U.S. attorney general. In March of that year, the *Las Vegas Age* reported: "Because of a misguided public opinion on the part of a portion of her people, Arizona seems to have lost sight of the tremendous benefits the great project will bring to her and to have chased off after an illusive [*sic*] and unattainable will o' the wisp."

Las Vegas was probably the most nervous about Arizona's holdout—likely because it had the most to lose. It had been struggling since the Union Pacific Railroad withdrew its service and repair yards over a labor dispute. The little town was in serious danger of being swallowed up by the desert and simply disappearing—something it was bound and determined not to do. Las Vegas's leaders saw the dam as exactly what they needed to give their town a lifesaving boost. So much so that in anticipation of Arizona finally ratifying the compact, Las Vegas mayor J.F. Hesse named Sunday, February 17, 1929, "Ratification Sunday" and set it aside as "a day of prayer and supplication." The mayor requested that all places of business "suspend their activities until twelve o'clock noon," for the purpose of "permitting

those in their employ to attend services at their respective church edifices where prayer will be offered for Divine Guidance for the delegates at this importance conference." The local newspaper, the *Las Vegas Age*, encouraged "every Las Vegan and every visitor" to set aside an hour on Ratification Sunday to "attend the services in their own churches."

Dr. Roy W. Martin, a delegate from Nevada, reported that his Arizona counterparts were "in good humor and ready to talk business," adding that he expected a "favorable agreement to be reached by Monday night." Unfortunately, Martin's expectation would not be met. When the smoke cleared at the conference, Arizona remained firm on its refusal to sign. However, the conference wasn't for naught. Shortly after that second Santa Fe gathering, Utah's governor George Dern pushed for an immediate ratification by his state—it was all that was needed. The Colorado River Compact, which would later also be known as the Santa Fe Compact, was agreed to and signed by the six remaining states.

With the approval of Congress, the seven-state compact was ratified— without Arizona's approval—and on June 25, 1930, President Herbert Hoover greenlighted the building of a dam in the Black Canyon. The terms of the Boulder Canyon Project Act dictated that enough revenue would

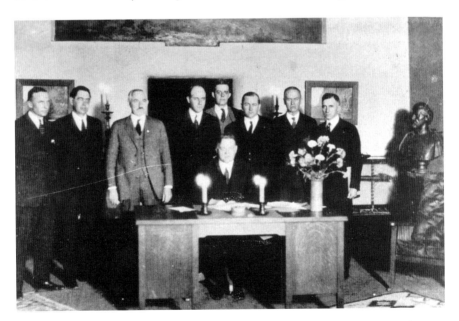

Members of the Colorado River Commission signing the Colorado River Compact in Santa Fe, New Mexico. Herbert Hoover is seated. *Courtesy of Boulder Dam Museum. Reuel Leslie Olson Collection.*

be produced from the power plant "to pay for the entire cost of the dam and appurtenant works." It was also indicated that the building of the dam would "yield a very substantial income" for Arizona and Nevada.

Ray Lyman Wilbur

From my very first day I showed a lack of superstition
by being born on the 13th of April.
—*Ray Lyman Wilbur*

The actual construction of the dam now fell squarely on the shoulders of the secretary of interior, who was tasked with "the responsibility of making the project a sound financial undertaking." It was the secretary's job to "see that the Government is protected in its investment by contracts that will repay the U.S. Treasury, in full, all moneys advanced, together with interest." Basically, it was the secretary's job to secure contracts that would allow the government to reap a certain level of income through the sale of power. These contracts had to be obtained before construction on the dam could begin. The man who took on this task was Ray Lyman Wilbur.

The man who would be responsible for building the Hoover Dam was born on April 13, 1875, in Boonesboro, Iowa, the fourth of six children to Dwight Locke Wilbur and Edna Marie Lyman. At the age of twelve, Ray Wilbur moved with his family to Riverside, California, where his interests and ideas began to form. "As I look back, though, upon the attitudes I developed in regard to education, religion and politics, I think the discussions I heard at the family table and the books that were available in the family library had more influence upon me than the schools or anything else," he wrote.

The six-foot, four-inch Wilbur attended Stanford University in its second year of establishment, graduating with a BA in 1896 and a MA a year later. Wilbur had been interested in Stanford University since he first heard that former California governor Leland Stanford was to donate his entire fortune to the establishment of a school devoted to higher education. "I particularly liked Mr. Stanford's idea of what education should be, that it should be for 'direct usefulness in life,'" Wilbur wrote. It was an interest that would stay with him most of his adult life.

Wilbur began teaching at Stanford in 1896, eventually graduating with a medical degree from Cooper Medical College in San Francisco. In 1900,

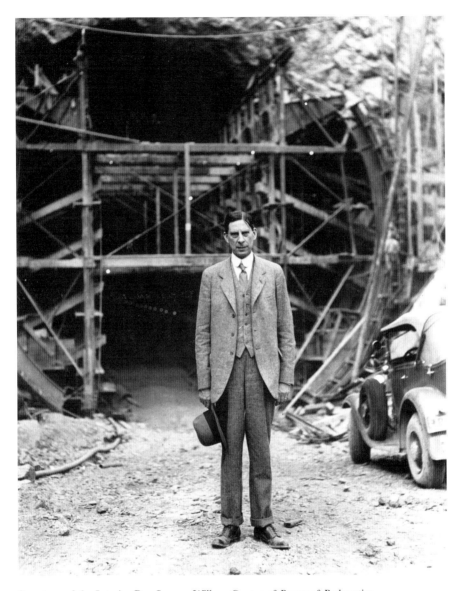

Secretary of the Interior Ray Lyman Wilbur. *Courtesy of Bureau of Reclamation.*

he became an assistant professor at Stanford. He stayed there even while practicing medicine; nine years later, he became a professor of medicine. Two years later, he became the dean of Stanford's newly established California Academy of Medicine and, in 1916, was chosen as the president of the school—a position he held until 1943.

A champion of social hygiene his entire life, Wilbur also served as president of the American Hygiene Association (1936–48); president of the American Medical Association (1923–24); president of the Association of American Medical Colleges (1924); president of the California Society for Promotion of Medical Research (1915–38); and chairman of the White House conference on child health and protection (1929–31). On March 5, 1929, Wilbur was nominated to the position of secretary of interior by President Herbert Hoover. He was confirmed by the senate and took office the very same day. Wilbur immediately went to work on the building of Boulder Dam.

Secretary Wilbur took over his position at one of the worst periods in American history. In October 1929, the stock market crashed, sending Americans spiraling into the "deepest and longest-lasting economic downturn in the history of the Western industrialized world," according to the History Channel. The Great Depression, as it came to be called, put millions of people out of work, forcing them into soup and bread lines and causing them to do anything they could to get enough money to feed their families. Simply making ends meet was not a possibility. Even those lucky

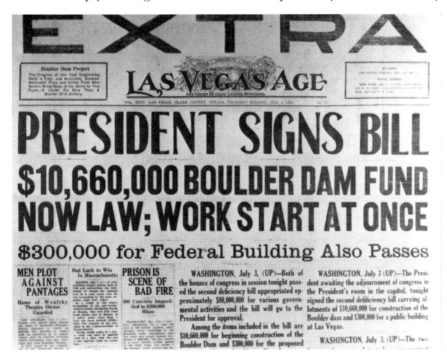

The *Las Vegas Age* headline for July 3, 1930. *Courtesy of Boulder Dam Museum.*

enough to keep their jobs had their wages garnished. It didn't take long for most people to lose their homes and, in many cases, everything they owned. By 1930, four million people were looking for jobs—a number that would increase to six million only a year later.

The impending need to contain the Colorado, combined with the immediate need to put thousands of Americans to work, created an urgency to get the ball rolling on the dam as soon as possible. This meant the two years that would have most assuredly been allotted to prepare for bids had to be cut substantially. Less than a year before the bids were accepted, on July 7, 1930, Secretary Wilbur sent a one-sentence telegraph to the commissioner of reclamation, Dr. Elwood Mead: "Sir: You are directed to commence construction on Boulder Dam today." Four days before, the *Las Vegas Age* reported on its front page that the president had signed the bill and the Boulder Dam Act was now law, adding that work was to start at once. Mead immediately established headquarters in Denver, Colorado, and put 175 engineers to work on creating plans and specifications. Within six months, by December 1930, the government was ready to call for bids.

Six Companies, Inc.

On March 12, 1931, the *Los Angeles Times* wrote, "Notice of the formal award of the Boulder Dam contract to Six Companies Inc., of San Francisco was received here as Frank T. Crowe, construction superintendent for the company, reached the new city near the dam site to prepare the way for the movement of necessary equipment to get the work started." The paper further noted, "A trainload of equipment is ready at Salt Lake City to move at a moment's notice." Crowe told the *Los Angeles Times* in a phone interview on that same day that "his concern will be able to start work within thirty-six hours of receiving the order to go ahead." This was most certainly true, because even before the contract was officially signed, Crowe had spent more than $300,000 on equipment and supplies.

The Boulder Dam was the largest project the United States had ever undertaken to that time. According to George A. Pettitt:

> *It meant the careful estimating of costs on a long program of hazardous construction involving more rigid requirements and more varied types of work than ordinarily fall to a contracting firm in a lifetime of practice. The*

amount of money concerned was so large, and the amount of preparatory work required so great, that even minor errors in calculation might result in bankruptcy for the contractor.

It would take a special construction company, one with a great deal of experience, to even know what to bid, let alone actually build the dam. Since such a company didn't currently exist, it had to be created.

As the name suggests, the Six Companies was formed by a conglomeration of six different companies, namely: W.A. Bechtel of San Francisco, California; Henry J. Kaiser of Oakland, California; Utah Construction Company out of Ogden, Utah; MacDonald & Kahn Company of Los Angeles, California; Morrison-Knudsen Company from Boise, Idaho; J.F. Shea Company out of Portland, Oregon; and the Pacific Bridge Company, also out of Portland, Oregon. "In submitting their bid for Boulder Dam they presented for the Government's consideration a combined record of 3,024 contracts completed, with a total value of $409,000,000, and not one default in the lot of them," wrote Pettitt.

Six Companies chose Frank T. Crowe as its superintendent, and he was the perfect man for the job. "Frank Crowe was a genius for organized thinking and for imparting organized thinking to other people," said *Las Vegas Age* journalist Elton Garrett. Crowe, a graduate of the University of Maine, had been employed by the Bureau of Reclamation for twenty-one years. In that time, he had assisted in the construction of the Jackson Lake Dam in Wyoming, the Tieton Dam in Washington, the Arrowrock Dam in Idaho and the Flathead Dam in Montana—on which project he was the construction manager. "I built dams before Boulder, Arrowdock Dam in Idaho, Jackson Lake in Montana, and Tieton in Washington," said Crowe. "Those were practice for the big one. I was able to perfect the mechanical systems to carry the concrete and equipment."

If there ever was a man born to build a dam, it was Frank Crowe. "I was wild to build the Dam," said Crowe, who had had his eye on the construction of Boulder Dam for years. "I spent my life at the river bottoms since graduating from University of Maine with an engineering degree in 1905. When I heard Frank Weymouth's lecture at the University I had to follow the dream, the dream of reclaiming the West. I worked all over the west, but my mind was on the Colorado. Back in 1921 I told Marion's [Allen] father that I am going to build the Boulder Dam."

Crowe knew engineering. More importantly, he knew how to construct a dam, so much so that it was Crowe who put together Six Companies'

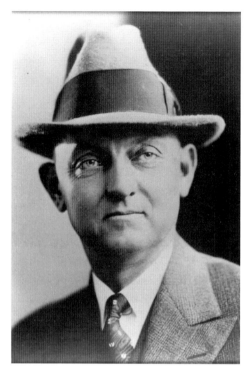

Construction superintendent Frank T. Crowe.
Courtesy of Nevada State Museum.

winning bid. "Knowing Mr. Crowe for over twenty years," said Hoover Dam worker Marion V. Allen, "I have every reason to believe he had completely built Hoover Dam mentally before he submitted the bid. It was still a big gamble. Some might prefer to call it a calculated risk." Six Companies' winning bid was only $24,000 more than the cost estimated by the bureau's own engineers. "I'll never forget the day the bid was chosen," said Crowe, "with us waiting in the room, the envelopes opened. My bid came in at $48,890,955, only $24,000 more than the Bureau's estimate. The government considered it to be a 49-million-dollar job—so just a 0.05% difference."

While the difference may have been small enough to get the bid, it left little room for inefficiency or mistakes. Six Companies estimated the cost of placing concrete at $2.70 per yard. Its nearest competitor, the Arundel Corporation, placed it at $4.15 per yard. "If this latter figure were right," wrote George A. Pettitt, who authored *So Boulder Dam Was Built* for Six Companies, "the Six Companies stood to lose several million dollars and go broke." But the firm wasn't worried. "They had arrived at their contract bid, low as it was, by exceedingly careful computations based not on guesses nor on opinions borrowed from others, but on a fund of first-hand information gleaned from works completed during a period of a third of a century or longer," wrote Pettitt. As it turned out, the company was right.

Las Vegas and the Dam

*With Block 16 in Las Vegas and all the entertainment that even in those days
Las Vegas had, Uncle Sam's people had a hunch they should protect the workers
from those temptations to a certain extent.*
—*Elton Garrett, journalist and Boulder City resident*

On a cool winter day, December 21, 1928, when the news was announced that President Coolidge had signed the bill announcing the building of a dam in Black Canyon, the tiny town of Las Vegas went wild. "Las Vegas had been looking forward to that for a long time," said resident Elbert Edwards. "The business community recognized that as holding the potential for the future of Las Vegas." Las Vegas resident Dean Pulsipher was a mere eighteen years old when the early Christmas present came. "That was the beginning of Las Vegas. That put Las Vegas on the map," he said. "Everybody in Las Vegas was out celebrating until the wee hours of the morning, and I was one of them. I was out there celebrating right up until the time I had to go to work."

"When that bill was signed, they just broke loose with everything they had in celebrating," said Edwards. "The volunteer fire department turned out in full force, leading the parade. Bootleg alcohol liquor just flowed like water." Leon H. Rockwell was one of the people celebrating. "We got the fire truck out," he said. "Everybody that could hooked on to it! In carts and baby buggies and everything else—just like they was nuts." Of course not everyone celebrated with alcohol and revelry. "Somebody hit upon the clever idea of having a meeting on the banks of the river as a thanksgiving for the passage of the bill," said Las Vegas resident Charles Squires. "Perhaps 100 people made the hard drive from Las Vegas over the sandy, unimproved roads and knelt in the sand on the banks of the river while a prayer of thanksgiving was offered."

It is easy to forget that in 1928, Las Vegas was a town in its infancy, little more than twenty-four years old. It had struggled through many of those years and was feeling the effects of the Great Depression. The Union Pacific Railroad had pulled out of the town in a dispute over labor; the creation of a dam and the promise of work was a godsend. "I didn't find a whole lot in Las Vegas that was opposed to the building of the Boulder Dam," said Pulsipher. The town took action even before the dam began construction. "The Chamber of Commerce in Las Vegas was actively promoting, as you might expect them to do, whatever would

heighten the adequate facilities to take care of people who would be streamlining in," said *Las Vegas Age* journalist Elton Garrett. "They knew people would stream in as workers, as tourists, as journalists from afar who wanted to get in on the act." In 1929, the *Las Vegas Age* reported, "We are not dealing with the Las Vegas of the past twenty years, but with the new city which…will inevitably be built here whether we wish it or not."

In celebration of the dam, Secretary Wilbur was invited to Las Vegas, but he wasn't fooled. They had set up welcoming banners, held a parade and even shut down the brothels while he was there, but none of it had any impact. Las Vegas had welcomed Wilbur with open arms, but in his eyes it was a town of sin. He had no intention of letting that brew of temptations lure his workers, like sirens, into the depths of depravity, let alone housing his men there. Still, the secretary smiled, shook hands and played the cordial politician. But when it came right down to it, he had other plans—ones that didn't involve gambling, drinking and legalized prostitution. No, the secretary knew all along, well before his visit to Las Vegas, that he intended to build his own town. It would not only house the dam's workers, but it would also stand as a beacon of modern construction and efficient planning.

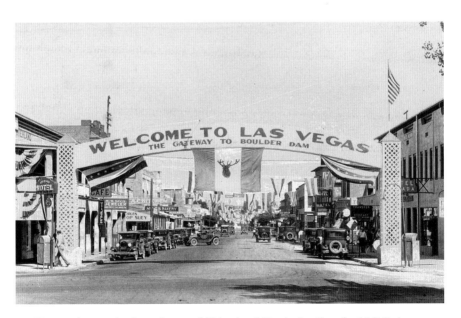

Las Vegas welcomes the dam. *Courtesy of University of Nevada–Las Vegas Special Collections.*

While Wilbur's unfavorable view of Las Vegas was a factor in the decision not to have the town house the workers and their families, there were other significant factors as well. Certainly, the foremost of these was the fact that Las Vegas was more than twenty miles from the dam site. Getting three shifts of workers to and from the site every day over twenty-five miles of road—even if the road was to be paved—would be a daunting task. Such a task would, at the very least, require lengthy travel and, at the worst, limit the amount of sleep the workers got between shifts. It was important to keep workers who would be handling explosives and scaling steep, rocky cliffs sharp and aware.

This last factor certainly also contributed to the decision not to house workers in Las Vegas. Staying up all night drinking and being entertained would make for groggy, dangerous workers. Also, having entertainment so close to one's fingertips might entice some men to spend more money on vices than their pitiful budgets could bear. Neither Six Companies nor the government wanted to deal with workers who, having squandered their money on entertainment, would be unable to make ends meet.

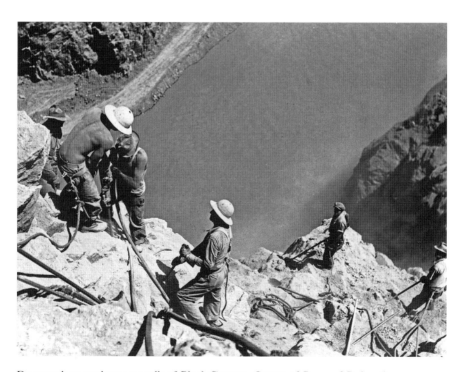

Dam workers on the steep walls of Black Canyon. *Courtesy of Bureau of Reclamation.*

A NEVER-SAY-DIE ATTITUDE

From its very inception, Las Vegas was a town marked by its resiliency. While Secretary Wilbur may have had plans to keep his men from going to Las Vegas, he certainly couldn't keep Las Vegas from coming to them. Almost immediately, the Clark County Road Department began construction on a road between Las Vegas and the spot where Wilbur planned to build his city. "It was just a gravel road and a corduroy road," said Pulsipher, whose job it was to drive a truck pulling three six-foot rails to create the road. "We'd just knock the tops off and then fill the chuck holes up." Bureau of Reclamation hydrographer Leo Dunbar recalled the road: "The highway was anything but a good highway between [Boulder City] and Las Vegas. It wasn't even graveled yet when I first arrived." So eager were the town's leaders to become part of what would eventually capture the attention of the entire country, the chamber of commerce even erected a billboard on the side of the road, claiming Las Vegas to be the "Gateway to Boulder Dam."

Las Vegas even held a Boulder Dam Rodeo, which it scheduled for April 6 and 7, 1929. The *Las Vegas Age* promised "fifty head of the wildest outlaw

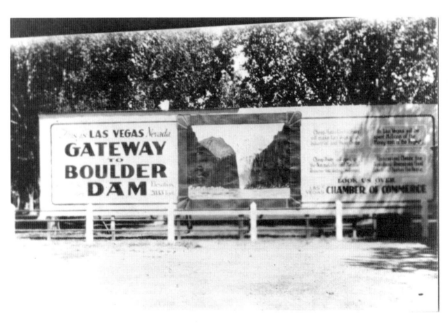

Billboard claiming Las Vegas to be the "Gateway to Boulder Dam." *Courtesy of Boulder Dam Museum. Keeler Collection.*

horses from the western range country and a carload of longhorned steers." It also said there would be "a bucking horse competition, bulldogging, steer roper, horse racing, trick riding, fancy roping, clowning, and, as an added attraction, the bulldogging of a steer from a popular make of automobile by the man who originated the event." Rodeo manager "Chub" Morgan was so excited about the rodeo that everyone who rode a horse in the parade was promised free admittance to the grounds. The Union Pacific even offered "special rates" from Los Angeles and Salt Lake City to Las Vegas for the event. But the town's preparations, much like its celebration, would prove to be in vain.

While the chamber took action, the residents of Las Vegas themselves prepared for the inevitable onslaught of workers and their families, who would most certainly visit Las Vegas, shop in their stores and eat in their restaurants. But the town didn't expect the onslaught to occur almost instantaneously. From the very beginning, the Boulder Canyon Project attracted hordes of people looking to find a better life. "We came from Kansas," said eventual Boulder City resident Mary Eaton. "We were victims of the Depression. My husband found out that they were going to build the Hoover Dam, Boulder Dam. This was the only place we knew that there was any work." Once the dam was announced, every able-bodied man packed up everything he owned and headed to Las Vegas looking for employment—some with, and some in advance of, their families. While Secretary Wilbur's city was little more than a mirage in the desert, Las Vegas was being descended upon.

"This was the Great Depression," recalled Leo Dunbar, "the period of 1928 to 1932 or '33. The fact that there was going to be work here induced people to come in here—not only the men, but their families came with them. They just picked up whatever they had and loaded it into a truck and drove here all with hopes of getting a job." *Los Angeles Times* reporter Ben S. Lemmon wrote an article in 1929 after a recent visit to Las Vegas: "Las Vegas is booming in anticipation of the construction of the Boulder Dam. After 6 p.m. it is pretty hard to engage a room in this town right now. Obliging taxi drivers hover near the downtown hotels and will transport you to private homes where rooms for the night may be rented for $2 per up to $5."

Las Vegas became the hiring headquarters for the Six Companies, and the Union Pacific depot yard quickly became a gathering place. "I remember going to Las Vegas and seeing at least a thousand people laying in the Union Pacific depot yard, a thousand of them sleeping there. Every

male in the group was waiting for his name to appear on the want list, meaning they had a job," said Dunbar. "That first night they slept on the depot platform," recalled Boulder City resident Erma O. Godbey, speaking of her husband and a friend. "The depot didn't even have a roof on the depot yet. Then they found out there was a chance of getting a job, although there were a lot of people already here trying to get work that hadn't yet." Thomas Wilson remembered the scene when he arrived in Las Vegas. "We got to Las Vegas in late afternoon—maybe 4:30—and came down the street, and I was sitting behind the driver, and I asked, 'Is there going to be a parade or something?' He said, 'Why do you ask?' I said, 'Well the streets are just black with people standing on the sidewalk—all these crowds.' He said, 'Oh, those are men waiting for jobs on the dam.' And they were!"

When Frank Crowe arrived on March 11, 1930, he was faced with the stark reality of just how many people were looking for jobs. Just as quickly as he was recognized, he was approached by down-on-their-luck men looking for work, their families literally starving. "I knew that with the Depression that this might get a response but I was surprised when I got to town," said Crowe.

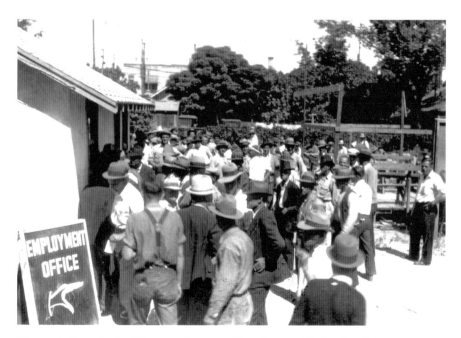

Workers in front of a Las Vegas employment office. *Courtesy of Boulder Dam Museum.*

I went to our office at the Clark Building in Las Vegas and saw that the streets had thousands of men waiting to apply. Men like John Gieck, who had been a rough neck in Long Beach making three dollars a day. Men who came from all walks of life, who had never been around a dam, musicians, store managers, and bankers. I respected men who had the skill and ambition to ask for the work, like Milton Mudron, a young carpenter who drove out from New Jersey, ignored the No Trespassing signs, found the carpenters. He showed his work and was hired.

"In Los Angeles it is common report that 5,000 people are living in tents in Las Vegas right now," wrote Lemmon. "That is a slight exaggeration. It isn't that bad. But there are several hundreds of persons temporarily domiciled in tents and shacks and not a few have found it more desirable to curl up in their cars for little repose than to accept what was left in the way of hotel accommodations after nightfall on the desert." Maybe there weren't 5,000 people in tents when Lemmon came to town, but it didn't take long for that to happen—and for more people to arrive. With so many people rushing to Las Vegas, the tiny town was pushed to its limits. "If you haven't lived through it, you can't imagine what would happen to a little railroad community of 5,000 people having about a good 10,000 to 20,000 people dumped on it all at one time," said journalist John Cahlan, who came to town at the request of his brother A.E. Cahlan, publisher of the *Las Vegas Evening Review and Journal*.

The water company couldn't supply water, because the charter wouldn't allow them to provide any for any places outside of the original townsite. Believe me, it was terrible! They just didn't know what to do. I mean, nobody knew what to do, because they were here and some of them could get jobs on the dam and some of them couldn't. You had problems—people problems. We just did the best we could.

Shortly after Crowe arrived to find tens of thousands of workers looking for thousands of jobs, the *Los Angeles Times* warned people not to come to Nevada looking for work on the dam. It posted a notice titled "Laborers Warned" that read: "Warning was again posted by the Interior Department against labor migrating to the site in the hope of gaining work. There is already a superabundance of labor gathered in the dam site vicinity, which has imposed a considerable burden on the town of Las Vegas to keep suffering and hunger at a minimum." The post further stated, "Between

2,000 and 3,000 men will eventually be employed in the construction of the dam, according to present estimates, but there are more than 10,000 men now available near Las Vegas, according to recent reports." Construction superintendent Crowe also encouraged people not to come looking for work. "No work will be available for some time," he said. "I already have three men for every job."

The *New York Times* also discouraged people looking for work on Boulder Dam.

> *The site of the dam is in one of the wildest and most inaccessible parts of the United States. It is a furnace in summer, and often bitterly cold in winter. There is little in the surrounding country for hundreds of miles to sustain life or provide a living. There are no jobs, there is no legitimate real estate boom. There is nothing but untold miles of burning desert and barren mountainside. Keep away from Boulder Dam. There is no dam—yet, only disappointment and loss for the man who treks west without knowing where he is going and what he is letting himself in for.*

It didn't matter. They still came. "They came in broken-down cars and they walked in," said Walker Young. Desperate for jobs, they brought "their families, babies, and everything they owned. They kept coming." It was easy to see why, by January 1930, "the number of men employed in industry had dropped to 83.4 per cent of what it had been even ten years previously," wrote George A. Pettitt in *So Boulder Dam Was Built*, a book he authored for Six Companies in 1935. "By July 1930, employment was down 73.4 per cent of its former total. Something had to be done to relieve the situation." That something was the Boulder Dam, and it was "materialized with a speed that has never before been equaled in engineering history," wrote Pettitt.

Crime was the biggest concern. "When I came to Las Vegas," explained Cahlan, "I came with the first chief of police. Prior to that time, they had two constables—a daytime constable and a nighttime constable. We didn't have anything but a volunteer fire department. We had a police force that had three members on it before the dam started." Crime was never an issue before the masses arrived, partly because the town was so small, but more so because of Las Vegas's location between the Mojave Desert and Death Valley. "There was very little crime in Las Vegas, mainly because of the fact that if you committed a crime, there was no way to get out of here," explained Cahlan. "You couldn't go out in the desert and escape, because if you did, you never came back."

A family with all their worldly possessions looking for a job. *Courtesy of Bureau of Reclamation.*

As one might expect, an influx of homeless, jobless and hungry people created issues. "We had an awful problem with the vagrants who came in here from other parts of the country and expected to get jobs right away," recalled Cahlan. "They couldn't get jobs right away. They had no money, and we had to get them out of here. Some of these people would get hungry and they'd go break into some houses so they could get money, or steal stuff from a grocery store." John Gieck who also came to Las Vegas looking for a job on the dam, recalled one such incident: "Couple of guys got ahold of a crate of cantaloupes and took them out where men was looking for jobs. They went at 'em like a bunch of pigs."

Las Vegas came up with a way to solve this problem. "The merchants put money together and hired people to watch their stores at night," said Cahlan.

> *You see, there again the community had no money to do these things, didn't have enough money for a patrol at night. The merchants would*

confer very much with all the members of the city commission. I mean, Las Vegas still was a small town, and everybody knew everybody else. That was the reason the "merchant police" was formed, because the city just couldn't afford it.

A TALE OF THREE...OR FOUR...CITIES

Possibly, excepting the Panama Canal, Boulder City is the most famous construction camp established by our government.
—Ray L. Wilbur Jr.

The Hoover Dam was the largest construction project the United States had ever undertaken. And it did so in the heart of the most difficult economic times the country had ever known. But even from the very beginning, Hoover Dam was destined to be different from any other dam that had been built. In most cases, during dam construction, tent-based camps—whose sole purpose was to provide a resting place for workers—were quickly erected, and they were just as quickly taken down once construction was complete. Maybe it was the magnitude of the project, or maybe it was Secretary Wilbur's vision, but the Hoover Dam, and everything associated with it, would prove to be atypical. There was never any thought of not establishing a town or of building the Hoover Dam with the usual construction-style campsite. Wilbur and the Bureau of Reclamation made that clear to Congress:

In a desert country of extreme heat with other conditions not naturally attractive and conducive to comfort and contentment, a temporary construction camp operated on a plan which might be feasible elsewhere, would be extremely inadequate at this point. On large construction work, particularly in the West, where natural conditions are not alluring, the necessity of providing comfortable quarters and other conveniences for

bodily comfort and enjoyment, not neglecting recreational and entertainment facilities, is now well recognized.

Congress agreed, and on July 3, 1930, President Herbert Hoover signed the Second Deficiency Appropriation bill, which allocated $10,660,000 for the construction of what would later be called Hoover Dam. A portion of that money, $525,000 was earmarked for buildings, streets, water and a sewer system for the town Secretary Wilbur would name Boulder City. Much of the construction was the responsibility of the Six Companies. In fact, the contract it signed said explicitly, "The main camp of the contractor and homes for not less than eighty (80) percent of the contractor's employees shall be established and maintained in Boulder City." The other contractor, Babcock and Wilcox, was also bound to "house at least 95% of its employees in Boulder City." Not only was Six Companies ("the contractor") responsible for building its offices and its employees' homes, it was bound to build them in Boulder City. True to his resolve, Secretary Wilbur managed to keep the men and women who would be responsible for building the dam away from sin-filled Las Vegas.

The original plan called for Boulder City to be completed long before construction on the dam even began. It was intended that when the workers arrived with their families, instead of finding dirt, dust and desert, they would find a clean, model city waiting just for them. However, there was little chance of that happening. So many people were descending on the area that Wilbur had little choice but to get unemployed men to work as soon as possible. Congress had already authorized the expenditure to build Boulder City, so Secretary Wilbur wasted no time in beginning the construction of his new town. The task fell to construction engineer Walker R. Young. But before Young could get started, there was much work that needed to be done.

Ragtown

You were really just existing.
—Ragtown resident Helen H. Holmes

It was hot, unbearably hot, and she just wasn't accustomed to the severe heat. Sure, it could get hot where she came from, but nothing like this. And why wasn't it getting any cooler as the evening came? Why was it getting hotter?

She took another sip from the ice-filled Thermos her husband had left her, but it was no use. Her knees were getting weak, and she was unable to stand for more than a few minutes without having to sit. She was in trouble and needed help. Her husband worked in the diversion tunnels, so there was no way of getting a hold of him. Even if she could get a message to him, it's not like he could leave his job—he'd be replaced in an instant.

When she moved to the desert with her husband from New York, she had taken all her worldly possessions. There wasn't much: a prize fur coat and her big dog. The coat couldn't help her now, but maybe the dog could. She grabbed some scrap paper and, sitting on the edge of a folding cot, scribbled a hasty note to U.S. Marshal Claude Williams, the man in charge of the camp. "Come get me," she wrote, "and take me down to the river so I can cool off." Then she tied the note to the dog's collar and sent him away. "Go find Williams," she told the dog. "Go find Williams!"

Williams was on the other side of the camp when the dog finally reached him, barking. Williams was at first confused, but he knew his camp and he knew who that dog belonged to. It was then that he noticed the note. He sprinted across the camp, racing the dog as it ran home. But when he got inside the tent, all he saw was a woman lying across a folding cot, not breathing.

"There were three of us that went over into her tent," said Ragtown resident Erma O. Godbey. "We kind of straightened her up on the bed." Word was sent to her husband, who tried to resuscitate her the moment he arrived. But it was no use. "The woman had been dead for probably an hour by the time he got there," said Godbey. The distraught husband then began asking if anyone needed a fur coat. "We all just batted our eyes hearing this in over 120 [degree] heat," said Godbey. "Who in the heck would want a fur coat?" Then it dawned on Godbey why the man was asking. "We got to thinking later that what that poor man was trying to do was get enough money out of the fur coat to bury his wife."

Even before construction on the dam began, people started pouring into the area. Many stayed in Las Vegas, hoping to see their names on the work board, while others decided to take their chances a little closer to where the construction would actually take place. One of the first settlements to pop up was a little area called Williamsville, but it came to be known by its residents as Ragtown. "It looked like Ragtown," said Godbey. "It looked like any place that is just built out of pasteboard cartons or anything else." Las Vegas resident Dean Pulsipher agreed. "It was all tents," he said. "The better people had boarded-up tents. They built them up three or four feet. They had canvas stretched over the sides and over the top." Those with

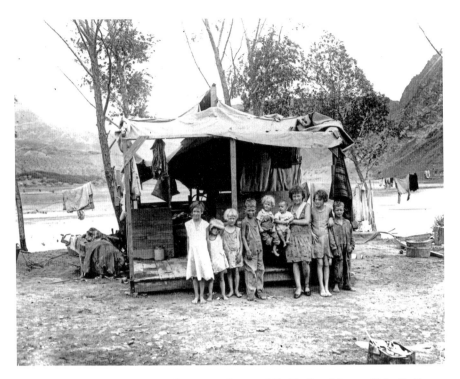

Family outside a makeshift tent in Ragtown. *Courtesy of Boulder Dam Museum. Union Pacific Railroad Collection.*

tents were the lucky ones. Most people were left out in the open, exposed to the hot Nevada sun, gathering whatever materials they could to make homes. Packing boxes, cardboard cartons, flattened gasoline tins and even tarred roofing paper became building material for makeshift abodes. Burlap was pressed into service as coverings for door and window openings in an attempt to keep the structures cool and relatively free of sand. It didn't work well on either part.

"We left Las Vegas and came out to the river, down to Williamsville, later known as Ragtown," said Ragtown resident Velma Holland.

> *The moon was shining on that river, and it was the most beautiful silver strand you ever saw in your life. It was about that time that the song was popular, "Where the Silver Colorado River Played." Well, there it was. I seemed to get a thrill out of it. I knew the song, and there was the silver Colorado. We came in and took enough off of the truck to pitch beds. We went to bed. We got up the next morning. I looked out, and right down there*

it was awful—tents, big wood-colored stuff that had looked so beautiful the night before in the moonlight. It was right at the edge of the water. There were about 500 tents there over quite a large area clear back to the bank. Some didn't really even have a tent, and a lot of them with little children. I imagine the first week or two, or maybe even month, we wouldn't go very much or do very much at all except just live, exist. I don't know how I stood it.

Ragtown was located along the riverbank, at a bend in the Colorado, in the valley below the plateau upon which Boulder City would eventually be built. The makeshift town was home to close to one thousand men, women and children who had come to the area in the hopes of finding work. "Somewhere around a thousand families at one time were camped on the riverbank," said Bureau of Reclamation hydrographer Leo Dunbar. The camp was named after Claude Williams, who had what was described as a nice home near the camp. In his late twenties, Williams was a "rather cocky individual, well-dressed, neat, very courteous to everyone, an easy man to talk with," recalled Young. Williams was in charge of the camp. He had a reputation of doling out justice with one hand and provisions to the needy with the other. "I thought he was a rather good selection to handle those people who had moved there and who had run out of money and were trying to establish places to live," said Young. "He was, I think, rather satisfied with his own accomplishments, which we were also. He did the job very well." Erma Godbey remembered Williams as "a good man in every way. He was trying to keep [the camp] as sanitary as possible. He never caused anyone any trouble that I know of."

When the project got started, Ragtown was the first place people came looking for work. When Erma Godbey arrived with her husband, Tom, and their four small children from Colorado, they stopped at the Six Companies camp, the area that would eventually be turned into an airport for Boulder City. "It was all tents," she said. "We stopped there and asked about a job." But instead of getting a job, they were sent down to a settlement at the river bottom. Like many of the other people who came to Ragtown, the Godbeys did what they could to set up camp. "All we could do was just put our mattresses on the ground and get ready to go to sleep because it was pretty doggone late," said Godbey. "We ate whatever I brought along as a luncheon thing, because we had no stove or anything."

Most "tent" homes in Ragtown were simply a piece of canvas or a blanket stretched across two poles. Godbey and her husband's new home fell into

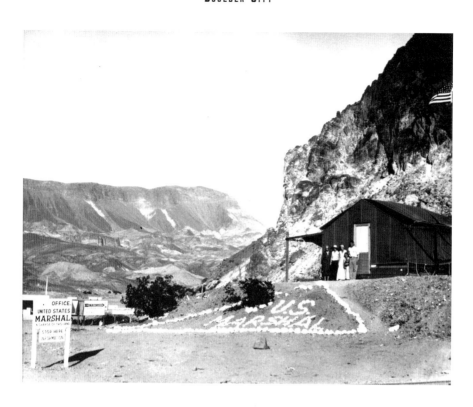

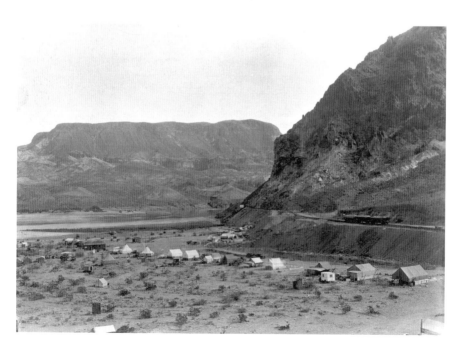

that category. It consisted of two double bed blankets made of pure wool she had brought with her. "They cost me $32 a pair," she said, "which was a lot of money in those days when men were only making four bucks a day wages." She and her husband found some poles, drove them into the ground, strung a clothesline between them, and "pinned those beautiful wool blankets with safety pins to these poles to try to make a little bit of shade from the terrible heat."

Godbey's mother had accompanied them on the trip. She was a tough woman who had driven cattle from Texas to her home in Colorado when she was but eleven years old. It was Erma Godbey's mother's seven-passenger Dodge touring car that had brought them there. As her mother turned to leave, she told her daughter, "Well, I'll never see you again." But Erma was from

Opposite, top: U.S. marshal Claude Williams and his family outside his Ragtown home. *Courtesy of Boulder Dam Museum. Union Pacific Railroad Collection.*

Opposite, bottom: The settlement known as "Ragtown" at a bend in the Colorado River. *Courtesy of Boulder Dam Museum.*

Below: Murl Emery's store. *Courtesy of Boulder Dam Museum.*

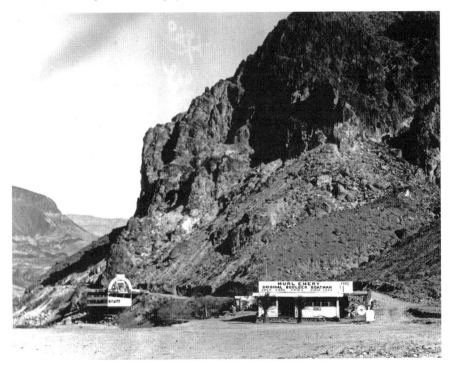

pioneer stock, and she had no intention of letting a little thing like 120-degree temperatures stop her. The Godbeys were eventually able to acquire the tent close to them, despite the signs forbidding people from selling structures on government property. The man who owned the other tent had died while working on the diversion tunnels, and his wife wanted out. "So we bought her out," said Godbey. "That way we had a small tent, but it still wasn't big enough for anything but maybe to do a little cooking in."

Food was purchased at a store run by Murl Emery. "He had a small store that was the only place that we could buy food unless you went to Las Vegas," recalled Ragtown resident Helen H. Holmes. Emery was a river rat who married and set up camp in Ragtown. He would get supplies at Las Vegas and bring them to the camp. Most items would sell even before he or his wife could get the prices on them. This created a great deal of confusion. "Everybody just paid him whatever they were used to paying for groceries wherever they came from before they came here," recalled Godbey. "The people from Texas would go and plop down thirty cents for a can of peaches. I was used to paying sixty cents for the same can, so I paid sixty cents," said Godbey. As you can probably guess, that made bookkeeping a bit of a nightmare.

"At first there was no electricity, so there was nothing but canned things and just things you could preserve like that," said Holmes. Everything purchased had to be cooked or consumed immediately. "There was no way to store food," said Godbey. "The only thing you could do was eat it as quick as you got it, because things would start to ferment. I decided very soon that the only thing my husband could possibly take in a lunch was hard-boiled egg sandwiches, because if you got anything like bologna, it would be green by the time the men could eat it."

As squatters moved into the area looking for work, Ragtown began to resemble a permanent settlement. At one point, its inhabitants were estimated to be anywhere from five hundred to fifteen hundred. While most residents of this makeshift encampment may have been poor financially, they were certainly rich in ingenuity. Whenever empty powder boxes—which held the dynamite used to create the diversion tunnels—were available, they were scooped up and used to sit on. Those lucky enough to have items such as ironing boards could place them atop two boxes to create a bench. Water was obtained indirectly from the river. "They had dug a couple of holes a little bit in from the river, and the river would seep through the sand and it would be pretty good," said Godbey. "The water would seep in there and it seemed to be a little cleaner," said Holmes. "You would go down to get a

pail of water, and then it would settle, and there would be sediment in the bottom so it would be clear."

Some people came up with more creative ways of getting water—namely, stealing it from the Six Companies' mess tent. Others drank the water straight from the Colorado River. "That is why there was a lot of dysentery," said Holmes. "Everyone was lined up to go to the Maggie and Jigs" (the name given to the outside toilets set up by the government). "They were real careful about keeping them with lime on account of the flies." The river was also used for bathing. "I wore my dress," said Godbey, "but no petticoat and stuff, and we'd wash up underneath and do the best you could without becoming naked for other people to see us." Of course, bathing in a swift-moving river came with certain hazards. "One day I was holding the baby by one leg and I darn near lost her in the river," said Godbey. "My husband managed to rescue her before she floated on down the river."

People weren't the only residents of Ragtown. Insects, tarantulas and scorpions would hide under boxes, looking for relief from the scorching heat. "I had suitcases underneath the baby's crib," recalls Godbey. "I pulled the two suitcases out one day to get some clothes, and two tarantulas came out and scared the devil out of me." Godbey hit the intruders with a stick and threw them on the fire she had outside for burning garbage. "Later I wasn't so afraid of tarantulas." Rattlesnakes and sidewinders would also come into camp looking for water or kangaroo rats. On one occasion, Godbey caught one of the snakes, skinned it and "made a necklace out of it with garnets in between."

While Ragtown did provide shelter, that shelter often came with a cost. Murl Emery remembered waking up one night to a sinking feeling. "Come on, we've got to go," he told his wife. "Come on, come on." She was unwilling, or just too hot, to move, so Emery grabbed her and shook her as he continued to yell. "Evidently there was something in my voice that gave her a warning," he said. His wife picked up their little child from the crib and ran out into the hot night. But Emery wasn't finished there. He woke up all the people in Ragtown, and as they emerged from their makeshift abodes, he herded them away from the campsite. When they finally were sufficiently awake to ask him what was going on, all he could say was, "I don't know." It was about that time that the ground began to rumble and the mountain behind them began to fall. "Rocks flying in every direction," recalled Emery, "and fortunately I had led everybody far enough away that nobody was hit by rocks." A man came down and apologized—they had been blasting a tunnel for the railroad and hadn't realized anyone was below

them. When Emery and his wife returned to their tent, the baby's crib was crushed. "Right to the floor," said Emery.

Heat was a constant in Ragtown. "It just seemed like the river drew the heat right down there," said Godbey. "You could just see the heat dancing off of the mountains." Walker Young recalled, "For one period of seven days, the temperature never got below a hundred and seven degrees Fahrenheit. The reason for that was the drift of that air was upstream through the canyon." During the day, the canyon walls absorbed the heat of the sun. At night, what breeze did blow collected the heat that had been baked into the rocks all day and passed that heat back out onto Ragtown. To stay cool during the day, people would take frequent trips to the river or dig a hole in the ground and sit on a powder box inside. At night, mothers would wrap their children in a wet sheet so they could sleep. Men and women would do the same. "The only way to get any sleep was to have a bucket of water alongside your bed," said Emery, "and you'd take your sheet and dip it in the water and pull it over you, and you'd just sleep for an hour or two."

"The biggest challenge I faced turned out to be the heat of the desert," said construction superintendent Frank Crowe. "We could not escape it. We all felt it. It was always in the hundreds, on up to 138 in some places. The men struggled, withered, and fell. I had been raised in a cooler climate, but I needed to be out there with the men. I had lost 27 pounds. After that first summer I was determined we would never live through that again."

The heat was so bad, it created an ever-present danger of death. In fact, three other women died the same day as the twenty-eight-year-old woman who sent her dog for help. "That was the twenty-sixth of July and it was terribly hot," Godbey recalled. "There was a woman that was sixty years old, and a girl sixteen, and another woman that I don't know how old she was or anything much about her." When Godbey's husband came home that day, she told him, "We've got to get out of here. We've absolutely got to get out of here."

COWBOY BILL'S CAMPSITE

Las Vegas was cut off from Boulder City, but that didn't mean the town couldn't profit from the dam workers. Certainly, it could provide heat relief in the way of a cooling libation or stress relief in the arms of a hired woman, but some Las Vegans took a slightly different approach. On

a ranch just outside of town, a man named Cowboy Bill charged people five dollars a month to have a place where they could set up a tent. It was here that Tom and Erma Godbey took their family when Erma decided they needed to get out of Ragtown. It was a marked improvement. Bill's ranch had trees to provide shade, and more important, it had water. "The artesian wells were just bubbling with water," said Godbey, "and they had streams along under trees."

"Everybody was pitching their tents under the trees and along by the streams," said Godbey. Such a situation put a premium on space. "You could just barely walk between," Godbey said of the tents. "So everybody knew what everybody else was doing, so if anybody spanked their kids or they had a quarrel, we all knew about it." While the residents of Cowboy Bill's camp were still in tents, their condition had improved remarkably. "Cowboy Bill had a second camp where he had bath houses, and he had fixed places where people could take a shower," recalled Godbey. He had outside toilets—complete with lime—and a big hole where garbage was burned. He even had a store where residents could buy items such as milk, bread and eggs. The only problem with Cowboy Bill's campsite was that it was far from the actual dam site. Unlike the Godbeys, as construction on the dam began, or as men got hired to work on the dam, they moved out of Cowboy Bill's campsite in favor of a location closer to the dam. After all, with so many people looking for employment, nobody wanted to take the chance of not being able to show up for work—not when they could so easily be replaced.

A Search for a Town Site

While Frank Crowe might be responsible for actually building the dam, the entire project fell under the jurisdiction of Walker Young. It was Young who supervised the team that made the recommendation to use Black Canyon instead of Boulder Canyon; it was Young who supervised the teams that surveyed the area; and it was Young who was charged with finding a place to build Secretary Wilbur's shining, modern city. In fact, finding a place to build the town was Young's top priority, not because he was looking to please Wilbur, but because Young understood the need to have a place where the workers on the dam could feel at home and, more importantly, could get away from their job between shifts. This was a huge concern, as construction of the dam was to go on twenty-four hours a day, every day of the year "except

a couple," said Young. Both Young and Crowe wanted to get their workers into a completely different environment when they were not engaged in the building of the dam. "We wanted them to forget all about the work at the dam site, what they were going through down there, and get away where they'd have a family life," said Young. As Crowe put it, "We were not just making a Dam, but starting a community."

Before Young could find the perfect location for Secretary Wilbur's town, he needed to find a place where he could set up his own camp. The area where Ragtown had sprung up wasn't an option, nor was placing the camp near the dam site, for two main reasons: heat and noise. "We knew that we were working in an area of extremely high temperatures," said Young. "For living quarters, the contractors had all the employees away from the dam site to get away from the noise." Finding the right location was a much harder task than it may initially have appeared, mainly because Young knew very little about working and living in the desert. He wrote in a letter to John F. Calhan, the previous news editor of the *Las Vegas Evening Review and Journal*, "My only experience in the desert was acquired on a prospecting trip made with a college classmate in 1909 from the Salome gold strike east of Blyth, California, to the south rim and river at Grand Canyon, Arizona." But as with everything he did, Young took the task seriously. "There was more to it than just locating a feasible dam site and suitable construction materials. One very important facet was to learn the environment in which the work would be performed," Young wrote, noting that on his previous experience he "did not learn to respect the desert and its washes."

Young's foresight would once again prove spot on. Hoover Dam worker and Boulder City resident Marion V. Allen would later write, "I think one of the reasons the construction work on the Hoover Dam went so well, even under such adverse conditions as the terrific heat, which never let up day or night until late fall; the floods; slides and falling rocks, [is that] all were coped with because after a shift was over we went back to Boulder City where we were able to relax and forget the job."

The first thought was to place the campsite in Hemenway Wash, near the point where the railroad and highway depart from the wash. "That didn't work out very well," said Young. "It wasn't particularly suitable." While the materials needed to make concrete were present, those materials weren't quite the quality needed. And while it was somewhat cooler than the dam site, "it was dirty," recalled Young. It was, however, the location where Young and his crew routinely ate lunch during their scouting trips, and they weren't alone. "The burros soon found out where we ate our lunch and

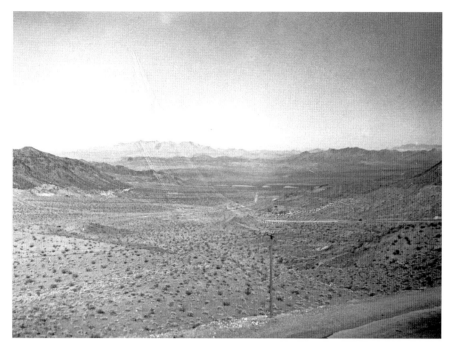

One of the first areas considered for placement of Boulder City. This area would eventually become Boulder Beach. *Courtesy of Bureau of Reclamation.*

they participated," recalled Young. "We found that they would eat pickles, tomatoes, bacon rinds, most anything that anybody would eat, and a lot of things that most of us shouldn't eat."

Eventually, Young and his team decided on a summit between the Eldorado Valley and an area just west of the river known as Hemenway Wash. The site was at the upper end of Hemenway Wash, less than seven miles from the dam site and 1,850 feet above the Colorado River. "We went up there many times, and all we found when we went was greasewood and sagebrush, a few burros, tarantulas, centipedes, snakes—not particularly attractive." However, the area was around ten degrees cooler than the dam site. "We also found that the air currents, particularly from the lake area, from around Hemenway Wash, created almost a continual breeze—very slight on some occasions, very stiff and very severe in other instances," recalled Young. To test out this site, Young erected his campsite on a lower summit between Hemenway Wash and the proposed town site, establishing Government Camp Number 1. "This was very speeded up work too," said Young. "Because of this unemployment situation, everything was in a hurry.

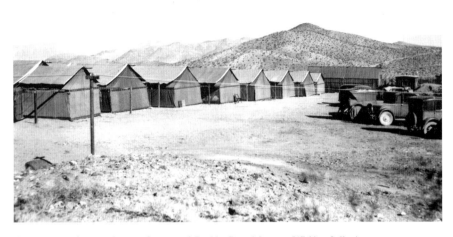

Government Survey Camp. *Courtesy of Boulder Dam Museum. Wieking Collection.*

In those days, 1931, people were standing on the street selling apples. People had been out of employment in all the United States, trying to recover from the deepest depression I believe we ever had. So every effort was made to get this project started as soon as possible." That meant large tents—thirteen or fourteen in a row—and cramped living quarters until dormitories could be built to house the men.

The first "buildings" to be erected in what would eventually become Boulder City were tents. "Those were the first structures of any kind," said *Las Vegas Age* journalist Elton Garrett. "Just two rows of temporary tent houses for surveyors. Later, the very first thing built here was the temporary little mess hall, and a string of about a dozen tent houses for carpenters and the original workers to use temporarily," said Garrett. "The old government camp was set up with the tent camp and all, but that was all," said Tex Nunley, a worker on the dam. "With the tent camp, the government had a mess hall and tents for the men—four men to a tent. The tents were built up. They had floors that was walked up four-foot-high and screened in, and had canvas over the top where you could put the awnings out or could drop the awnings down, depending on the way the wind was blowing."

McKeeversville

When Walker Young set up Government Camp Number 1, the camp's cook, a man by the name of Michael C. McKeever, crossed the street and pitched a tent. "McKeever had been on the initial surveys of the Colorado River," said hydrographer Dunbar. Others soon followed, and the area became a bit of a subdivision for camp number 1. "It was what later became known as McKeeversville. Where McKeeversville originally got its name was from the cook in the mess hall there for the government," said Nunley. "His name was McKeever. He set up a tent just over the hill and his wife lived there. That's where McKeeversville started."

McKeeversville wasn't much better than Ragtown, and in many ways, the two places closely resembled one another. The main difference was that McKeeversville was closer to an actual government camp—meaning it had access to electricity. Still, the buildings that popped up in McKeeversville were just as pitiful as those found at its cousin site near the river. Makeshift houses that looked as if a strong wind would topple them, automobiles and large buses were used as shelter. "At first [we lived in] a tent," said Bob Parker, who was seventeen years old when he arrived in Nevada with his family looking for work. "Then we kept adding to it and boarding it up and finally put a roof over it." Parker described the camp in a manner similar to how residents of Ragtown described their camp. "It wasn't anything to brag about," he said. "Some of the homes weren't too bad." But unlike Ragtown, this camp would last long after the waters of the newly formed Lake Mead flooded the area.

McKeevers was well known and quite a cook. However, it's not always easy to find a reliable food source in the desert, and sometimes people just get sick of the same old thing. One day, McKeevers announced that he would be serving mountain sheep for dinner. This was met with both excitement and trepidation by the workers. They knew that eating a wild animal taken from the area was against federal regulations, but they also eagerly anticipated some new meat. Once the dinner had been served and the plates cleaned, one of the workers announced that the sheep would have objected to being eaten with a great "Raaaah," which he emphasized by mimicking the noise. Almost immediately, another worker chimed in. "It wouldn't have made a noise like that," the worker said, "it would have brayed because we just ate burro, not sheep." Apparently, McKeevers wasn't as good a cook as he imagined.

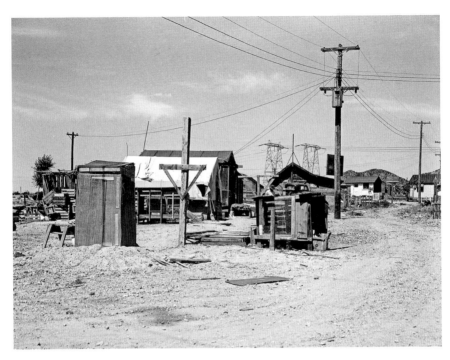

Makeshift shacks in McKeeversville. *Courtesy of Bureau of Reclamation.*

The mess hall at the survey camp where Michael C. McKeever cooked. *Courtesy of Bureau of Reclamation.*

While conditions were tough in McKeeversville, the people knew how to make the best of the situation. "I was over there just a few times," said Dorothy Nunley, wife of Tex Nunley. "It seemed to me like people had a lot of fun there, but they still had just shacks and outhouses. They didn't have any indoor plumbing or anything. But the times I was over there was in the evenings, and they'd be around a big campfire, singing and having a great time, really."

River Camp

Six Companies already had close to 450 workers on-site, and those workers needed a place to stay. To accommodate these men and to house its offices, Six Companies built a construction camp, called River Camp, in April 1931 at the entrance to the Black Canyon on the Nevada side of the river. While the men were probably happy to have a place to get out of the heat, they might not have been thrilled with their accommodations. The long, two-story, white wood buildings were constructed on the side of a steep bluff, known as Cape Horn, where one false step could prove disastrous. "That first year the married men set up in Ragtown and McKeeserville, and the single men lived in a campsite called Cape Horn, deep in the Canyon, 150 feet up from the River," said Frank Crowe. "It was so dark that the sky, sun, and stars were but a sliver. Wooden steps were built up the side of the Canyon Walls."

"They called us cliff dwellers down there, because the dormitories were built on stilts at the side of the canyon." recalled Parker, who managed to get a job with Six Companies as a swamper's helper in the mess hall. "The mess hall was down on the road level, and they had wooden stairways up the side of the canyon wall there to these dormitories up in the canyon there. We traveled up and down that hill on those wooden steps three or four times a day, going back and forth to the mess hall down on the road level below." Of course, the stairs weren't the only obstacle the workers in the mess hall had to deal with. A constant in the desert, and especially in that area, was the heat. "It was a very well-laid-out kitchen, except it was very hot down there that summer," recalled Parker.

The temperature got to 112. It was the coolest it got at five o'clock in the morning for six weeks straight. In that kitchen, with all those big ranges

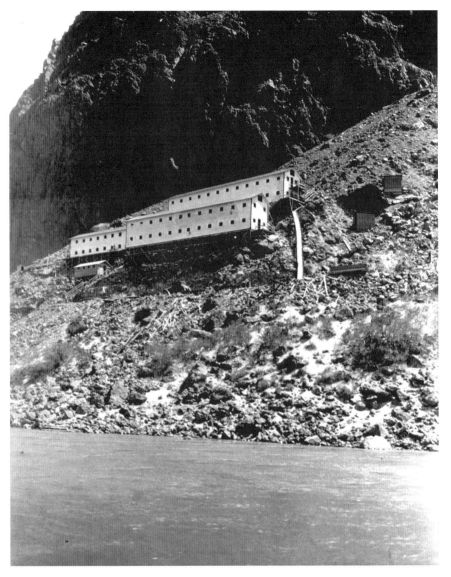

Six Companies bunkhouses at Cape Horn. *Courtesy of Boulder Dam Museum. O.G. Patch Collection.*

and cookstoves, it was a fright in there. In those days we didn't have any air conditioning; we didn't even have any swamp coolers. If I hadn't been a young fellow, I'd never managed to make it.

Getting to the Dam Site

While Young and his men were busy scouting out a site for Secretary Wilbur's city, Six Companies began building both a road and a railroad leading into the canyon. Superintendent Crowe understood that there needed to be a way to get to the dam site that did not involve boats or water. While Murl Emery was the main transporter on the Colorado River, men, equipment and supplies would all need to make their way to the site, and none of that could be completed on a river that was about to be dammed. This created quite a problem, for two main reasons, both of which involved the physical location of the dam. Though "nearby" Las Vegas was an established town, there wasn't much past it to the east. In fact, there wasn't much to the west, north or south of the tiny town, which boasted a population of only 5,165 in 1930. The site of the dam was over thirty miles to the east. With vehicles reaching top speeds of thirty to fifty miles per hour, the dam site was a good hour away on a good road, and there were no good roads.

This is why both Walker Young and Frank Crowe built their camps much closer to the dam. They may have started out with offices in Las Vegas, but those offices were never designed to be anything more than temporary.

Building roads in Boulder City. *Courtesy of Bureau of Reclamation.*

There was no way business could be conducted so far away from the dam site, which was another reason why a closer town needed to be built. But even though the problem of distance was solved, another, more difficult problem faced the two men—a difference in elevation. The site of the dam was 1,341 feet below the city of Las Vegas, and traveling to the east of the town presented an increase in elevation of another 509 feet, where it eventually reached a plateau above the Colorado that Young had picked as the best spot to place Wilbur's city. This meant a path had to be built that would allow a change in elevation of 1,850 feet. Men and equipment would have to be safely transported on rails or roads that had roughly a 123-foot elevation change every mile.

While a railroad could transport the heavy equipment to the site, it would take too long for workers to be transported by rail. Instead, a road was needed. Not just any road, but one that could be used safely over and over again. It's not that a trail didn't already exist, it just wasn't much of a road. "There was just a cow trail," said Dean Pulsipher. "Two tracks for one car. If you'd meet a car, you'd have to pull off the road and let the other car by." It could never be used to safely transport men and equipment down to the base of the canyon. In order to accomplish that task, a real road would have to be built. Crowe took to that task immediately.

BUILDING A ROAD

Dean Pulsipher was a teenager fresh out of high school, one of three men hired for four dollars a day to help build the road to the construction site in the spring of 1929. "I was a flunky. All I was doing was throwing rocks off the road." Any rocks that were too big for Pulsipher to handle were pushed out of the way with the blade of the "big ol' cat." Unlike modern pavers, these road pavers weren't operated by hydraulics, but by hand. "We had to crank to raise and lower the blade," Pulsipher said. They had a Caterpillar-brand paver with a hand-operated blade, a cook shack made of hard rubber tires and a Dodge touring car. "1923 or '24…we had to take along in case of an emergency so we could get to town." The three men started the road at a point just west of where Boulder City would eventually be located, the spot where the Railroad Pass Casino is today. The road went over to the present site of Boulder City, turning left at what is now Buchanan Boulevard and heading down the hill. "We followed that old road all the way down to the

Building the road from what will be Boulder City to the construction site. *Courtesy of Bureau of Reclamation.*

river," Pulsipher said. "We made it wide enough so that if two cars would come along to pass each other without one having to pull out of the tracks."

The Le Tourneau Construction Company was eventually hired to extend the road originally created by Pulsipher and his crew all the way down to the dam site. And while the company had much better equipment than Pulsipher, there was another obstacle, one that would plague the workers on the dam during the entire construction project. "They would go to work at seven in the morning," recalled Erma Godbey, whose husband worked on building the road. "It was so terribly hot by noon that men were passing out with the heat. So they decided that they would go to work at four in the morning and work until noon. Another shift would come on at four in the afternoon and work until midnight."

Though the Le Tourneau Company may have built a much nicer road, much of the road the three men carved out of the desert back in 1921—in only two and a half months—is still in use to this day. And while a road was perfect for transporting men and lighter equipment, such things as turbine

parts were much too large and heavy to be transported on a road, never mind roads that had such a great change in elevation. No, this type of equipment could only be transported by rail.

BUILDING A RAILROAD

"It was necessary, of course, before much activity could be started at the dam site, or the town site, either, to have some way of getting through there other than by truck," said construction engineer Young. Never one to miss an opportunity, Nevada governor Fred Balzar talked Secretary of Interior Wilbur into making the start of the railroad a publicity event. Balzar, who had a spike made of Nevada silver, declared September 17, 1930—the date of the festivities—a state holiday, and he made sure a bit of track was laid at Bracken, Nevada, so that the spike could be driven. Balzar also brought in chartered trains packed with notables, spectators, press members and, of course, Wilbur. "There was a circle of newsmen with cameras taking a picture of the secretary of interior when he got off the Union Pacific train on the main line of the Union Pacific at Boulder Junction," said *Las Vegas Age* journalist Elton Garrett.

Governor Balzar was trying to make an impression, no doubt to erase the negative one already emblazoned in Secretary Wilbur's mind from his visit the previous summer. This second, begrudged visit would do little to dissuade that opinion. Bracken was south of Las Vegas, just to the east of what is now the Las Vegas Strip. In 1930, there was little there but dust, wind and, well, more dust. Wilbur arrived at the ceremony dressed immaculately—as usual—in a three-piece suit, starched collar and wingtip shoes. It was already 103 degrees, and if that wasn't bad enough, his pocket had been picked shortly after his arrival. Now, he was standing there in the dust, listening to bands from both the Mojave Indian School and the battleship *Nevada*, surrounded by Balzar, Nevada senators Pittman and Oddie, Congressman Arentz and many other dignitaries, not to mention a drove of reporters and photographers, all waiting for him to symbolically drive the gleaming spike at the Silver Spike Ceremony.

"When the secretary was ready to drive the silver spike, circled around behind him were senators and congressmen and publishers," said Garrett. There had to be a great deal of pressure with all those people watching you raise a spike hammer and symbolically start what at that time would be the

Secretary of the Interior Ray Lyman Wilbur drives the silver spike. *Courtesy of Bureau of Reclamation.*

largest construction project in the nation's history. A great deal of pressure indeed. "His first effort was futile—he missed the spike," recalled Walker Young. "Missed it completely," confirmed Garrett. "He was not a spike driver; he was an administrator in a college." Undaunted, Wilbur lifted the hammer a second time and took another swipe at the spike. "He did succeed on the second try," said Young. "This was definitely one of the milestones of the construction of the Boulder Canyon Project."

While the driving of the spike marked the commencement of the construction of the railroad as well as the commencement of the Boulder Canyon Project, it had a much greater significance and at the same time sparked a bit of a controversy that would last several years. Secretary Wilbur announced, "I have the honor to name this greatest project of all time—the Hoover Dam." Construction engineer Young understood the significance of those words. "Perhaps the most important thing that happened at that meeting was the naming of the dam publicly by Dr. Wilbur as Hoover Dam," he said. Elton Garrett also understood the statement's import. "People who wanted it to be Hoover Dam were happy. People in another political party

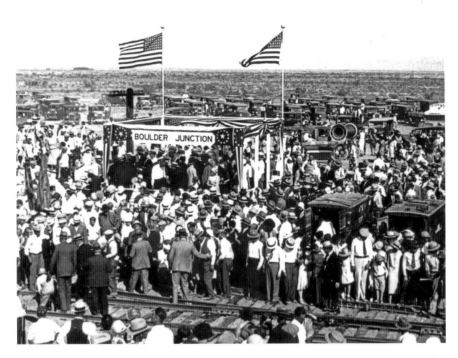

Crowds gather to hear Secretary of the Interior Ray Lyman Wilbur speak at the silver spike ceremony. *Courtesy of Boulder Dam Museum. W.A. Davis Collection.*

who resented it backed Secretary Ickes later in changing all the printed stationary back to Boulder Dam."

Young would write about the name change years later in a letter to John F. Calhan.

> *I agree with you that old timers are very apt to say "Boulder Dam." That is easily understood as for ten years or more that identification had been used in reports, congressional appropriations, news items, etc., even after the site selected for construction was in Black Canyon. Opposed to this, however, is the fact that "Hoover Dam" is perhaps more significant considering the part Mr. Hoover played in bringing the Colorado River Basin States into agreement with respect to the division of water. That was quite a feat. Although I am one who impulsively still would say "Boulder Dam," I believe the change to "Hoover Dam"…is quite appropriate for posterity. Personally, I continue to be a great admirer of Herbert Hoover. In my opinion, he set a good example for all of us.*

Workers building the railroad that would eventually run from Las Vegas to the dam site.
Courtesy of Boulder Dam Museum. Union Pacific Railroad Collection.

The U.S. government built the first part of the track. That is, they paid for Merritt, Chapman and Scott, Inc. to grade the track bed from the old Union Pacific yards in Bracken to the Boulder Junction and for the Union Pacific Railroad to lay the track. The contract was then awarded to Lewis Construction Company to build the U.S. Construction Railroad that would run from Boulder Junction to the dam site. Lewis Construction had the task of building almost thirty miles of track that would eventually be used to transport materials to and from the dam. The tracks, which were laid in only five short months, would be used twenty-four hours a day during the entire construction period.

In order for the railroad to get to the dam site, the builders had to overcome one very large obstacle—the mountain. There was no way to get around the mountain that would border Lake Mead. The only option was to go through it. To do this, Lewis dug large tunnels into the mountain. Each tunnel was eighteen feet wide and twenty-seven feet high. The width and height were needed to allow massive pieces of pipe, turbine

One of the tunnels built into the mountain. Note the timbers at the far end of the tunnel. *Courtesy of Boulder Dam Museum. W.A. Davis Collection.*

and construction equipment to pass through unobstructed. Many of the tunnels were also reinforced with timbers meant to prevent rock from falling onto the train. Five of those tunnels, along with the timbers used to support them, still exist to this day.

Squatters' Camps

An army of unemployed was steadily converging on Las Vegas, Nevada from all over the United States. They had burned their bridges behind them and staked their last dollar on Boulder Dam.
—*George A. Pettitt*

Well before the first hammer was purchased or the first piece of equipment moved into the canyon, men—with and without their families—began

Men lining up for work at Railroad Pass, just outside what would eventually be Boulder City. *Courtesy of Bureau of Reclamation.*

pouring into the valley, many of them setting up tents or sleeping in their vehicles near the proposed dam site. "They had five thousand men working at the dam and five thousand waiting out there to go to work between railroad pass and Vegas," said Las Vegas resident Dean Pulsipher. But how could they not? Estimates of 29 million man-days to be supplied by the Bureau of Reclamation and private contractors, on top of the 42.5 million estimated man-days to be supplied by the Metropolitan Water District of Southern California, made the possibility of finding work—no matter how remote—too appealing to pass up.

Most of the men who came looking for jobs were familiar with physical labor, having always made a living with their hands. Others were "white-collar" workers who had lost their jobs and needed to feed their families. Still others were men who had paid their "penalty to the law" and were given a chance to start over again in this construction camp. Frank Czerwonka, who lived in a squatters' camp for a time, said, "I ran into a couple of self-styled professors, safe blowers, and skilled mechanics." Men came from all over the

country. Ray L. Wilbur Jr.—son of Secretary Wilbur—once wrote, "The inhabitants who make up the population of Boulder City have come from nearly all the states and present a veritable cross section of American life."

"I had struck up an acquaintance with many of the men," said Hoover Dam worker Marion V. Allen, "all of whom were waiting for their names to come up, and several told me they had registered under several names. They hoped this would increase their chances of being hired." Allen had come from Jackson Hole, Wyoming, looking for a job on the dam. Allen's father had worked with Frank Crowe at the Jackson Lake Dam in Wyoming, and he sent his son a letter instructing him to see Charlie Cliff when he got to Vegas, promising him that Cliff would send him right out on the job.

When Allen got to Vegas and asked for Cliff, he found that Cliff had died just a few days prior. "With that news, the ground fell right out from under me!" he wrote. Allen would eventually get a job at the dam working as a checker for Six Companies. "My job as a checker was to get [the workers'] work slips with their names and numbers," he said. One day, as he was doing just that, he ran into a man whom he had met in Las Vegas. "When I took this man's slip his name was listed as Joe Brown," said Allen, "and I remembered the name was not the one he had given when I first met him in Las Vegas." When Allen asked him about the discrepancy, the man simply shrugged and confirmed his name was Joe Brown. "He worked on the dam for three or four years still using that name," said Allen. "Years later I met him again on Shasta Dam and when I called him 'Joe,' he just laughed and said that wasn't his name."

People looking to change their fortunes set up tents almost anywhere they could find land. "Every mesquite bush had someone living under it," said Pulsipher. "They'd put up a tent, or any kind of a shack to live in. They were getting along the best they could." Ragtown wasn't the only place squatters set up camp. "I imagine a thousand people had camped just on the other side of what is now Railroad Pass," said Leo Dunbar. "Day by day they arrived with carloads of wailing children," wrote George A. Pettitt. "Auto camps sprang up on every side to accommodate them. Mushroom communities of roughboard shacks appeared overnight, and even tents were pressed into service though they were scarcely more than a gesture of defiance to the pitiless summer sun."

In the late 1920s and early 1930s, segregation was the norm, and the federal government had little qualms about ensuring that most, if not all, workers being hired were white males. "No one wanted us around," said Louis Edward Banks, an African American. "We were the outcasts of the

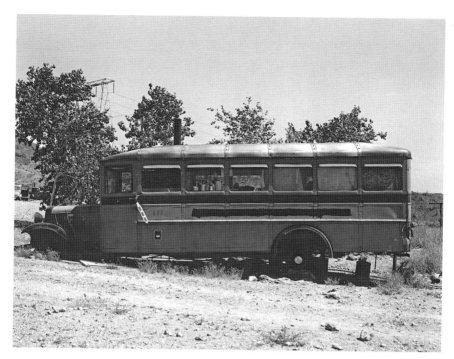

An old bus set up as a house. *Courtesy of Bureau of Reclamation.*

camps. We were even hated more than the Okies or the Texans." Banks tried to get a job at the dam, but he was turned away on several occasions. "They didn't hire me because I didn't belong to the right kind of race. I was back out at the camps. That hurt me pretty bad, the race part."

Living conditions in the tent camps were deplorable, and the danger of death was ever-present. "I remember this one guy everybody called 'Joe' fell asleep in his tent," Banks said. "He died from the heat. Everybody was sad." Of course, there was always two ways of looking at a death during a depression. "We also kinda felt like—one less person to have to beat out for a job," said Banks. Besides the heat, starvation was also a very real danger. Having no automobiles, groups of men and women would venture out into the desert, making the long walk to Las Vegas just to stand in soup or bread lines. "They set up a soup line and the food was clean and it was delicious," said Banks. It was also one of the few places where the color of a person's skin wasn't a factor. "Many people, colored and white, I didn't see any difference in the lines," said Banks. "There were just as many white people out of work as were colored."

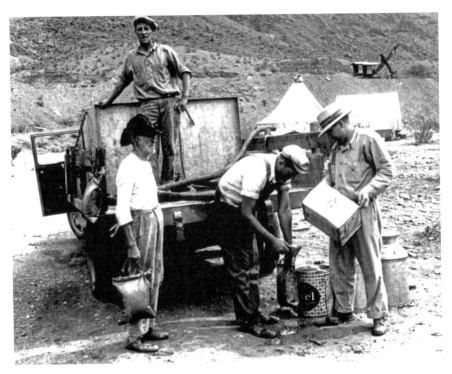

A truck delivering water to a squatters' camp. *Courtesy of Boulder Dam Museum.*

Water was also scarce. "Once in a while, I don't know if it was regular or not, this truck would come from the dam and bring water to us," said Banks. The truck was from the Six Companies, and the water was brought to the camps in big jugs. "It had to last you all week long," said Frank Czerwonka. Many just went down to the Colorado and drank straight from the river. "We got sick sometimes," recalled Banks, "but when you're hungry and thirsty, it doesn't matter where the water or food comes from." Besides water, sometimes the trucks would also bring out food. "Most people got dried beans," said Czerwonka. "All the good food went to the men, and the families of the men, that worked on the dam."

While food and water might not have been abundant in the desert, fine sand certainly was. At no time was this more noticeable than when a strong, hot desert wind kicked up. "Oh the dust storms, they were terrible," said Banks. "You could wash and hang your clothes on a line and if you happened to be away from the tent and couldn't get back before that storm got there, you'd never be able to wash all the dirt out." Even those who didn't have clothes hanging when the storm hit had to deal with the mess it made of

the tent. "You would have to clean the tent from top to bottom," said Banks. "Everything was covered in sand."

RAILROAD WYE

Six Companies eventually set up a switchyard where Government Camp Number 1 was positioned. The firm had as many as seven engines that would take cargo to the dam site. The area became known as Railroad Wye, and it too became populated with workers who didn't have homes. "Anyone who moved into Railroad Wye just had any kind of tent that they had," said Railroad Wye resident Erma Godbey. She and her husband had lived in Ragtown and considered Railroad Wye a step up, mainly because there was better access to clean water—"at the tank," said Godbey, referring to the two-million-gallon water tank that had been built up on the hill. "At night, when my husband would come home from work in the evening, he'd carry me a lot of water."

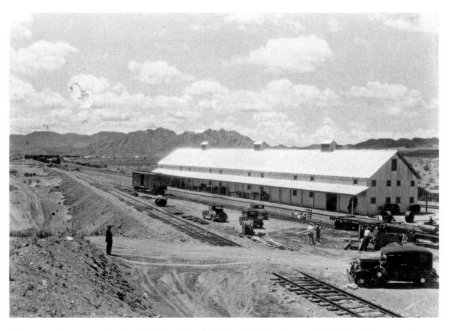

The area known as Railroad Wye. The building in this photo still exists. *Courtesy of Bureau of Reclamation.*

The main problem with living in a tent around railroad cars and engines is, well, railroad cars and engines, especially when those engines ran twenty-four hours a day. "I was rescuing kids from trains all the time," said Godbey. While trains were an ever-present problem, they could also be beneficial at times. "Every once in a while the refrigerator cars would throw out some ice," said Godbey. "I managed to get my hands on a little old tin ice cream freezer. Once in a while I would make some ice cream."

The good and bad of the situation didn't just apply to trains. "Another thing, there were no toilets over there," said Godbey, whose husband ended up digging one. Of course, once you have modern conveniences—like a toilet dug into the ground—people tend to gather. "First thing we knew, everyone wanted to use ours," said Godbey. Wind was another inconvenience. "Whenever the wind would blow," recalled Godbey, "you'd pick up whatever was closest to your tent, because maybe your wash pan and your dish pan went rolling off somewhere else, you didn't know where it went. You just picked up everything." Sometimes "everything" meant other people's clothing. "Once in a while we'd pick up some pajamas that had blown from there," said Godbey. And, of

Anna Bissell with her students in front of the Railroad Wye schoolhouse. *Courtesy of Boulder Dam Museum.*

course, there was the sand. "It was terrible," said Godbey. "Everything was sand."

Another thing that made Railroad Wye more desirable than other squatters' camps was that it actually had the first school in the area. "By the spring of '32 we had a school in the Wye," said Godbey. "The Government had made no way to have a school here; they hadn't even thought about it." The school was started by a Mr. Elder, who lived in McKeeversville. Elder had a sister named Anna Bissell in Kansas who was a teacher in search of a job. He sent for his sister, and while they were waiting for her to come, several men built a makeshift shack out of scrap lumber that was used as a schoolhouse. A school in Ragtown would soon follow.

A City on a Hill

Boulder City was not an ordinary construction camp.
It was a community of families.
—George A Pettitt

With both Government Camp 1 and River Camp established, it was time to begin building Secretary Wilbur's Boulder City. Wilbur had begun planning this moment well over a year ago, when he, Commissioner Elwood Mead and Walker Young had chosen three possible sites for the location of Boulder City. Wilbur had authorized surveys of all three spots and hired renowned city designer and landscape architect Saco Reink DeBoer out of Denver, Colorado, to help with the process. "In the summer the winds that swept over the gorge from the desert feel like blasts from a furnace," wrote Ray L. Wilbur Jr. "In order to overcome this heat and to ensure that no Oriental or other un-American labor would have to come in and finish the job, the selection of a site and planned city were necessary."

Young had already scouted out what he felt was the best location to place Boulder City, and he showed it to DeBoer. "He came to the location and he and I personally went over that for several days, considering what kind of layout we would have for the town," recalled Young. It couldn't have looked like much to DeBoer. While the Colorado might run through the valley below, the plateau, which was "at the summit of a saddle between the river and Las Vegas," was desert. To the untrained eye, there wasn't much so see except cactus, desert fauna and tarantulas. The place could be best

described as hot, dry and empty. But Secretary Wilbur didn't see a desert. He saw a thriving town in a near-perfect location.

Here there was fertile soil; here the winds had an unimpeded sweep from every direction; here there is also an inspiring view of deserts and lonely gorges and lofty mountain peaks. When the dam is completed and the marvelous lake fills the foreground, the view from Boulder City will be so inspiring and wonderful as to be worth traveling around the world to see.

If the location of Boulder City wasn't inspiring enough to seal the deal for Secretary Wilbur, then the climate on the plateau certainly would have done the trick. Being close to ten degrees cooler, this location represented a small but significant break from the one-hundred-plus temperatures workers were experiencing at the dam site. When all was said and done, Boulder City would be located on a plateau twenty-three miles southeast of Las Vegas and six miles northwest of the dam—four miles from what would become Lake Mead. At an elevation of 2,500 feet, the town would sit nearly 1,000 feet higher than the top of the Black Canyon wall. With a highway slated to be built across the top of the dam, projections were soon made as to the importance that highway would attain. "The highway will soon become one of the most traveled in the Southwest and Boulder City should clearly benefit by its location thereon," wrote Ray L. Wilbur Jr.

Boulder City was expected to have about 2,500 residents, though Mead conceded that number might be low. "We are planning for a town of 2,500 people," he told the *Las Vegas Evening Review and Journal* in 1931. "It may be more—in fact, it might grow to around 5,000. But we feel safe in estimating the former figure." Commissioner Mead would actually be off by almost 4,200, as the final population hovered around 6,700. Boulder City really had only one purpose: "to house the employees of both the government and the contractor." Of course, that also meant the families of those workers and those who would set up businesses of all types in the newly developed town. "There was to be no piecemeal growth as with the average community," wrote Lee E. Walker. "Boulder City was to be planned to the last detail. Parks, playgrounds, fire protection, industrial and residential zoning, and parking needs were all to be carefully predetermined."

Under the guidance of S.R. DeBoer, Boulder City was "expected by some to be a model in town planning for years to come." Secretary Wilbur's Boulder City would "lack nothing to be found in the average progressive community elsewhere in the United States." Mead said about Boulder City,

"This will be the first municipality purposely planned in advance of its development to be laid out with all the exigencies of an automobile age in mind." Walker Young had a more realistic view of the proposed town: "It was intended to be a comfortable place to live, as near as that was possible in that particular place."

DeBoer wasn't the only expert used to help plan the government's prize city. Gordon B. Kaufmann, born and educated in England, was brought in from Los Angeles, where he had run his own firm. Kaufmann was known for the many different styles of buildings he had designed. His professional credits included the Los Angeles Times building; the Scripps College Campus in Claremont, California; the Athenaeum at the California Institute of Technology; and several buildings at the Santa Anita Racetrack. He also had designed private mansions.

The bureau had already used Kaufmann on the dam. He was hired to add aesthetic elements to the monolithic structure so it wouldn't just look like a giant slab of concrete. Kaufmann's influence can be seen in the streamlined art deco elements of the dam, especially the power plant, dam crest, intake towers and the spillway. In mid-October 1930, Kaufmann was asked to submit a report containing recommendations regarding the type of architecture he believed would best suit this city in the desert. In addition, he

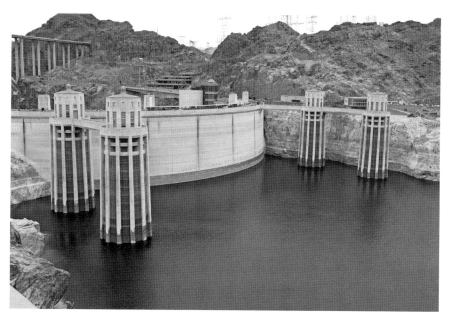

Art deco elements of the intake towers. *Courtesy of the author.*

was asked to submit general plans and elevations for the major government buildings, such as the administration building, as well as floor plans and elevations for four-, five- and six-room residences.

Kaufmann favored the "California style" of architecture, which had its roots in the Mediterranean style and was perfectly suited to the Southern California environment. It was, therefore, no surprise that Kaufmann's designs for the smaller residences were a "modified Spanish type of architecture." One of the features of his designs was known as "hallow wall." In this design, the outer walls were constructed of brick, and a four-inch air space was placed between the outer and inner faces. Research indicated that this method provided 35 percent better insulation than did solid brick walls.

While Kaufmann was designing homes and businesses, DeBoer was laying out the town. He knew full well that after construction of the dam was completed the population of the town would decrease to only those permanent employees needed to operate the dam, and he said so in an issue of *American City* magazine in February 1931. He stated that his solution was to "develop two distinct areas for residential use" separated by a forested beltway. When the population dropped after the dam was completed, the inner beltway could be used for permanent houses, while the outer beltway was designed to be the location of more temporary dwellings. The town's businesses would all be located in the inner beltway as well.

To facilitate this idea, Boulder City was to be shaped like a fan, with the handle of the fan being the main office buildings of the government. "It was decided that the town would be built in the shape of a triangle, with the administration building as the official headquarters of the Bureau at the point of the triangle, which is the north end looking down Hemenway Wash toward Fortification Hill," said Young. "The recreational part of the city and the school area would be next, away from the point. Farther out would be the business district. Up in that location would be the hospital. Below the business district then would come the residences, principally for the contractor's forces," explained Young.

The town was to be divided into residential, business and industrial zones, with "a belt of forest trees to encircle the whole town and make a definite boundary for the [inner] unit." The second, or outer, unit was to be the location of such things as the airport and the golf course, as well as the contractor's single-family temporary houses. The main axis of the town was positioned nine degrees from true north and south in order "to get a good distribution of light and shade." This placed the outside edges of the fan shape at about forty degrees from true north and south. DeBoer

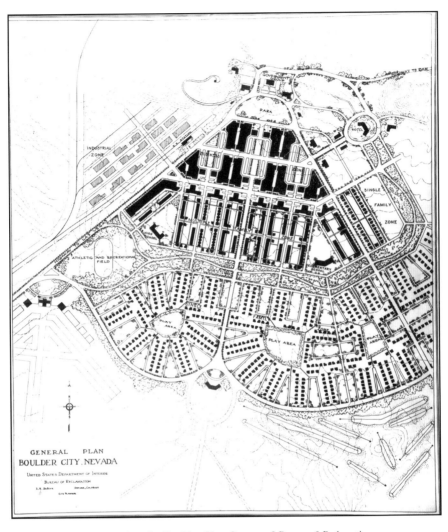

S.R. DeBoer's original plans for Boulder City. *Courtesy of Bureau of Reclamation.*

positioned the city so that no one building wall would get "too great an exposure of sunlight."

Single-family residences were designed on circular fifty-acre tracks that were subdivided into V-shaped building blocks. All residential blocks were designed to have a play area with "considerable space" for play. Each block would have a small community park that was actually part of the adjacent building lots but was expected to be maintained as a front yard by the owners. This design created a seven-acre play area, accessible by sidewalks, directly

in the middle of a seven-score track of homes. Residential blocks were designed to be nine hundred feet in depth, each with a crosswalk through the middle and a very "shallow front yard."

While the intent was to design Boulder City for the automobile age, neither DeBoer nor Secretary Wilbur could have foreseen what would be needed down the road in a modern city. DeBoer planned the residential streets to be one-way, accommodating only one lane of traffic—which was just fine for a city where few of its actual residents owned a car; not so great many years later, when a car showed up in every driveway.

In DeBoer's plan, all residential areas would have a direct connection to the central business section in the inner unit. Business streets and through traffic would be separated, and automobiles were not allowed to be parked in the streets, but instead were expected to be parked in spaces specifically allocated for that purpose. Space would be created in the alleyways for loading and unloading, and all block corners were cut off to "provide greater visibility." Churches were grouped in a central area to "promote a stronger religious life," and all public and semi-private buildings were to be an "integral part of the city."

Much of the costs to build the city would be absorbed by Six Companies, Inc. and Babcock and Wilcox, the two main contractors, which were required under contract to build the majority of the residences in the town. The construction of government buildings, residences for government workers and various businesses would fall under the U.S. Bureau of Reclamation, which estimated those costs at $1,808,092. The cost was intended to cover the administration building, dormitories, the municipal building, an auditorium and an estimated ninety dwellings. It also included fifty garages for Bureau of Reclamation employees, civic improvements such as playgrounds, landscaping, sidewalks and streets, as well as the water and sewage systems and the electrical distribution system.

"No argument should be required to demonstrate the wisdom of providing comfortable quarters and living conditions for employees of the Government and the contractor," the bureau told Congress. "This is believed to be indispensable in order to forestall rapid employment turnover with its attendant disadvantages." Secretary Wilbur fully expected Boulder City to be a self-supporting community. Money would come from leasing businesses, as well as from government services such as water and electricity. Any remaining costs, reasoned Wilbur, could come from the sale of power generated by the Hoover Dam.

A Change in Plans

After DeBoer submitted his plan for Boulder City, Walker Young had some changes. In a letter to the commission, Young pointed out that DeBoer's plan was certainly a very attractive and artistic plan on paper, but it lacked the proper consideration of the topography of the terrain on which it was laid out. Young proposed to rotate the town eleven degrees counterclockwise. He also wanted to change the location of several streets to better suit the topography. This, he reasoned, would considerably reduce the amount of excavation and grading needed and would improve lot elevations—a problem he noticed in DeBoer's plan, which had some residential lots several feet higher on one side of the street than on the other. DeBoer's plans of organizing communities with a common play area did not come to pass, nor did his plan to group all the churches into one area.

One of the modern parts of DeBoer's plan was to place all utility lines in tunnels under the ground. While this made for a much more attractive city,

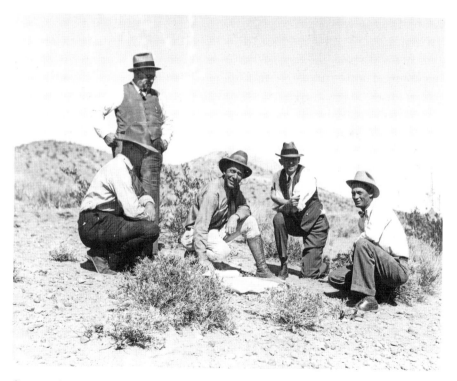

Construction engineer Walker R. Young (*fourth from left*) and others laying out Boulder City. *Courtesy of Boulder Dam Museum.*

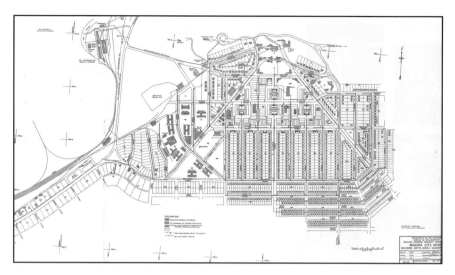

Boulder City's final plans, signed by construction engineer Walker R. Young. *Courtesy of Boulder Dam Museum.*

that attractiveness would come with a high price tag—one the government was not willing to pay—so the plan was scrapped. As the construction of the town progressed, Young, along with assistant chief engineer Sinclair O. Harper, made changes whenever substantial savings would result. Additionally, when it was clear that the proposed business section of the town was too big for the businesses that would actually be there, Young informed Commissioner Elwood Mead that he would relinquish the eastern portion of the business area so that schools, churches and even some residences could be built.

Probably the biggest change to DeBoer's plans came in the residential areas themselves. Young expressed to Mead that "DeBoer's somewhat radical arrangement of the residential blocks with courts and walks in the interior of the block and no sidewalks was alright if these courts were landscaped and maintained at government expense." Water is a pricy commodity in the desert, even when the third-largest river in the United States runs right by your door. If the government had to maintain these public lawns along with other grounds, the cost could quickly become overwhelming. Faced with this potential drain on the government's coffers, Mead vetoed the idea of interior courts and opted for a more conventional arrangement of residential blocks, complete with sidewalks.

Another change in DeBoer's plans came with the initial thought that no automobiles should be allowed to park on the streets. Originally, the business

district was to be the geographic center of the city; however, as the city developed, the business district was moved to Nevada Way and B Streets so that it could be closer to the workers' dormitories and the Six Companies' store. It was not possible at this point to create the designated parking spots envisioned by DeBoer, and the plan was discarded.

While many of DeBoer's original ideas were changed, several others were left intact. One of these was the creation of three main arterial highways as the basis of the street plans: California Avenue, Nevada Highway and Utah Street. California Avenue remained the axis of the town and connected with the other two streets just below the administration building. The main highway, the one connecting Las Vegas to the dam and eventually to Kingman, Arizona, was positioned just to the west of town. This had the dual purpose of allowing the road to be used for larger vehicles and keeping the heavy traffic away from the city streets.

Many of the parks in DeBoer's plan were also carried out, with the largest being in front of the administration building. In fact, both the building and the park remain in their same locations. Playgrounds were eventually limited to schools and a lighted adult area in lot 27. "The town was not so much a model of city planning," wrote Ray L. Wilbur Jr., "as a 'made' construction camp. Financial limitations and local conditions exercised considerable effect in making the plan of Mr. DeBoer too fanciful for Boulder City, but in the main, all the basic accepted principles of good planning were carried out."

While DeBoer suffered significant changes in his plans, Kauffmann experienced only minor changes, mostly to the names of his buildings. Originally, Kaufmann designed a clubhouse intended to house the workers. However, Commissioner Mead worried about how this name would be received by Congress. In a March 17, 1931 letter to chief engineer R.F. Walter, Mead stated that Secretary Wilbur was "being watched for extravagances in the building program." Mead suggested a name change might do the trick. "Could we not safeguard ourselves by dropping the term 'club house?' Will not 'dormitory' answer for the present?" Mead also cautioned against another well-used name. "Also the term 'city hall' rather hits some of our people in the eye," he wrote in the same letter. "In other words, just now some of the members of Congress are pretty finicky about this part of the expenditure." After the letter was received, "club house" was changed to "dormitory," and "city hall" was changed to "municipal building." The administration building kept its original name. Once the name changes were made, Wilbur approved the preliminary sketches on April 7, 1931.

Gordon B. Kaufmann's drawing of the administration building. *Courtesy of Bureau of Reclamation.*

Gordon B. Kaufmann's drawing of the dormitory. *Courtesy of Bureau of Reclamation.*

Interestingly enough, Kaufmann's name was not on the set of drawings for Boulder City that were issued with specification, though it is clear the bureau used the designs he presented them. The drawings do bear the initials "H.G.K.," which most likely belong to Harold G. Kennedy, a supervisory architect with the U.S. Bureau of Reclamation. Though Kennedy held the title, nothing in his biographical information suggests that he ever received training as an architect, so his initials were probably simply for official approval.

What's in a Name

Newspaper advertisement for the Boulder City tract of homes in Las Vegas. *Courtesy of the* Las Vegas Age.

Secretary Wilbur decided the name of his new town would be Boulder City, most likely because the title "Boulder Canyon" had stuck, giving the Boulder Dam its original name. The name, however, was not without controversy. A "sensibly restricted first-class" tract of homes in Las Vegas, registered in Clark County, already bore the name Boulder City, and the woman who owned the tract had written several letters asking for a name change. Her letters were largely ignored by Secretary Wilbur. In April 1931, in a memorandum to Commissioner Mead, Louis C. Cramton, chairman on the House Sub-committee on Appropriations and special assistant to the secretary of interior, urged the name of the town be changed to simply Boulder or to "some Spanish name," stating that the post office officials preferred having a one-word name. The first suggestion was met with objections from the residents of Boulder, Colorado, who preferred their name not be used. But Secretary Wilbur had made up his mind, and he had no intention of changing the name of his new town, so Boulder City became the original and only name.

A Federal Reservation

On September 8, 1930, the Bureau of Reclamation put out a press release about Boulder City:

> *When construction of Boulder Dam is fully underway, this is likely to prove to be a most interesting community since its establishment will be on a very unusual basis. In the first place it will be planned by the best experts obtainable, as a model town. An outstanding peculiarity will be the fact that all the land in the town will be owned by the federal government.*

From the very start, Boulder City was designed to be different. Unlike its anything-goes cousin a few miles to the west, Boulder City was never intended to be a Wild West town where sin reigned supreme and drinking, gambling and prostitution were the norm. In an article in the *New York Times*, a resident said, "A feller couldn't make a real old-time western town out of Boulder City if he tried." Neither was the town meant to be the usual male-ruled construction camp common to large-scale operations that resembled more a college frat house than a respectable community. Instead, the intent was for the city to be held as an example of wholesome American morals and values. As long as Secretary Wilbur had control over it, Boulder City would never become a miniature Las Vegas.

Nevada, and Las Vegas in particular, was a place where the defiance of the Eighteenth Amendment to the Constitution was a common practice. A small canyon just to the east of Las Vegas had garnered the nickname Bootleg Canyon due to its production of alcohol—alcohol that was routinely sold in the backrooms of many Las Vegas saloons. Secretary Wilbur knew it would not be a good thing to have hungover men working with dynamite, nor would the desert heat be kind to a body already dehydrated by alcohol. If Boulder City was run by the government, "One would not expect the government to let the law be violated within its own jurisdiction," wrote Ray L. Wilbur Jr.

Another contributing factor to support the need for a federally controlled town was the proposed location of Boulder City itself. The site where the dam was to be built was little more than a "deep narrow gorge where the river flows between solid mountains of rock." And while much of the valley was green, the Black Canyon and its surrounding area were "at the center of one of the most furious sectors of the great American heat belt." At the time the dam was built, it was not at all uncommon for summer

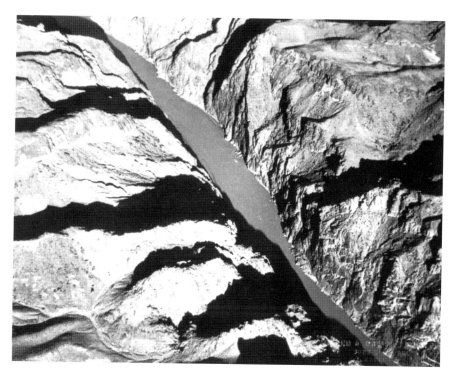

The eventual location of Hoover Dam in the Black Canyon. *Courtesy of Boulder Dam Museum. W.A. Davis Collection.*

temperatures to reach 120 degrees; there was little to no vegetation to provide shade, and the area was crawling with scorpions and tarantulas, not to mention rattlesnakes and Gila monsters. Additionally, except for the river itself, there was little water in the area—almost no rain—and although air conditioning had been invented in 1902, window cooling units wouldn't hit the market for another couple years, and low-cost units wouldn't be available for almost another fifteen years. "I've seen it down there when it was 115 to 125 degrees, down there in that canyon," said Las Vegas resident Dean Pulsipher. "And you didn't have any swamp coolers, they didn't even have swamp coolers in them days."

Creating a living environment where three to four thousand men and their families were both content and healthy in hard-labor jobs was a necessity if the project was to be a success. In the eyes of the government, the only possible way to make this happen was to establish Boulder City as a federally run reservation instead of a locally controlled municipality. "With the establishment of a reservation, the government could supervise

the health of workers through sanitary water supply, control of epidemics and the like, to a degree far beyond anything obtainable in a regular Nevada municipality," wrote Wilbur Jr.

"We have the responsibility, we must have the control," said Secretary Wilbur at a congressional hearing in May 1930. One year later, in May 1931, he established the area of Boulder City as a federal reservation. Almost ten years prior to that act, in anticipation of the building of a dam, the State of Nevada enacted a law that ceded "all lands embraced within the Boulder Canyon Project" to the United States. Arizona took no such action; as a result, Wilbur made the decision not to "embrace" any lands officially owned by Arizona as part of the federal reservation. Instead, the area around the reservation on the Arizona side of Black Canyon was to be patrolled by a deputy U.S. marshal in Arizona who would also act as deputy sheriff of Mohave County.

THE GATE

The gate pretty well controlled the question of people in Boulder City bringing in liquor or excessively handling liquor.
—*Elton Garret, Boulder City resident and journalist*

In the midst of a depression, people counted themselves lucky to even have a job. When the dam started hiring, droves of men came looking for work. It was hard work, the kind that caused your bones to ache at the end of your shift. And if that wasn't bad enough. the infernal summer heat combined to create a recipe for disaster. In the world of construction—especially on a site as large as the Hoover Dam—such a disaster usually comes in the form of a strike. "The IWW, which we called 'I Won't Work,' represented the International [Industrial] Workers of the World," said Bob Parker. "They were down here trying to stir up trouble and organize the workers at Hoover Dam. They were agitating and trying to get things set up so that they could dictate to the Six Companies and the government about a lot of the labor rules." One of the union's two weekly newspapers, the *Industrial Solidarity*, stated: "We hope to have this dam job one hundred percent organized before it is half completed and be in a position to dictate under what conditions and wages the construction workers will build this gigantic monument of human accomplishment."

The union tried its best to agitate the workers. It criticized the food and water, reminded workers that there were no flushable toilets or cooling systems in the bunkhouses and pointed out many of the unsafe conditions the workers were forced to face on a daily basis. Luckily, Frank Crowe knew his men. "He knew how to motivate," said journalist Elton Garrett. "He knew how to be friendly with the guy that was tamping the powder into that hole. He knew how to smile at a good gag. He not only was an engineering genius; he was a people genius. That went a long ways." Crowe made sure some of the men's grievances were addressed. Instead of pumping river water up to the campsite, he brought in water from the artesian wells in Las Vegas. He installed a water cooler in the mess hall and moved the magazine containing blasting supplies to the Arizona side of the river so they would be away from the electrical lines and welding equipment. He even discontinued the practice of using gasoline as a cleaning fluid.

Although the working conditions were not optimal, the men laboring on the dam were hesitant to buy into the union's rhetoric. Not much time had passed since most, if not all, of these men had been out of work, homeless and desperately searching for a way to feed their families. They also knew that for every job, there were ten men in Las Vegas waiting for their turn to find employment. But while Crowe and Six Companies made several changes, there was one contributing factor that no one could change: 1931 was proving to be the hottest summer on record in Nevada. As Joseph Stevens wrote in his book *Hoover Dam: An American Adventure*, "On July 20 the mercury hit 117 degrees in the shade, five men were stricken with heat prostration in Black Canyon and Edna Mitchell, the fifteen-year-old daughter of worker Elmer Mitchell, died in Ragtown." Three days later, the temperature returned to 117 degrees, causing three more deaths in Ragtown. In June 1931, when Six Companies announced it was going to reassign some of the positions of the men working in the diversion tunnels—a move that would result in a wage cut—it was enough to make workers walk off the job.

"It was kind of a wildcat strike," said dam worker Neil Holmes. It started with the muckers. "They were going to cut the wages on the muckers in the tunnels," said Erma Godbey. "And they were getting $4 a day anyhow, which was nothing. You could live on it in those days, but you couldn't hardly." At the time, a lady's housedress cost anywhere from $0.79 to $9.75; overalls cost $0.89; and a sports coat set you back $4.95. A head of lettuce was $0.10; eggs were $0.20 per dozen; bacon was $0.16 a pound; five pounds of bananas cost $0.28; and a new car was $430.00 to $630.00. Men struggling

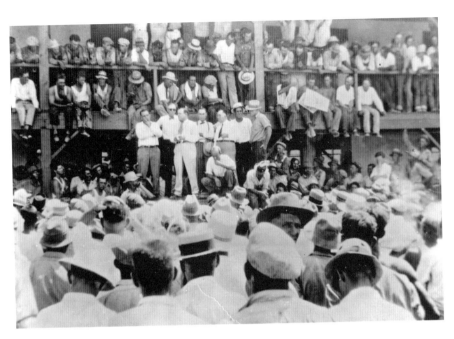

Above: Men gather during the labor strike.
Courtesy of Bureau of Reclamation.

Left: Bulletin promoting the strike.
Courtesy of Bureau of Reclamation.

STRIKE APPEAL

BY THE
CENTRAL LABOR COUNCIL

We appeal to every man on the project to
SUPPORT THE STRIKE

Our cause is just – we'll win with your support.
The strike committee of the Central Labor
Council appeals to all Six Company workers to
STAY OFF THE JOB

WE ARE DEMANDING

1. One dollar per hour for skilled labor.
2. Seventy-five cts. per hr., common labor.
3. A forty-eight hour week.

BE LOYAL TO YOUR FELLOW WORKER
STAY AWAY FROM THE JOB

CENTRAL LABOR COUNCIL

to make ends meet feared that if the wages for one position were cut, other positions would follow.

When Crowe was given the list of demands from the striking workers, he thought about it for a day and then fired all but a skeleton staff, telling those who were fired they could report to the paymaster to pick up the three days' pay they were owed. The flaw in the workers' plan was that the dam and the property surrounding the dam had been declared a federal reservation, meaning Walker Young had the right to kick anyone off the reservation at any time—and he had the backing of the U.S. military to do it. In fact, Young had already alerted the troops at Fort Douglas, Utah, asking them to be prepared to defend U.S. property if the need arose. Young built a fence along the reservation and posted guards at the only entrance—one way in and one way out. "A big fence, with guards, about halfway between Boulder City and Railroad Pass," said Murl Emery.

When the strikers gathered in the mess hall, Walker Young, accompanied by a U.S. marshal, thanked the men for the peaceful way in which they had been acting and added that he hoped that peaceful behavior would continue, after which he threw all the workers off the reservation. As two trucks and a bus pulled up outside, Young said, "We ask you to go, and we depend upon you to go. There's been no question at all of force." Joe Kline recalled that not everyone was asked to leave. "They rounded up everybody that was working there and took them all off. Everybody," he said. "They tried to get everybody. Then the foreman, or whoever it was, would go out and vouch for those guys and they'd come back in and be working."

Young also seized on the opportunity to do something about Ragtown and other squatters' camps, so after all the workers had been expelled, he got rid of the makeshift camps once and for all—all, that is, except McKeeversville. "We weren't aware of what was going on down in Ragtown until they came down and told us to leave," recalled Harry Hall. "They ran all the people out of Ragtown. They just told us to leave, period." With Young's gate and checkpoint, he could control who entered and left the reservation. "It was necessary to clean everything out," recalled Boulder City resident and project employee Leo Dunbar, "and get everybody out so that people couldn't move in and make homestead entries and set up little businesses."

This meant the tents and all those who inhabited them had to leave. Walker enlisted rangers and whatever police force he could get his hands on to remove everyone who wasn't employed by either the bureau or Six Companies. It was quite a project. There were thousands of tents, and the reservation stretched for miles. "The reservation area covered each side of

The guarded gate outside Boulder City. *Courtesy of Bureau of Reclamation.*

the river for quite a distance, all the way to Yuma," said Dunbar. "The only thing they could do is go back where they'd been at first."

Once all the commotion subsided, workers were eventually let back in, but only those with permission to enter. "Everybody that came through there had to show a card, a pass," said hydrographer Leo Dunbar. "The gate was manned day and night by federal rangers," said *Las Vegas Age* journalist Elton Garrett. Each man working for Six Companies, the Bureau of Reclamation or any other approved contractor was given a card in Las Vegas to verify his employment, allowing him access to Boulder City. All other people were issued passes that allowed passage into and out of the town. If you didn't have an employment card or a pass, you didn't get in and you didn't get out.

Just to the right of the road leading into Boulder City was a large sign on which were written three rules:

> *1. The possession of, or transportation, within the reservation, of intoxicating liquors, narcotics, explosives or firearms is prohibited.*
> *2. Speed limits of motor vehicles: 40 miles per hour on straighaways. 15 miles per hour on blind and dangerous curves.*

3. Dangerous or reckless driving is prohibited. Violators of any of the above regulations will be subject to prosecution and ejected from the reservation.

Even after construction on the dam resumed and the building of Boulder City was underway, the gate remained. In fact, it would remain for the entire time the dam was under construction. "There was a gate to come through to get into Boulder City," said resident Madeline Knighten. "It was a real reservation with a fence and a guardhouse. When we got to the gate, government rangers there checked out everyone that came in. Everyone was asked their reason for coming to Boulder City. We had to state our business in Boulder City, where we expected to live, who we were going to see."

"What a time those poor reservation guards used to have," said Boulder City resident Perle Garrett. "You'd always have a lot of things in your car. They'd be out there in all that heat, going through every one of those packages, feeling, trying to find a bottle of liquor." Not all people got searched. "The rangers knew pretty well who to search," recalled Dunbar. "If you were a government employee we never had trouble because we'd usually hold our pass out to the side of the car and they'd recognize us all anyway because we all knew each other. But they really went through the cars that came in for the first time." But even the best of searches can't find everything. "Of course, you can't get into every part of a car for every car, but it was a deterrent," said Garrett.

Liquor in Boulder City

Controlling who came in and went out of the town wasn't the only purpose of the gate. Secretary Wilbur was adamant about making sure the sins of Las Vegas didn't creep into his model city. "They were trying to keep the liquor out as much as possible," said Leo Dunbar. "If you had a bottle in your car, you swigged it and tossed it on the desert before you got to the gate," said Elton Garrett. "It was lined with broken glass—the far side of the gate." When you did arrive at the gate, your car was usually searched. "If you drove in you were subject to investigation of your car. They looked through it pretty good," said Dunbar. "If they could smell any liquor on your breath, why, out you got, and you walked this white line they had painted there at the gate," said Bob Parker. Those who couldn't walk the white line to the ranger's satisfaction were placed in a "bull pen" near the guardhouse until they sobered up.

Of course, even the best gate and fence can't keep out what people want to have in. "There was quite a lot of liquor in Boulder City," admitted Brue Eaton. "But it was an offense you could be removed from the reservation for. But that didn't keep it out." Liquor made its way into town through a "back door," aptly named Bootleg Road. "Men from Vegas or the ones with stills used to bring bootleg liquor to the men at the dormitories up Bootleg Road, up over the canyon," said Nadean Voss. "They'd miss the station that way." Bootleg Road was a dirt road running out of the canyon just to the northwest of Boulder City. The canyon became a manufacturing spot for bootleg alcohol during Prohibition, garnering the name Bootleg Canyon. To this day, the canyon has a large B and C on the side, which actually stands for Boulder City, though the initials also match the canyon's famous moniker.

In some cases, the government rangers would find stills and confiscate the barrels of alcohol. Rather than waste the alcohol, Walker Young placed the barrels in the paint house and instructed the painters to use it for paint thinner. It worked as thinner, but placing barrels of bootleg alcohol in a warehouse that was accessible to workers probably wasn't the best decision Young ever made. "When I'd be over there on Saturday morning," said Bob Parker, "just before noon a lot of painters, and the city maintenance foreman, the superintendent of maintenance, they all wound up over there at the paint house. That liquor that Walker Young designated as paint thinner kept some of those maintenance crews and painters around here pretty well supplied with liquor."

3

BUILDING BOULDER CITY

On March 1, 1932, Boulder City became the newest and
cleanest city in the United States.
—Ray L. Wilbur Jr.

With all the men, women and children arriving to the area on a daily basis, Boulder City needed to be built, and it needed to be built quickly. In March 1932, the *Las Vegas Evening Review and Journal* reported, "The government will spend close to $2,000,000 to make Boulder City a livable, clean, modern up-to-date, law-abiding town. It will do all that is permitted to maintain these conditions and increase the desirability of living in this construction camp." But the birth of the town happened long before its March 1932 inauguration. Almost two years earlier, men looking for work, many bringing with them their wives and children, began flooding the area. Tents were being set up wherever a bare spot of land could be found. Hygiene conditions were less than desirable—much less than desirable.

The residents of Las Vegas knew as far back as 1929 that Secretary Wilbur had plans to build his own town. On January 1, 1931, the *Las Vegas Evening Review and Journal* published a list of questions and answers about the proposed town site, including where it would be located, who would be housed there, who owned the land the town would be on and the name of the town, which, of course, was answered as "Boulder City." A month later, in the same paper, Commissioner Elwood Mead responded to some apparent misunderstandings that came about when Boulder City was publicized as a

"model city." It seemed the residents of Las Vegas were offended. "Boulder City and Las Vegas are cities of an entirely different character," said Mead. "One is purely and simply a construction camp and the other is a commercial city." Mead, in an attempt to mend hurt feelings, went on to explain why Las Vegas wouldn't have been a good choice for the "camp."

> *What we are doing there it would not be possible to do in Las Vegas. Boulder City will be seven miles from the actual scene of operations as it is, and that's about seven miles too far. It is, however, as close as we could find a suitable location for the city, which, if things were ideal, should be at the very edge of the canyon. It would be impossible to handle this work from Las Vegas—it's too far away. Naturally on a project of this magnitude, we must first concern ourselves with the welfare and comfort of the workmen, for these are paramount considerations in securing maximum efficiency and a minimum of trouble and delay. We are not sure, any more than anyone else, just what this new city will develop into—we may grow to be a considerable city—only time will tell.*

The construction of Wilbur's city of the future fell upon the sturdy shoulders of Bureau of Reclamation construction engineer Walker R. Young. He was already the bureau's man in charge of overseeing Six Companies, to make sure the dam was built on budget and as planned. It was now his responsibility to make sure Secretary Wilbur's city was built. Young was particularly suited for the task—perhaps more so than any other man. Not only was he a talented engineer, he knew the importance of both men and materials and how to manage each. "In the field of management," he once wrote,

> *The most important thing you will have to consider is people. In my estimation, one of the essentials one should learn in college is how to conduct one's self in association with others. Your success or failure will depend largely on your ability to influence people and to perform, yourself, in a manner to gain their respect and to develop their faith in you.*

Young had strong philosophies on management. "The objective of management," he wrote, "should be to perform the job assigned in the most efficient manner possible in order to get the most out of every dollar spent in the endeavor." It was a philosophy Young adhered to, and he knew just how to accomplish it. "In management, the first job is the organization of a group of

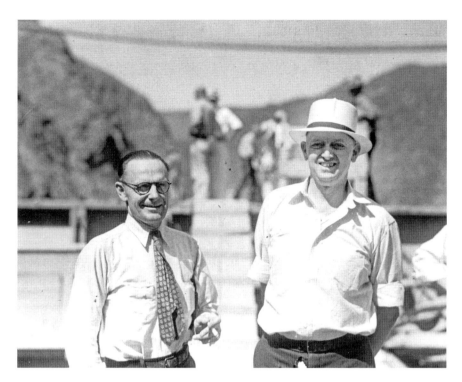

Construction engineer Walker R. Young (*left*) and superintendent Frank T. Crowe. *Courtesy of Boulder Dam Museum. W.B. Radford Collection.*

people to handle the work to be done and, after that, to develop individuals within the group, whether it be in government or private enterprise." Young believed that everyone working on the project had a common goal and that everyone—every single person—had a responsibility to ensure that goal was completed. "My theory is that everyone in the organization, including the janitor, is to be held partly responsible for the success or failure of the operation." Walker Young adhered to the philosophies he held dear and took to the task of building a city.

He knew that if he was going to build a city in the middle of a desert, he'd better make sure the city had plenty of water. He also knew that having that water was a top priority, so one of the first things he authorized to be built was an adequate water supply and a water storage tank. The tank, positioned on a hill at the northwest end of town, was the first permanent structure built by the U.S. Bureau of Reclamation. When completed, the tank—which is still present to this day—was thirty-five feet high and one hundred feet in diameter. It was constructed of steel with a concrete foundation. Water was

sent by pumps that pushed it from the pumping station in Black Canyon to the storage tank through nearly seven miles of pipe. The storage tank was built to hold two million gallons, thought to be more than adequate at the time of its construction. However, the residents of Boulder City would use half that much every single day, meaning that if something ever happened to the water supply, the storage tank would be emptied in only two days.

GOVERNMENT BUILDINGS

Now that Boulder City had water, a sewer system could be built and buildings erected. The first buildings scheduled for construction by the U.S. Bureau of Reclamation were the government administration building, municipal building and dormitory. Prior to this time, the bureau had been renting offices in the Berkley Building in Las Vegas. Government employees not living in tents in Government Camp No. 1 rented rooms in either the Six Companies dormitory or in Las Vegas.

Bids for the buildings opened on August 10, 1931. Nearly two months after the plans for these buildings were approved, a contract was awarded to B.O. Siegfus of Salt Lake City, who successfully bid $46,253. The bid did not include the materials or equipment needed to construct the buildings—that would be provided by the government. The administration building was to be erected on the highest part of town, overlooking both Boulder City and the area that would eventually be Lake Mead. "I remember getting stuck in the sand before the administration building was there," said Boulder City resident and journalist Elton Garrett.

THE ADMINISTRATION BUILDING

The administration building was to be located in a prominent position on the large hill just north of the town site, where it could overlook the

Opposite, top: Boulder City's water storage tank. *Courtesy of Bureau of Reclamation.*

Opposite, bottom: The water pumping station located in Black Canyon on the Nevada side of the Colorado River. *Courtesy of Boulder Dam Museum. W.A. Davis Collection.*

The completed administration building. *Courtesy of Bureau of Reclamation.*

entire town and, in return, be seen from anywhere. The position also afforded a view of Hemenway Wash and the Colorado River. When all was said and done, the administration building alone cost the bureau close to $50,000 in labor and materials. But the bureau got quite a bit for its money. The center portion of the building was two stories, flanked by one-story wings. The second story had a row of round arched windows that ran almost the entire length of the floor. The two-story lobby, complete with exposed beams, was adorned with a heavy brass and china chandelier. In addition to the first and second floors, the building had a full basement with a six-car garage, storage rooms and areas for the mechanical systems.

The first floor housed the offices for the engineers—construction, office and field—as well as the chief clerk. Areas were also set aside for drafting, stenography and clerical work. The *Las Vegas Evening Review and Journal* reported in March 1932, "Construction Engineer Walker R. Young and his Bureau of Reclamation staff conduct the business of the entire reservation and dam project from the new administration building atop the hill." The district counsel was located on the second floor, and there were rooms for visiting

engineers, as well as consultation and drafting rooms. The administration building, which is still in use today, even had air conditioning—a full two years before it was installed in the White House.

THE MUNICIPAL BUILDING

The one-story municipal building was also designed in the Spanish Colonial Revival style. The L-shaped building had a round-arched center entrance and was designed to house the post office, courtroom, jail and library. In addition, the U.S. marshal, city manager, city clerk and city engineer all had offices in this building. "Boulder City has its own municipal building," reported the *Las Vegas Evening Review and Journal* in March 1932, "with City Manager Sims Ely and Police Chief G.E. Bodell having their headquarters there, as well as Postmaster J.L. Finney and his post force."

DORMITORIES

Once the administration building was complete, work began on dormitory number 1, which was designed in the Spanish Colonial Revival style. The two-story stucco building had a low-pitched tiled roof and an arcaded façade with round-arched openings, The U-shaped building allowed for an internal courtyard, and slanted doors and large windows helped circulate air to the building, which had no air conditioning. Dormitory number 1 was located just to the east of the administration building. Like the administration building, dormitory number 1 was completed on January 11, 1932. "I moved there as soon as it opened up," said Tex Nunley. "Two men to a room, $15 a month, and everything was taken care of: the sheets and towels, everything. The bed made, everything."

The government would eventually build another dormitory, named dormitory number 2. Each of the two dormitories were "watched" over to make sure all the rules—including the prohibition of women—were followed. Dormitory number 2 had Hattie Peterson, whose husband, Charles, eventually became the Boulder City chief of police. "When Hattie Peterson said there would be no girls upstairs, she meant just that," recalled Curley Francis, who stayed at the dorms. "I don't think there were any girls

that ever got up there, because Hattie Peterson kept a pretty tight rein on everything that went on in the dormitory."

Hattie was not just tight-fisted; she also cared about each and every one of her charges. "We were all individuals and very special to her," said Francis, who recalled a time when Hattie took special care of a painter who had gotten lead poisoning. "Hattie Peterson saw to it that he never went without food. He couldn't go anyplace to eat. She saw that he got his meals. She'd even tell us fellows that could go out and get something to bring home for him to eat. He was well taken care of."

Six Companies Buildings

While Young was busy with the Bureau of Reclamation's buildings, Six Companies was also erecting dormitories and houses. This was done through the Boulder City Company, the subsidiary set up by Six Companies to build the part of Boulder City the construction company was obligated by contract to construct. Though it had already built dormitories on Cape Horn, the contract it signed required Six Companies to house its employees in Boulder City. Additionally, while most of what the firm did took place at the dam, it still needed buildings where it could conduct its business and place its equipment. To this end, Six Companies was given an area of town where it could build offices and headquarters, as well as other buildings such as garages, dormitories, the commissary, homes for its employees and structures for other incidental purposes. Six Companies was charged $5,000 per month for access to the town's water system and was expected to pay for a portion of the expense of operating the town.

Dormitories

One of the first buildings needed was a dormitory to house unmarried workers. While dormitories had already been built on Cape Horn, those buildings were high on the side of a mountain. Additionally, the contract Six Companies signed to build the dam legally obligated it to house its workers in Boulder City. In June 1931, Six Companies built ten two-story dormitories, each capable of housing 1,600 workers. Each wing of the H-shaped building

Six Companies' dormitories under construction. *Courtesy of Bureau of Reclamation.*

had numerous rooms, seven feet by ten and a half feet. Each wing housed 172 men. There was a shower room and a lavatory in the connecting portion between the wings. Porches ran the full length of the dormitory, and there was one on each side.

"Ten dormitories were built, each like a letter H," recalled journalist Elton Garrett. "A cross between two rows was a connecting—shall I say bath area—for the use of people from all four of the wings. I lived in one of those dormitories for a while before other housing was available for me. I had a room in Dormitory 3 right across the street from where the company store was." Carl Merrill recalled the accommodations in each room. "The only thing it had in it was a bed. It was one of those spring-type cots. They furnished your linen and blankets. Our wages were $60 a month and board and room. So that room was provided as part of our salary." Merrill and his colleagues may have thought the rooms were part of their pay, but in reality, the workers were charged $1.65 per day, $0.05 of which went to their insurance.

One of the main benefits of the dormitories was the heating and cooling system that kept the rooms nearly 22 degrees cooler than the outside temperature in the summer—important when temperatures regularly reached 120 degrees. "The men who were fortunate enough not to have their families living here with them, if that's how you want to put it, and who had to live in the dormitory had a decided advantage," said dam worker Bruce Eaton. "They did have a cool place to sleep, they had a good place to eat." As Eaton pointed out, staying in the dormitories, out of the extreme heat, was a "decided advantage." So much so that just as soon as a building was completed, it was filled with single men, eager to have a place to rest after a long, hard day. "By the time the accommodation for 350 men were ready, there were 351 men to live in them," reported the *Las Vegas Evening Review and Journal*. "This has been characteristic thruout [*sic*] the entire upbuilding of the town, so rapidly has the work been pushed and the forces increased."

ANDERSON MESS HALL

You couldn't have any better food than what Anderson Brothers put out.
—*Hoover Dam worker Tex Nunley*

Six Companies also built a mess hall at the cost of $65,000, which was run by the Anderson Brothers Boarding and Supply Company. The mess hall was made up of two eating areas, called wings, each 48 feet wide and 144 feet long, as well as a kitchen (47 feet by 112 feet) and a pantry (40 feet by 85 feet). Long tables lined each side of the dining areas, with four chairs placed on each side of the table. "The mess hall had two wings. We called them right and left wing," said Bob Parker. "Each wing would seat six hundred, with a kitchen in the center, and a warehouse, and a full-size bakery with three bakers." Underneath the large mess hall, which was built in only four days, was a concrete-lined basement where the refrigeration equipment was housed. Stored in this basement were the twelve to thirteen tons of fruit, ten thousand pounds of meat, twenty-seven hundred pounds of eggs, three and a half tons of flour, nearly two tons of potatoes and over one ton of miscellaneous groceries needed to feed the workers every week.

Because little was grown, raised or produced in the desert, all of these supplies had to be shipped into Boulder City every day. Meat packed in dry ice was trucked down from Reno, as were eggs. Canned goods came

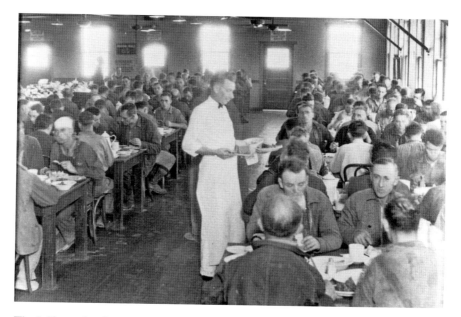

The 2:00 p.m. lunch at the Six Companies' mess hall, run by Anderson Brothers. *Courtesy of Bureau of Reclamation.*

from Utah and California, which also supplied fresh fruit. No dairies large enough to supply the needs of the Boulder City workforce existed in southern Nevada, so the Anderson Brothers built one. The firm bought a 160-acre alfalfa ranch in nearby Logandale and converted it into a dairy farm, bringing in water and adding sewer and refrigeration systems, a steam plant and a milk barn. The farm, which is still in operation today, was used by the company to make the milk, cream and butter that was then shipped daily to Boulder City in ice-cooled trucks.

Anderson Brothers ran an efficient mess hall. The menu changed daily, and the workers were allowed to eat as much as they wanted. On a daily basis, men could expect to find grapefruit, oranges, pork sausage, bacon, stewed figs, pineapple jam and hot biscuits. And that was just for breakfast. Lunch might include roast beef, mashed potatoes, creamed onions and rice pudding. For dinner, workers might be served grilled rump steak with French-fried potatoes on one day and Spanish stew with vegetables on another. Of course, coffee, tea and milk were always on the fare. Workers weren't the only people allowed to eat in the mess hall. Anyone could enter and eat as much as they liked. "You could eat as long as you could eat, and they'd keep bringing it to you," said Parker. Payroll deduction took care

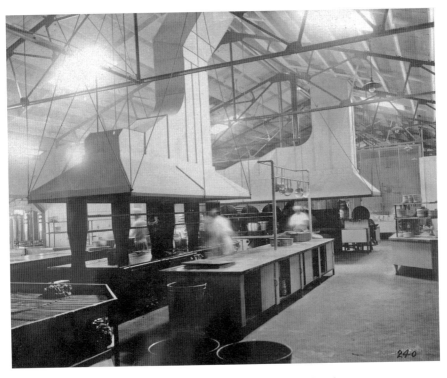

The kitchen of the Anderson Mess Hall. *Courtesy of Bureau of Reclamation.*

of the bill for the workers, while everyone else was charged sixty-five cents per meal.

Platters of food were placed at the head of the table and passed down. "They fed family-style," said Parker. "By that I mean they would take hotcakes and put them on a great big platter on the table, and take sausage, and take eggs and put them on a huge platter and put them on the table." It was usually good to be at the head of the table and not so good to be in the middle. "There was always plenty of food," said Wilfred Voss. "If you weren't at the far end of the line, though, where platters were passed down, chances are you'd have to wait for them to be filled up three or four times before they'd finally get some food down for you."

A large sign was placed by the food that read "Take all you want but don't waste." Men could fill their lunch buckets with an assortment of sandwiches, fruit and a variety of pies and cakes. "I ate at the Anderson Mess Hall," said Voss. "The food was excellent. As a matter of fact, I have never run into anything that would compare with it—the food and the amount of food that

they put out." Dorothy Nunley remembered eating in the Anderson Mess Hall. "It was very crowed as a rule," she said. "They had several different dishes, different kinds of meat and things. They didn't stick with just one thing. Fish on Friday, that was a rough one. You could smell it all over town."

GRADING AND PAVING STREETS

"The New Mexico Construction Company was employed for the streets and ditches and all that kind of thing," recalled Walker Young. While LeTourneau Construction was using the latest in earth-moving machines to build a road to the dam site, the streets in Boulder City were graded the old-fashioned way, with four-ups and Fresnos. "A four-up is four mules, and a Fresno is a scoop that you scoop dirt by hand, and the mules pull it," explained Boulder City resident Erma Godbey, whose husband was employed by New Mexico Construction. As the man rode behind the mules—or sometimes horses—and controlled the team, the large-bladed Fresno scraped and flattened the desert dirt into something resembling a street. "Farther on out I saw mules and horses grading streets," said twenty-one-year-old dam worker Marion V. Allen. "It was probably the last time teams were used for grading on this large a project."

By March 11, 1932, the *Las Vegas Evening Review and Journal* reported that "More than nineteen miles of street paving have been laid in Boulder City to date. With but half a block of Arizona Street remaining unfinished, the New Mexico Construction Company has completed practically two weeks ahead of schedule its contract for paving the streets of Boulder City." According to the paper, if the completed paving was to "be laid out in a highway section of 18 feet in width," it would exceed nineteen miles. Following DeBoer's original design, in addition to the paved streets, New Mexico Construction had also paved 21,774 square yards of parking areas, "to avoid parking of cars in the streets."

The main streets were named after the seven states of the Colorado River Basin: Arizona, California, Colorado, Utah, New Mexico, Nevada and Wyoming. California Street was the axis of the city; Utah Street and Nevada Way were the other main streets. Arizona, Wyoming and New Mexico ran between Nevada Way and Utah, perpendicular to California Street. Once the grading was complete, Nevada Highway and Arizona Street were paved with five inches of two-course asphaltic concrete, because traffic was

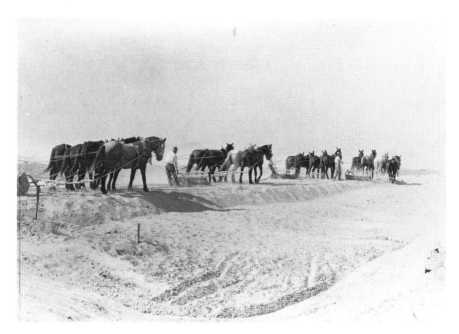

Mule and horse teams, known as "four-ups," and hand-run scoops, known as "Fresnos," grading a Boulder City street. *Courtesy of Bureau of Reclamation.*

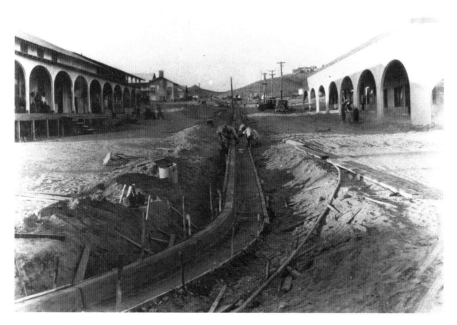

New Mexico Construction Company installing curbing along Birch Street. *Courtesy of Boulder Dam Museum.*

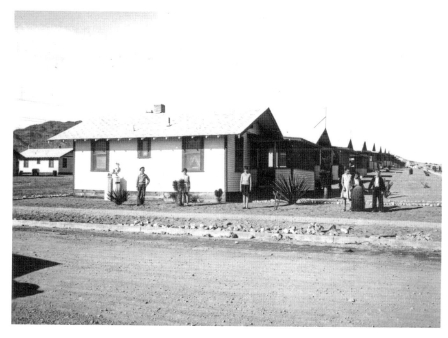

Unpaved residential streets. *Courtesy of Bureau of Reclamation.*

expected to be heaviest on these roads. Streets like Wyoming, Colorado and California were paved with a lighter two inches of one-course asphaltic concrete. Residential streets were left unpaved or received either one and a half inches of oil mix on three and a half inches of water-bound rock base or five inches of local gypsum agglomerate.

On the higher part of the town, at the north end, were located the government buildings and the homes of the government employees on aptly named Denver Street—the U.S. Bureau of Reclamation offices where the dam was laid out and planned were in Denver, Colorado. The point where California and Arizona Streets cross was the approximate center of town; because of this, the origin of street numbers was taken "at blocks north and blocks east" of this intersection. In general, even numbers were on the right-hand side of the street when facing the direction of increasing numbers. Residential lots were given two numbers, and all industrial lots were assigned one number for every 10 feet of frontage. The streets of Boulder City would vary in width. Main streets were 112 feet wide—the actual roadway was 56 feet and the rest was sidewalks. Business streets were 92 feet wide, with the roadway again at 56 feet. Residential streets were the narrowest, at 60 feet wide, with the roadway being a mere 30 feet.

Boulder City Houses

Leo Dunbar was thirty-seven years old in September 1931, when he left Montrose, Colorado, to come to Las Vegas to work on the Boulder Dam project. "When I arrived in Las Vegas in the afternoon, it was 101." Dunbar said. He was already employed with the U.S. Bureau of Reclamation (then known as the Reclamation Service) when he came to work on the Boulder Canyon Project. He was working as a hydrographer, making $126 a month, minus the amount the government took back. "We didn't lose our jobs, but we gave back fifteen percent of our salary." Dunbar was happy to have a job at the time. It involved taking water measurements and handling the water divisions and prioritizing water sections for that area of the Colorado River. "In other words, we relied on Leo to keep us fully informed of what the river was doing, clear up into Colorado," said Young, who was Dunbar's boss.

After he arrived in Las Vegas, Dunbar was taken over to a camp just outside the construction site called Government Camp Number 1. "The government had erected four large tents," Dunbar recalled. "There were four of us in each tent. Each one would pick a corner for his cot and so forth." But Dunbar wouldn't have to stay in a tent for long. He had left his wife and three small children in Colorado with the promise that the government would have a house built for him in Boulder City. Shortly after he arrived, he was told he would be getting that house.

Dunbar was a key employee of the U.S. Bureau of Reclamation. It was his job to tell Walker Young what the Colorado was doing at any given time, from its source all the way to the dam site. Young couldn't afford to be surprised by the unpredictable river; naturally, this meant the bureau didn't want Dunbar too far from the worksite for any given time. Knowing that he must have been tired of living out of a tent, the bureau promised him one of its new homes. "They told me I could have the house on the end of Denver Street," recalled Dunbar. "When I arrived here, there were just five houses on Denver Street under construction." The only problem was that the bureau hadn't finished building the house, but it wasn't about to tell that to Dunbar.

Dunbar asked for and was granted a leave at Christmas so he could visit his family. He was also given some good news. "On the 22nd of December '31, they told me that the house would be ready for me in a week." Of course, there was a stipulation. "If I would be back in a week," Dunbar said, "I could have the house and it would be ready for the family." The bureau sweetened the pot by offering to ship his possessions.

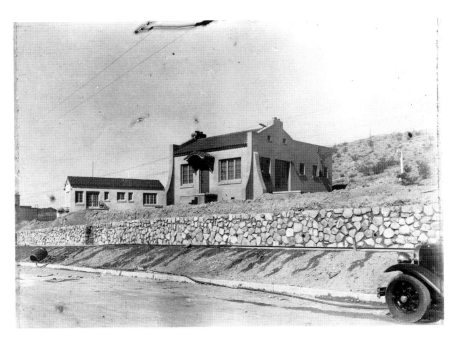

Houses on Denver Street. *Courtesy of Bureau of Reclamation.*

Dunbar accepted the terms, and on New Year's Eve 1931, he returned to Boulder City with his family in tow. During the week he was gone, the government had shipped his worldly possessions to Boulder City. But not to the house on Denver Street. Instead, it had given him a "temporary" residence on Ash Street until his permanent home could be finished. When he opened the front door of his house on Ash Street, Dunbar was greeted by his things. "It was piled in the front room of that house, bedding on the floor and the rest of the furniture on top of the bedding," recalled Dunbar. The house must have just been finished, because the brick and the plaster were still wet. A group of Dunbar's friends had gathered to help him move in, and they decided to start a good, old-fashioned fire. "We filled the fireplace with wood and put some papers in the bottom and touched it off." However, as the smoke began to build, instead of going out the chimney, it went directly into the house. "There wasn't one speck of smoke that went out the flue," said Dunbar. Luckily, he was able to borrow a blower from Six Companies and got the smoke out.

When a town is built as fast as Boulder City was, faulty chimneys aren't the only problems experienced. "The idea was to get the town built, not whether anything was right," recalled Young. Home construction happened so quickly

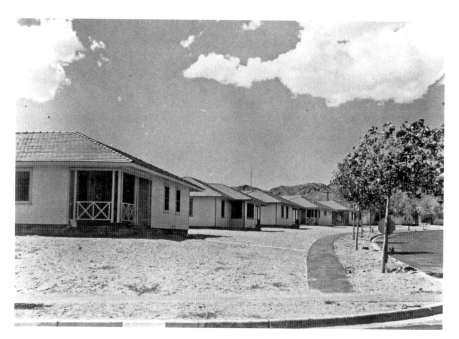

Houses on Cherry Street like the one that was temporarily given to Leo Dunbar. *Courtesy of Boulder Dam Museum. Cliff Segerblom Collection.*

that no one had time to properly test the soil. "It turned out that in excavation for the foundation we ran into a type of clay there which had swelling characteristics," said Young. Though it doesn't rain much in a desert, it does rain at times, and when it does, it rains hard. When the clay gets wet, it swells. "That raised the house[s]," said Young, "sufficiently to put zig-zag cracks in the joints of the brinks." This problem was eventually corrected with pilasters, but not for some years. Dunbar and his family would later move to a five-room frame house on Denver Street. "I'd been watching that construction—this was in 1932 and early 1933," said Dunbar. "That house and two or three of the other frame houses had been under construction because the Bureau decided that they needed more housing than they had originally."

PERMANENT HOUSES

On February 16, 1931, bids were put out for twelve permanent "residential units" to be built in the middle of March. The wording of the bids called

for "furnishing labor and materials and performing all work for construction of six four-room residences and six three-room residences." These houses were reserved for government employees like Dunbar. "Residences which were built of brick, for the government employees, having in mind the future employees required to operate the dam and powerhouses, were located up near where the administration building was, but looking down toward the lake," recalled Young, who himself had a brick house at 1300 Denver Street. These houses were meant to be permanent, and it was expected that they would not only house the government employees working on the construction of the dam but also the employees who would be responsible for operating and maintaining the dam once it was completed. "That's why the permanent buildings were built for the government forces, whereas the temporary buildings were built for the contractor," said Young. Temporary buildings went to the clerks, laborers, rodmen, mechanics and other lower-grade employees. The main reason these employees didn't get permanent homes wasn't that they were deemed unworthy of such structures; they simply couldn't afford the more substantial rent of a permanent home.

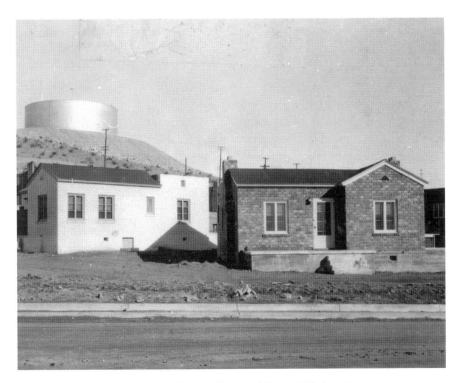

Examples of the brick permanent houses. *Courtesy of Bureau of Reclamation.*

The government also built some Spanish-style houses that, according to the *Las Vegas Evening Review and Journal*, would be "complete in every detail, even to a place in the kitchen for the laundry tubs." These well-appointed homes came complete with space for an electric refrigerator, a built-in ironing board, a broom and linen closet, a breakfast nook in the kitchen and a fireplace in the living room (which may or may not work properly). While the houses did not contain air conditioning—it was far too expensive—they did have insulated roofs, which protected the homes from the hot sun. These houses were also made of brick and contained the same hollow wall feature Kaufmann designed for the administration building, the municipal building and the dormitories. In fact, according to a report put out by Christine E. Pfaff for the Bureau of Reclamation, "It would be the first and only time that Reclamation constructed its permanent camp buildings of brick, indicative of the unique status of Boulder City."

Houses built in the Spanish style were stuccoed on the outside. By mid-November, the bureau had completed twelve brick houses, with twelve more near completion on Colorado Street. To make the streets more interesting and to prevent all houses from appearing the same,

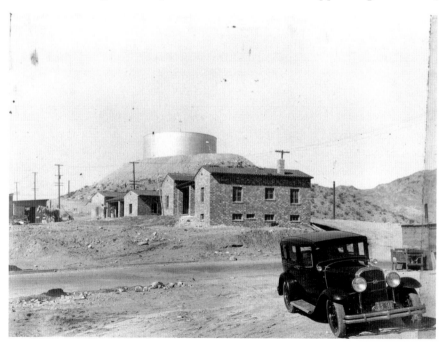

Houses intended for the highest upper-level employees, like Walker Young. *Courtesy of Bureau of Reclamation.*

floor plans, façade treatments and roof types were varied from one house to the next. Four of the fanciest residences were intended for the highest upper-level employees: the chief construction engineer, the office engineer, the field engineer and the district counsel for the Boulder Canyon Project. These four residences would cost $18,000 to build and include tiled roofs, casement windows and exposed brick exterior walls. Each house had a central living room with a three-bedroom wing on one side and a kitchen and a dining room on the other, complete with a telephone niche. They had front porches and rear patios accessed by French doors. The third bedroom, the one facing the rear patio, came with several windows, giving it the feeling of an "open air bedroom." The three six-room houses and one seven-room house—which were over two thousand square feet—were to be placed on prominent lots on Denver, Nevada and Park Streets.

In April 1932, the bureau began construction on nine houses along Utah and Denver Streets. These houses were intended for ranking bureau staff like city manager Sims Ely. They consisted of two bedrooms, a kitchen, a bathroom, a combined living and dining room and a small enclosed porch. They had tile roofs and entrances with round-arched openings.

SIX COMPANIES HOMES

Six Companies built some permanent structures, as well. One of those was the Executive Lodge, built at the base of the water tower on Water Tower Hill. Designed by architect George DeColmesnil and built in 1931, this Spanish Colonial Revival, ten-room, six-bedroom house had rooms for guests and servants. The house, which had a one-story section and a two-story section, had white stuccoed walls and gently sloping clay-tiled roofs with intersecting pitched roofs.

Guests entered at the center of the house and, once inside, were greeted by a well-decorated interior, a massive chimney and picturesque views. Six Companies built the structure to house visiting dignitaries, so it could show off a bit—which it routinely did. "Two structures up there, on that ridge, west of that water tank—one was Frank Crowe's residence, the other was for entertaining prune-picker senators and congressmen from California and other big shots from other important states," said Boulder City resident and journalist Elton Garett. Crowe's house was smaller but just as magnificent as

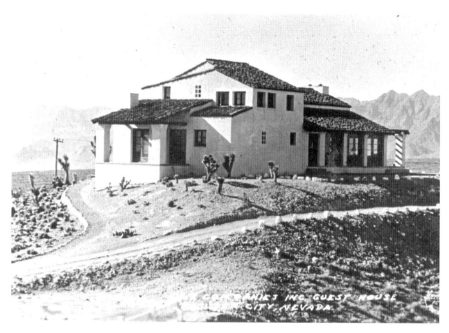

Executive Lodge on Water Tower Hill. *Courtesy of Boulder Dam Museum.*

Interior of the Executive Lodge. *Courtesy of Boulder Dam Museum.*

the lodge. Built in the same style of architecture, it had Mission-style doors, open timbering and massive stuccoed piers.

Six Companies also built permanent dwellings along Ash Street, where it housed its engineers and superintendents. By the fall of 1931, eight of the eleven houses had been built—one of which was used by Leo Dunbar until he moved to his permanent home on Denver Street. Two standard plans were used for these houses: one for a five-room house and the other for a six-room house. The houses had intersecting hipped and gabled roofs, south-facing sunrooms and rear porches with screened entries to protect against insects.

Babcock and Wilcox, the second-largest contractor on the Boulder Canyon Project, employed around three hundred workers. Many of those workers were housed in a 101-man dormitory, which was later torn down. However, the company also built twelve single-family dwellings and two executive homes—one for the company physician and one for the superintendent. Of the twelve single-family homes, four were one-bedroom, seven were two-bedroom and one was three-bedroom. All twelve houses were located in an area originally reserved for commercial use but released by Walker Young to be used as a residential area. The houses were located on California Street, Colorado Street, Nevada Way and Avenue C.

Superintendent R.S. Campbell's dwelling was an eight-room split-level house on 2 Hillside Drive. It had a cross-gable roof, a garage and servants' quarters that could be accessed from the lower level. It had broken massing, Mission-style shutters, flanking pairs or wood casement windows, timber lintels and wrought-iron fixtures. Dr. Julius Kehoe's dwelling was adjacent to Campbell's on 3 Hillside Drive. A much smaller home, the five-room, two-story plan was covered with a double-pitched roof with intersecting cross-gable wings and designed in the English country house style.

Temporary Housing

Much of the temporary housing was built by Six Companies, which was contractually obligated to do so. While upper-level employees would have custom homes built in the town, the line-level employees would have no such luxury. Their homes were manufactured homes, designed by a Southern California firm. The rectangular design was based on those used to house workers building the Panama Canal. The floor plan was simple: living room, kitchen, bathroom and bedrooms.

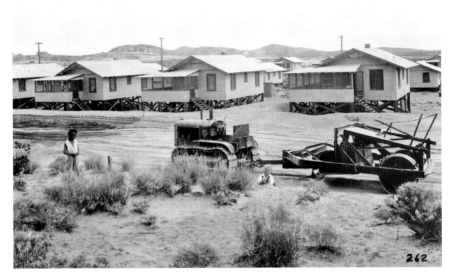

Homes built by Six Companies. *Courtesy of Bureau of Reclamation.*

"Each of those had one bedroom and an L-shaped porch that was capable of becoming a couple of bedrooms more if a fellow wanted to partition them off," recalled Elton Garrett. "That L-shaped porch came around the front and there was then a porch coming across to the other side. So here you had an outdoor porch, an L-shaped porch, a living room, one almost square bedroom, and a bathroom and a kitchen. This was standard for most of the Six Company Houses."

By summer of 1931, Six Companies had built two rows of houses on Avenues A and B below Wyoming Street on the broadest portion of the base of the fan-shaped town. The one-, two- and three-bedroom single-family cottages were built on long, rectangular blocks that extended from Wyoming to New Mexico Streets. "They started building them on Avenue B and Wyoming," recalled Boulder City resident John Gieck. "They built the three-room houses first, then the two-bedroom [houses]." These houses were strictly for married workers with families. Single workers and those who didn't have their families with them were relegated to the dormitories.

"The last built was the dingbat houses," said Gieck. How these boxy, three-room homes got their name is a bit unclear. Some say it originated from the speed with which they were built. Others claim the term came from the stick frame and stucco apartments being built in California that had decorative ornaments—called dingbats—adorning their outsides. Since those apartment buildings didn't show up until the 1950s and '60s, it's unlikely they were the source of a term used for houses that were built thirty years before them.

Two carpenters were expected to put up a dingbat house in twelve hours or less. "They had to lay the foundation, put the flooring in, frame it, and put the siding on and put the roof on and then paper it," said Gieck. "That didn't include the finishing work: the screens, the doors and windows, or the sheetrock inside." Most houses were placed on fifty-foot dirt lots on unpaved streets. They had thin, cracked walls that did little to prevent the blowing dust from entering the home. "The houses were put up in one day, child," recalled Wilma Cooper. "You think you can put up a house in one day and have it look like anything? They never were comfortable, because there was no insulation in 'em." The houses were built so quickly that large gaps were overlooked. "And we didn't need an alarm clock," said Cooper. "Where the ceilings came down to meet the wall, they didn't meet. When the sun shone in, it hit our faces, and we knew it was time to get up."

Dingbat houses had rough wood floors, which created its own set of problems. "The floors were terrible," recalled resident Mary Eaton. "The floors were just plain old pine wood. I had no flooring, so I had to keep the children off the floor as much as I could because they'd get slivers in their little behinds and legs." Wilma Cooper also had trouble with the floors. "The floors were that old three-inch pine and the wind and sand'd blow up between the boards. I had sinus trouble so bad we decided we'd get some linoleum to lay down. Then when the wind blew, that linoleum'd slide this way and that."

Six Companies started building in June 1931, and by March 1932, it had constructed 661 of these detached dwellings on the east and south sides of Boulder City at a rate of one and a half per day. Like Secretary Wilbur when he visited Las Vegas, the residents of Boulder City weren't fooled. They had no illusions of the houses being anything but what they were—temporary. "But they were never meant to stay here. It was all supposed to revert back to desert when the dam was finished," said Cooper. The fact that the houses were, more or less, slapped together didn't curtail their desirability. After all, living in a house, any house, was better than living in a tent—or worse.

"There were people just scrambling for houses," recalled Boulder City resident Rose Lawson. "Always a big lineup of people begging for houses and applications for houses." As soon as houses were built, the lucky ones moved in. "My father succeeded in getting a house for us—I believe it was at 515 Fifth Street," said Boulder City resident Marion V. Allen. "This was on the edge of the desert and I believe the rent was $19.00 per month." Others had to wait. "The lists were very long for the Six Companies houses," recalled Alice Hamilton. "People waited for sometimes a year before they could get into Six Companies housing. A good many of them lived in Las Vegas in the beginning, until housing became available to them."

"These were called one-room houses," wrote Allen, who had fond memories of his Boulder City house.

> *But to us it was beautiful! It had a sink in one corner on a 2 x 4 frame and a little three-burner gas range across from the sink. The bathroom was across the end of the screened-in porch, but opening in the house. It was about four by six feet, with a shower and a toilet but no wash basin or hot water heater. Our house wasn't much by today's standards, but we had a roof over our heads, a screened-in porch that kept the bugs out. Even though it wouldn't keep the sand out, we could always shake it out of the bedding. I heard that these houses cost $140.00 each when they were built.*

Sand was a constant problem when living in a desert, even more so when the wind blew—and it blew quite a bit. "We'd sleep out on the screened-in porch that was exactly the width of a double bed," said Wilma Cooper. "The sand blew incessantly. They always warned me that if you slept on your back, you always flopped over and turned your head down before you opened your eyes in the morning, or you'd get sand in them." To combat the wind and sand, many home renters put up boxes, canvas or burlap on the screens. "I went out to the dump and got some pasteboard boxes and come in and lined those screens on the porch," said Cooper. "Then we had the screen and the canvas and the pasteboard boxes flopping in the breeze all the time. The wind blew incessantly—it was a noisy place to be."

"The house was built exactly like a shoebox," recalled Rose Lawson. "Two rooms with a little porch. They were sitting on sand. Two steps, you were out into the sand." Helen H. Holmes also recalled what it was like living in her dingbat home. "There was one quite large room. I would imagine it might have been twelve feet, or maybe it wasn't over ten feet. That's where we lived, and where our bed was. Then there was a small kitchen." These houses had

Lida Buck and her daughters Marjorie and Eileen stand outside the screened-in porch of their dingbat home. *Courtesy of Boulder Dam Museum.*

few luxuries; they had plumbing, but there wasn't always water. "We had to haul our water from a tank car out on the railroad," said Lawson. "Soon our little shower rooms were finished. There was a toilet in there, but no washbowl. So for several years we brushed our teeth and washed our faces in the [kitchen] sink." The houses were only available to Six Companies employees, who were charged for water, electricity and monthly rent— around $17.00 per month. "They had a porch built on which was screened in," recalled Holmes. "There was room enough for a small cot out there. I painted the living room, papered it and all, spent so much time, thinking we were going to live there forever."

On March 11, 1932, the *Las Vegas Evening Review and Journal* reported: "Today more than 4,500 men, women and children are living in Boulder City, and 280 more homes are being added by Six Companies and the government to the 480 or so already constructed. While nearly 2,000 men live in ten dormitories." Two months later, the *U.S. Daily News* ran this headline: "City for Workers at Hoover Dam Now Nearing Completion." The *News* reported the population of the town to be 5,000 and stated that it was "no longer a construction camp" but had become the third-largest community in Nevada. In not quite one year, nine hundred buildings were completed,

90 percent of which were residences. Another one hundred were under construction, and 93 percent of the residences had electric refrigeration.

GETTING LOST

Unlike the permanent brick homes, the temporary homes didn't have as standard features the conveniences of electric refrigerators or ranges—they could be added for a price. If the family wanted a Frigidaire, they could buy it from the Six Companies for $150, or $15 per month. In fact, these four- and five-room houses, scattered throughout the town, were "constructed as cheaply as possible." Because the houses were expected to be temporary, no attempt was made to vary their appearance. Each street front contained seventeen identical houses. They were so similar that in 1931, the *Boulder City Journal*, the local newspaper, reported an almost deadly incident caused by the similarity of houses:

> *J.N. Smith had quit work on the "swing shift" and wended his way toward his home down in the last row of houses. He had gone to the last row and then counted eight houses. He kicked the sand off his boots on the porch, and banged on the door and yelled, "Woman, let me in." A strange woman opened the door, pointed a gun at him, and said: "Run or I'll fire."*

Smith had gone to the wrong home. In the time he had returned from his shift, an entire new row of houses had been built. "There were no street grades, no street lights, and nothing to mark one's whereabouts but the row of similar houses," reported the newspaper. Some homes were smaller and some bigger, but it clearly wasn't enough to be noticeable.

"There were always being stories told of men getting in the wrong house when they would come off shift, especially off swing shift," wrote Boulder City resident Marion V. Allen. "This was easy to do. The houses were all alike and all white, very little light and no way of determining any difference. Not even numbers then."

Adults weren't the only ones who had trouble with the similarity of the houses. "I had to watch real close," said one-room house resident Helen H. Holmes, "especially when my little boy was a year or two old. All the homes were the same, and they all had the same kind of lawns, so they didn't dare get out of your sight because they didn't know where their home was. Of

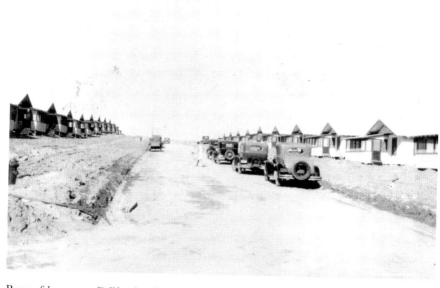

Rows of houses on Californian Avenue. Their identical appearance often made it confusing to determine which one was which. *Courtesy of Bureau of Reclamation.*

course the neighbors were all friendly and found them immediately, but you kept an eye on them right under your feet all the time."

PRIVATE HOUSING

Not every house in Boulder City was built by the government or by the contractors. In an effort to get people out of their tents, city manager Sims Ely decided to allow private houses to be built on the eastern edge of town. "Well God knows we wanted to get out of the tents too," said Erma Godbey, whose family was the first to build a private home in Boulder City. While Godbey's husband, Tom, was working in town for the different contractors, he wasn't working specifically for either the Bureau of Reclamation or Six Companies, meaning he wasn't eligible for a house. So Erma, Tom and their four children went to the administration building to find out how they could build a house of their own.

"They didn't even have the lots surveyed yet," recalled Erma Godbey. "But they said 'We know where they're going to be, they're going to be way

over on M Street.'" The Godbeys strolled over to M Street with their kids in tow to have a look. "The lot wasn't surveyed yet, because it had just come out from Washington," Godbey said, speaking of the official announcement. She didn't want a corner lot, so she chose one farther down. "I had them survey me the third lot down," she said. The idea of building private homes was so new that the Godbeys couldn't even get a list of conditions or restrictions on building.

A lack of published building codes didn't stop businesses—mostly from Las Vegas—from advertising their ability to furnish plans and building materials, including concrete block. "No Job Too Big, None Too Small," advertised Wm. M. Bickell & Co. out of Las Vegas. Bickell & Co., the builder of the Union Bus Terminal building in Boulder City, was eager to build homes "of which the owner may be proud."

While newspaper advertisements promoted plans and material with which to build homes, it was the heart of the Depression in 1932, and any money people did have went to feeding their families and keeping clothes on their bodies. Few, if any, people had enough money to pay for a house. Luckily, Tom Godbey was a resourceful man. The Edison Company had a tent mess hall close to the dam that it was getting rid of. "We got their mess hall tables which were built with pine flooring," recalled Erma Godbey. "We got the canvas and boards." As they waited for word from Washington on how they were supposed to build their new home, Tom just kept gathering materials wherever he could find them. "My husband just kept piling all this lumber, and anything he could get, by the tent."

Eventually, word came from Washington that the house needed to have a flush toilet, could not have a flat or tarpaper roof and had to cost at least $250. With all the materials gathered, the Godbeys just needed a carpenter. They found a man who had worked for New Mexico Construction and was putting a roof on the Browder Café. "We stopped and talked to him," said Erma. "He said, 'have you got any plans?' My husband said, 'No, but my wife will draw some.'" Erma did just that. She drew out the entire house on paper and then told the carpenter how long each side of the house was to be, as well as where to place the doors and windows. When the framing was finished, the Godbeys discovered the carpenter had forgotten to take into account the width of the two-by-fours when planning the total size. "I had wanted a nine-by-twelve living room, and it was twelve minus eight inches, so it was eleven feet, four inches," said Erma. "Each room was like that."

That wasn't the only issue with the house. "I didn't know where we were going to connect to the sewer, because the sewer lines weren't in yet," recalled

The Godbeys with their children Alice, Ila, Lara, Jim and Tom in front of their Boulder City home. *Courtesy of Boulder Dam Museum.*

Erma. The house was also missing some important items. "We didn't have doors," she said. "We just had the two screen doors that were on the two tents that were the mess halls that were torn down." They also didn't have any windows. "We just had screen on the side with canvas flaps." If that wasn't bad enough, the Godbeys received even more bad news after the plumbing had already been hooked up. "We wanted to know how far back to set the house," Erma said. "I said to the carpenter, 'Set it back from the curb thirty feet.' So they did." A few months later, the government came out with another mandate stating that all houses had to be forty feet from the curb. What does one do when the government tells you you're ten feet too close to the curb? "Well, we moved the house back ten feet," Erma said. Friends helped the couple. "They put two-by-fours underneath and rolled it on pieces of concrete, and set it back down again. I always had trouble with my sewer because that last ten feet was flat."

OLYMPIC HOUSES

Not all the houses used in Boulder City were built in Boulder City. Some were actually shipped in from California. These houses had the distinction of previously housing the athletes who competed in the 1932 Games of the X Olympiad in Los Angeles, California—an event held in the heart of the Great Depression. Los Angeles was the only city that bid to host the Olympics that year, and many of the athletes were unable to raise enough money to attend. In fact, attendance was less than half of the previous summer Olympics (1928 in Amsterdam) and the lowest since 1904 in St. Louis. The houses had actually been used in the Olympic Village for male athletes—female athletes, like America's Mildred Ella "Babe" Didrikson, stayed in the Chapman Park Hotel. "The Olympic Village houses were brought in temporarily to the south," said Boulder City resident and journalist Elton Garrett. Two rows of Olympic homes were used to help house the overflow of workers.

"I moved into an Olympic house," said Dorothy Nunley. "The Olympic houses were built in 1932 for the Olympics in California, in Los Angeles. Somebody was smart enough to buy them and bring them up here. They were put together later. They were built in from the highway [at] New Mexico Street, about two blocks. There was a very tiny combination front room and kitchen, and there was a tiny bedroom and a little bedroom." Like the dingbat homes, the Olympic homes had no luxuries. They didn't even have windows in the bathroom. But the resourceful residents of Boulder City were used to adapting to their environment, and this was no different. "So my husband one day took a knife and cut a window in it," said Nunley. "It was made out of something—I think they call it Celotex. It was pressed paper, or pressed wood, something like that."

LANDSCAPING

Not since Jack and the Beanstalk has there been any planting to compare with that in Boulder City.
—*W. Darlington Denit, Bureau of Reclamation controller*

Before Boulder City would be complete, ten thousand trees and nearly twenty-five hundred pounds of grass seed would make the town "an

Landscaping helped turn Boulder City into a peaceful little town in the heart of the desert. *Courtesy of Bureau of Reclamation.*

enviable city in the landscape respect," according to Ray L. Wilbur Jr., son of Secretary Wilbur. Putting a city built with bricks, asphalt and concrete in an area already scorched by the sun's rays does not make for a pleasant environment. "The reflected sun rays from the soil minerals, accentuated by the glare from the street paving and concrete sidewalks was most disagreeable and almost unendurable when coupled with the intense summer heat," said Wilbur Jr.

This could have been a recipe for disaster had not the government performed studies on the right types of trees and other foliage to plant in the city. These studies had been completed when S.R. DeBoer originally designed the town. At that time, an investigation of soil types and the possible additives needed to make the soil able to support life were conducted. In late 1931, after Congress authorized a special appropriation for landscaping, Oregon landscape architect Wilbur W. Weed was hired to landscape Boulder City. It was the appropriately named Weed's responsibility to "design and field-supervise the installation of landscaping along all streets, parks, and around public buildings."

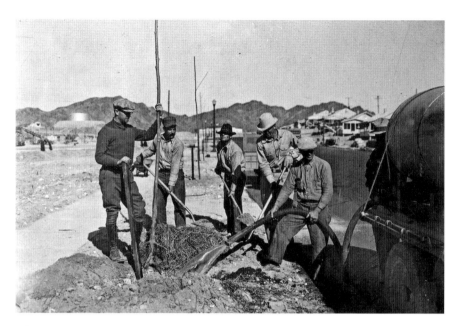

Wilbur W. Weed (*far left*) and his crew planting trees in Boulder City. *Courtesy of Bureau of Reclamation.*

Weed had graduated from Oregon Architectural College (now Oregon State University) with a degree in landscape architecture in 1921. After working the family business—Weed's Landscape Nursery—in Beaverton, Oregon, for a number of years, he joined the U.S. Bureau of Reclamation and came to Boulder City in his new capacity in December 1931. Weed spent the first few weeks studying the area and trying to determine which plants would be suitable for the desert environment. He considered species such as black locust, Arizona ash, Chinese elm, Carolina poplar, European sycamore, Guadalupe cypress and incense cedar. All of these trees had thick, leathery leaves that would make them resistant to the intense heat.

In early 1932, Weed had opened bids for nursery companies. Within weeks, arid desert was replaced with lush green lawns. "Quick growing shade trees for residential areas and small decorative trees in the business district were emphasized," according to Ray L. Wilbur Jr. In March 1932, the *Las Vegas Evening Review and Journal* reported:

> *Many thousands of trees and shrubs, now being planted, will make Boulder City beautiful....Many carloads of the greenery already have arrived and are being planted in park plats and streets. Under the direction*

Landscaping along Birch Street. *Courtesy of Boulder Dam Museum.*

of landscape architect W. W. Weed the trees will be planted in the plazas and in residential streets....Due to the absence of gypsum or alkali from the soil in Boulder City, the supplying of plenty of water is believed the only requirement to good healthy growth of trees and lawns.

Of course, not all areas of Boulder City had landscaping. Over on the other side of town, where the streets were still dirt, it was an entirely different story. "On California, and many more of the streets, the residents had planted lawns and shrubbery," wrote resident Marion V. Allen. "On Seventh Street, where we lived, they didn't want us to do that—too much water would be used—so I built window boxes on the screen porch and we planted anything we could find that stayed green." Allen's boxes didn't last for long.

It appeared that Six Companies didn't want anyone getting the idea that they should have flowers or lawns or any other type of landscaping in homes that were meant to be temporary. When its efforts to double the water rates from $2.50 to $5.00 (more than a full day's wage) didn't deter the Allens from watering their flowers, more drastic measures were undertaken. "We continued for a while until one of the company men came to see us and told us we would either have to quit watering the plants or take them inside

125

where passersby wouldn't see them," said Allen. The man told the Allens that the company was getting complaints about their flower boxes and that if everyone in Boulder City tried to have a lawn, the city would run out of water. "It was strange," said Allen, "but they never complained when people would turn their hoses on the roofs and let the water run day and night. This was the only way graveyard workers could get any sleep."

BOULDER CITY CHURCHES

The church was a real outlet for us.
—Boulder City resident Edna French

While much of Boulder City was beginning to shape into a real town, one very important ingredient was still missing: people needed places to worship. With no churches yet available, residents began meeting in a nondenominational environment in the Anderson Mess Hall, under the

St. Andrew's Catholic Church. *Courtesy of Boulder Dam Museum.*

guidance of Pastor Tom Stevenson. "People were wanting a church," said Boulder City resident Mary Eaton. "They were meeting over in the mess hall, a group of people from all denominations, and they wanted to build their own church." Bob Parker helped set up the mess hall for meetings. "Late on Sunday evenings we would clear the back end of one of the wings, clear out the tables and set the chairs back up for Parson Tom to hold a church service."

By early 1932, there were four churches "satisfying the religious need of Boulder City." Saint Andrew's Catholic Church, headed by a Father Hogan, was the first church to be built. It was located at a triangular plot at the junction of Utah and Wyoming Streets, facing the southeast corner. The Spanish-style church was constructed of concrete block with a stucco interior and had three buttresses on each side. On Sunday, March 6, 1932, the members of the future St. Christopher's Episcopal Church, headed by the Reverend Arthur S. Keane, held a ceremony on the site where the church was to be built. "A cross, the first of its kind in Boulder City, was erected on the spot," reported the *Las Vegas Evening Review and Journal*. That same year, the Church of Jesus Christ of Latter-day Saints also built a church.

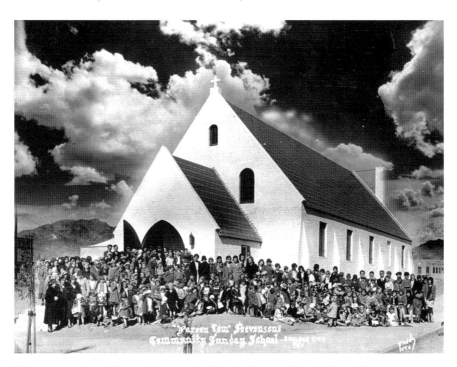

The congregation of Grace Community Church. *Courtesy of Boulder Dam Museum.*

While many congregations were rushing to erect a building where they could meet, the first church to actually hold services was the Grace Community Church, headed by Tom Stevenson. Previously the minister at Ragtown, it was Parson Tom's mission to "carry out the idea of making religious service of use in practical every day [*sic*] life," according to the *Las Vegas Evening Review and Journal*. "He was a nice man," said Mary Eaton. "He was just a big ol' country boy. He was very good to work with the children."

"When we came up here, there was a Young Matron's class, and everybody went to that," recalled Boulder City resident Helen H. Holmes. "We had around 120 members. We had a very active membership," said Rose Lawson. "That was our social part. We had the most marvelous programs or plays we just put on. It would be like you lived in the country, when you'd have a community program," said Holmes. "We gave so many parties," said Lawson. "We gave money-making affairs. We gave a real fine circus every year. Lots of activities going on all the time."

Grace Community Church would eventually hold baptisms in Lake Mead, the body of water created by the damming of the Colorado River. "All my children were baptized in Lake Mead," said Holmes. "Because they were born here, because their Dad worked on the dam, it seemed to them such a deeper feeling of pride, I guess you might say."

BOULDER CITY SCHOOLS

We felt like the school in Boulder City was a very good school.
—Boulder City resident Edna French

Secretary Wilbur envisioned a model city, but he neglected one important element. His workers would have families, and those families would have children, and those children would need an education. While there were plans for businesses, houses, recreational areas and even churches, nowhere in the plans for Boulder City were schools. This seemed like a large oversight on the part of a man who had dedicated much of his life to education. "The school year rolled around, and there were no schools," recalled Elbert Edwards, a Las Vegas high school teacher.

The federal government had made no provisions for schools. They said schools were a state responsibility. Normally Boulder City would have

qualified for elementary schools, except for the fact that the land on which Boulder City was built had been set up as a federal reservation. There was a question as to the where the Nevada laws operated.

Parents were left with little options. The only schools available were in Las Vegas, and there were no buses available to take their children to these schools. More important, Las Vegas was under no obligation to accept children who didn't officially live in a Nevada town. Irritated parents decided not to wait for an answer from the government. Several Boulder City residents were schoolteachers, and they began holding classes for their own children. One of those women was Zella B. Larson, who began teaching her daughter Shirley Jane in her home. The word spread. "The neighbors learned, 'She's teaching her kid; why can't I send mine?' Pretty soon here is a classroom of 15, 20 kids sitting on benches," said Elton Garrett. On September 16, 1931, Larson opened her school with eighteen first and second graders. At the end of the first week, she had added three third graders.

A school had already been established in McKeeversville, and other squatters' camps had their own makeshift schools. Looking to help, "Six Companies decided they would turn over three of their houses for schools," said Boulder City resident Erma Godbey. "Some of the ladies here in town who had taught school before would be the teachers. We didn't have books or anything, just whatever anybody happened to bring with them, and everyone came with very little." A parent-teacher association was formed, and other teachers were brought in. Maxine Provost came from Phoenix, along with Margaret Hunt, who had "recently graduated from teachers' collage in Reno." The *Las Vegas Evening Review and Journal* reported on March 11, 1932, that "there are now 35 first graders, and more coming every week." Parents were charged five dollars a month per student and another four dollars per month for additional family members. Desks and chairs were made and donated by the Boulder City Company (Six Companies), which also furnished stoves and fuel. "Charles Williams and Floyd Currie built swings and other playground apparatus," the paper reported. Soon the little schoolhouses were functioning like real schools. The only problem was that they were not recognized by the State of Nevada.

By 1932, the government realized it had a problem. There were nearly five hundred children going to school in Boulder City, and the few school facilities that existed were becoming overcrowded. Faced with a dire situation, Secretary Wilbur went to Congress and requested $70,000 for the construction and maintenance of a school, teachers' salaries, supplies

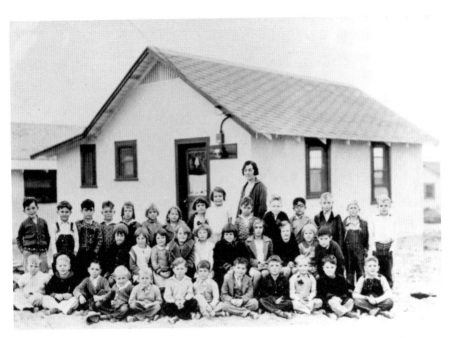

Zella Schooler Larson and her first-grade class in a Six Companies house converted to a school. *Courtesy of Bureau of Reclamation.*

and materials. With more than 80 percent of the children belonging to Six Companies employees, the company was persuaded to pitch in $18,800 to the cause; it was enough to get Congress to approve the measure. On May 26, 1932, I.M. Bay construction company was contracted to build a school and was given a one-hundred-day deadline. It was a deadline the company would miss by only twenty-three days. On Monday, September 26, 1932, Boulder City's first official school opened on the north side of Arizona Street and California Avenue, across from the Municipal Building.

Three rooms in the new school were dedicated to high school students. The salaries for the two teachers of these students were paid for by Babcock & Wilcox. The administration and operation of the school—including the selection of the teachers—fell squarely on the shoulders of city manager Sims Ely. "He had a lot to do with hiring the teachers," said Elton Garrett, "with the assistance of people like Walker Young. It happened. He helped line it up. He got Six Companies, Inc., to pay the teachers one year." Instead of taking the teachers the city had already found, Ely published a call for teachers throughout the United States. The only requirements were that the teacher be unmarried and show an "unusual intelligence, earnestness, and a high standing in scholarship." The "unmarried" requirement was

largely ignored. Ely chose seven elementary teachers and two high school teachers—one of the nine teachers served double duty as the principal.

The school lasted about a year before a new secretary of interior was named. Secretary Harold Ickes turned educational control over to the State of Nevada, and on August 28, 1933, the Clark County Commission created Boulder City School District No 1. Ickes leased the building to the school district for $250 a month but continued the maintenance, supplies and materials. The school district provided the salaries to all teachers, who were required to get Nevada licenses.

4

LIFE IN BOULDER CITY

I've been exceedingly happy all my life and I'm sure that started in Boulder City.
—Alice Dodge Brumage

The *Las Vegas Evening Review and Journal* reported:

> *Boulder City is a well-ordered and thriving community, complete in every essential but still growing—one year from the starting of actual construction of Uncle Sam's wonder city. The community is now in the midst of an era of construction of business houses and homes, with 16 or 18 business houses going full tilt and half a dozen more under construction, all of permanent construction with attractive arcades across the wide concrete sidewalks to shade passersby from the sun in summer.*

While the newspaper did its best to paint a rosy picture of the little town, the first impressions of many eventual residents weren't quite so positive. "I thought this was the weirdest place I'd ever seen," recalled Dorothy Nunley. "It was going night and day; everything was open all night. I wasn't used to a town like that. The houses were all alike. There wasn't any landscaping except at the government houses and the government lawn. I thought I could never stand to live here." Alice Hamilton agreed. "We arrived in a dust storm. The road from Las Vegas to Boulder City was just a dirt one-track road. Boulder City was bare of greenery. I was aghast! It was terribly warm. I really thought I had come to the jumping-off place." But even these

future residents would eventually fall to the charm that was Boulder City. There were still some issues that would need fixing. But as Walker Young and Frank Crowe had envisioned, as houses were completed and businesses started, Boulder City was becoming more than a town, it was becoming a community—a community that would need a manager.

RUNNING THE TOWN: SIMS ELY

Any success that has attended the handling of the town's affairs has been due to the luck I have had in carrying out departmental policies in a common-sense way.
—Sims Ely

This was going to be tricky. The man standing before him had been found in possession of a bottle of whiskey at a dance the night before. Unfortunately, that man was also the assistant superintendent of Six Companies, Inc. The man was also a belligerent fool who had demonstrated as much many times in the past to the men working under him. Still, this was the first time he was caught with alcohol—the punishment for such was expulsion from the reservation. If he expelled the man temporarily, he risked looking like there was one set of rules for the workers and another for their bosses. On the other hand, expelling a man who played a key role in the construction of the dam could possibly cause delays and disrupt the organization of Six Companies.

Sims Ely brought the contractors in and explained the decision he was up against. "If the offender is prominent in the public eye," he told them, "a special reason exists for treating him with no more leniency than is handed out to the humblest worker; otherwise the whole policy of law enforcement is brought into disrepute." Then he pronounced sentence. The man was to be expelled from the reservation for a period of thirty days. This more-than-just sentence proved to be of "great moral value to the workers on the project," wrote Ray L. Wilbur, son of Secretary of Interior Ray Lyman Wilbur.

In the early planning stages, it was decided that Boulder City would be a federal reservation instead of a local municipality. A three-member advisory commission would be appointed, with the city manager running the city. Two of the members would be chosen by the government, with the third being a representative of the contractor (Six Companies). On March 1, 1931, the Department of Interior put out a bulletin, signed by Commissioner Elwood

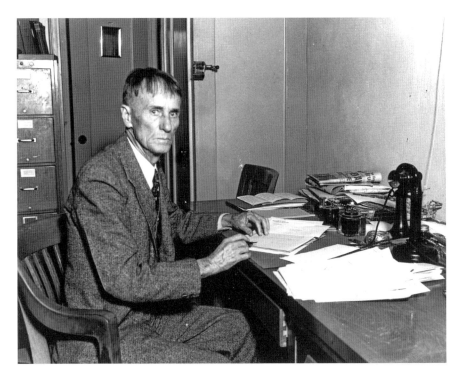

City manager Sims Ely. *Courtesy of Boulder Dam Museum. Union Pacific Railroad Collection.*

Mead, that stated, "A city manager will have direct charge under supervision of the commission, with the necessary assistance of guards or police officers clothed with the required authority under federal or State laws." On October 2, 1931, sixty-nine-year-old Sims Ely was appointed to that position by Secretary Wilbur. He arrived in Boulder City one day later.

Sims Ely had been the head of the board of equalization, the board of control and the railroad commission in Arizona. He played a part in the drafting and presentation of legislation for the state of Arizona and California and the National Congress on the storage and distribution of the water from the Colorado River. He had served as editor of the *Arizona Republican* and was the director and treasurer of the Federal Land Bank of Berkley, California. Additionally, Ely represented Arizona in the negotiations during the Colorado River Compact. More importantly, Ely was a close friend of Secretary Wilbur, so much so that Sims's son Northcutt was Secretary Wilbur's personal assistant.

Ely took on what was likely to prove a thankless job. In addition, he had way too many bosses. He was responsible to construction engineer Walker

R. Young, Commissioner of Reclamation Elwood Mead, Secretary of Interior Ray Lyman Wilbur and, ultimately, the president of the United States, Herbert Hoover. Ironically, President Hoover would technically be responsible to the very people who would not have a say in how their own town would be run. While he was tasked with managing the town, Ely wouldn't have many of the responsibilities common to a city manager. He wouldn't be able to choose his own personnel—that would be taken care of by the U.S. Civil Service. He wouldn't handle budgets—that would be the responsibility of Young, Mead, Wilbur and, of course, Congress. He wouldn't even be handling purchasing—that would also be taken care of by Walker Young.

While there was a lot of things Sims Ely wouldn't do as a typical city manager, he did have quite a bit of power. In fact, he was given "broad discretionary powers in all matters pertaining directly to his official duties, with responsibility for the initiation and development of an efficient plan of city management." Sometimes, his duties entailed the enforcement of laws. "Sims Ely was the judge and jury, and he really enforced those regulations when someone had a serious infraction," recalled reporter and Boulder City resident Elton Garrett. "Probably one of the reasons Boulder City was such a nice place to live was due to the managership of Sims Ely," said resident Marion V. Allen.

It wasn't just Ely's job to enforce the laws; he made some of his own—many following the preferences of Secretary Wilbur. "He established the rule that there was to be no liquor, no gambling, no prostitutes," recalled Walker Young. "That rule stuck. That was the rule that I respected all my life while I was there." Besides keeping the peace, it was also Sims Ely's job to "receive and consider applications for permits for businesses or residential purposes within the town." In other words, if you wanted to build something, open something or conduct any business whatsoever in Boulder City, it had to be approved by Sims Ely. He was even charged with investigating "the living conditions of the laborers hired by the contractors" and correct any conditions that needed correcting.

"A hasty glance at the way some of his administrative problems were settled reveals how, for once in running a city, common sense has been the main point, and not political favors or strict legal rules," wrote Ray L. Wilbur Jr. Sims Ely had a unique perspective on life, one that he brought with him to the job. He truly believed that no worker on the reservation "gained any right of ownership in his job through the mere fact of working." In fact, he believed the worker had a responsibility to be a good, law-abiding citizen.

He also believed that every man should take proper care of his family and anyone else who was dependent upon him. This is evident in a rule he once passed down that allowed a man to return to work so long as that man promised to write his wife and child and send "a certain sum semi-monthly." Ely said, "If he would be a man thereafter, he would feel that his action and the time he had taken to write this letter were worthwhile."

While Ely believed in the law, he also believed that good judgment and a fair hand played an equal part. That doesn't mean he was lenient—just fair. On one occasion, Ely and the chief ranger went to the shack of a man who had been expelled from the reservation. After checking to make sure the man left behind nothing of value, he ordered the shack burned to the ground to prevent anyone else from squatting there. He even stayed until there was nothing left but ashes. Sims Ely kept a close eye on all parts of the town. On one occasion, after receiving a complaint of "poor vegetables" being sold in a store, he went to the store himself to have a look. After examining the produce, he made sure all complaining parties received their money back.

Not everyone was happy with the way Ely managed the town. Many of the children especially were afraid of him. "He was not a nice man," said Lara Godbey Smith, who grew up in Boulder City. Alice Dodge Brumage, who grew up in nearby McKeeversville, agreed. "He was something else," she said. "He was scary and he ruled with an iron hand." That view of him by children was likely due to one of his most stringent rules. To ensure that children didn't stay out on the streets past a decent hour, Ely had a horn blast made at nine o'clock every night. The horn warned every child sixteen and under that it was time to get off the street and head home. One worker even tried to sue him after being expelled. The man, who had hired a lawyer and was threatening a lawsuit, was told by Ely to "go ahead" and sue him. That was the last Ely heard of the man. "Ely was a very, very hard man," said John Cahlan. "He sat up there on the throne. Sims Ely was made a virtual czar. There was nothing that went on that he didn't handle."

Running a federal reservation was a hard job, and Ely had to deal with daily problems the common resident of Boulder City couldn't even imagine. This is why some people saw only the façade Ely created. "It seemed to me he was a hundred years old," said Boulder City resident Thomas Wilson. However, Ely had a softer side, which he allowed to come out every once in a while. This was seen by residents Erma and Tom Godbey when a cow they owned made its way into the downtown area. The rangers managed to capture the cow and place it in the fence behind their station. "And, of course, Sims was right there in the office too, in the Municipal Building,"

said Erma Godbey. "When Tom went up to get the cow, Sims comes out and he said, 'Well, leave it here until after the kids go back into school. They're all having such a good time talking to it through the fence and petting it and everything. Wait until the noon hour is over.'" The event helped Godbey see Ely in a different light. "So he wasn't such a bad old guy," she said.

Ray L. Wilbur Jr. said of Ely:

> *In a way, one test of Mr. Ely's success is the fact that he is one of the very few appointees of a Republican administration in the Interior Department who still held office under the present strongly New Deal administration. He has done his job so well and the personal relationships he has built up with county and state officials are so important to keep, that no sound reason can be found for relieving him of his office.*

Of course, Wilbur Jr. may have been biased, since Ely was hired by Ray L. Wilbur Jr.'s father and Ely's son worked for the secretary. Still, the length of time Ely held the job is probably the best testament to his success. From the time he was appointed in 1931, he served as city manager until April 16, 1941, nearly ten years later, when he retired at the ripe old age of seventy-nine. Additionally, once Ely retired, the position was abolished in anticipation of the town being passed to the State of Nevada.

POLICING THE RESERVATION

During its phenomenal growth and unceasing change of conditions there have been no disturbances of consequence, no major crimes, and no serious interruption in the construction of Hoover Dam.
—Las Vegas Evening Review and Journal

Being a federal reservation, Boulder City didn't have an actual police force. Instead, it had rangers who were federally commissioned and deputized by the sheriff of Clark County. Led by Chief Glen E. "Bud" Bodell, the rangers policed both Boulder City and the dam site. Bodell was an automobile racer who had turned to law enforcement. His iron-fisted method, as well as his physical stature, earned him the nicknames "Butcher Bodell" and "Little Mussolini." Bodell walked around in riding britches, cavalry boots, a dark brown shirt and his very distinguishable Stetson hat. His Sam Browne belt

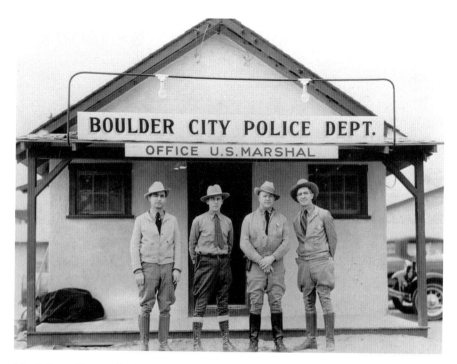

Marshals standing outside the Boulder City Police Department. *Courtesy of Bureau of Reclamation.*

was adorned with a large ivory-handled revolver that he wore high on his hip. Bodell earned his nicknames, averaging nearly three evictions a day according to a U.S. Bureau of Reclamation report that stated 1,056 people had been labeled undesirable in the period of time between October 1931 and October 1932. "Mr. Bodell was the only fearless man that I believe I've ever known in my life," said Bodell's secretary, Alice Hamilton. "I've never seen him afraid of anything." Six Companies also maintained a security force in Boulder City. In 1932, Bodell left the rangers and took charge of that force. "Bud Bodell was chief investigator and in charge of security for the Six Companies," said Hamilton.

The real power behind the badge was city manager Sims Ely. No court system was ever created in town; all disputes were either decided by Ely or by a justice of the peace in Nelson, Nevada. Anything that went to Nelson was restricted to small claims and petty offenses. "When the ranger had someone accused of something, they took him before Sims Ely, the city manager, who as a one-man official really ran the town," said journalist Elton Garrett. "He would tell the men, 'Here's what your penalty is,' and it might be, 'You're

going to leave the reservation. You've lost your job.' The company didn't lose him his job—the judge did. And that was Sims Ely."

Sims ruled with an iron fist and had total authority. "I'll never forget Sims Ely," said Boulder City resident Mary Eaton. "Whatever he said, that was the law. He had unlimited power." Mary's husband, Bruce, agreed. "Sims Ely had full authority to govern Boulder City," he said. "He was the judge, jury, the prosecutor, and the defender." It was a position that had a tendency to make him hugely unpopular. "He incurred the wrath of some people at times by that directness and that decisiveness," said Garrett. "He was a dictator in the city. He made the rules. If you broke the rules, you went up before Sims Ely," said Boulder City resident Carl Merill. "He was a hard man," said Carl's wife, Mary Ann. "I guess he was fair in a lot of ways, but he had his own ideas and he put them into practice. And you had to go by his rules. He thought of it as his town. I've heard that said so many times: 'This is Sim's town.'"

However, like many residents, Bruce Eaton respected Ely. "To my knowledge, he didn't abuse his authority. He was a good administrator. I had lots of respect for him." Mary Ann Merill saw the need for strictness in rules. "You had to have regulations," she said. "There were so many oddballs that would come in. You didn't know whether they'd been murderers or what they'd been." Bruce Eaton agreed. "Generally speaking, the people in those days especially who followed construction work were not pansies. They were rough and tough." Ely would let people stay in Boulder City for three days without having a job. After that, they had to leave, unless someone could vouch for them. Even then, if one couldn't obtain gainful employment, he had to leave.

DOING BUSINESS IN BOULDER CITY

The dam site became thick with people, all with one thought in mind, a job. Others were there with rackets and schemes to separate the workers from their money.
—*Hoover Dam worker Marion V. Allen*

Secretary Wilbur hired Michigan lawyer and former congressman Louis C. Cramton to plan Boulder City's business permit system. "Knowing that a depression was affecting the whole economy, and knowing that there would

be a rush of businesses if it was open for everybody, the planners did establish a permit system," recalled Elton Garrett. Class A permits were exclusive, allowing only one business. This was limited to such things as utility and phone companies. Class B permits allowed for two or three of the same types of business. These permits were issued to such things as wholesale and retail stores. Class C permits were issued to businesses, such as banks and gas stations, that had no restrictions on the number allowed in the town. Class D permits were restricted to professions such as doctors and lawyers.

The purpose of the permit system was to keep the city from being overrun, to control prices and to, as much as possible, limit fraud. "Each field of activity had a number of units that could be set up in Boulder City," said Garrett. The "number of units" was usually two. This meant there would be two barbershops, two grocery stores, two hardware stores and so forth. "If you wanted a third barbershop, you put in your application, but the choice is made," said Garrett. "Here are those that qualify, the rest of you, no."

Not all types of businesses were limited to two. "The number of cafés was more than some of the other types of businesses," said Garrett. And some businesses, such as beauty parlors, were allowed to be operated out of homes. "Nelle McDougal is one of Boulder City's beauty culture workers, operating in all lines of the art from her residence at 600 Avenue G," reported the Boulder City edition of the *Las Vegas Evening Review and Journal* in March 1932. However, most businesses, after they were issued a permit, were expected to erect their own buildings. On May 18, 1931, the government announced that

Boulder City business under construction. *Courtesy of Bureau of Reclamation.*

it "will not erect any buildings for commercial use or for residence for any but its own employees. Permittees engaging in business in Boulder City will be obligated to arrange for their own business and residence quarters."

Who did and did not receive a permit was up to city manager Ely. Decisions were made on such qualifying factors as financial stability, history of operating a business, the ability to operate a business in a new town and moral aptitude of the owner. Ely didn't want anyone putting up a front while selling illegal substances, such as alcohol, or running prostitutes in a back room. In fact, the lease issued by the city itself protected against such vices, stating,

> *If any premises…shall be used for the purpose of manufacturing, selling, or otherwise disposing of intoxicating liquors as a beverage, or for narcotics, or habit-forming drugs, or for gambling, prostitution, or any other unlawful purpose…or if loose or immoral characters shall be sheltered thereon…all rights…shall terminate.*

Allowing business to come to Boulder City was shown in a positive light by the *Las Vegas Evening Review and Journal*, which reported, "By allowing businesses to be established in Boulder City, the inhabitants are assured of equitable prices thru the restrictions imposed by competition." The paper also showed its support for the permit system established by Cramton. "On the other hand, if the town had been thrown open to all comers the effect would probably have been disastrous financially to the greatest percentage of those entering the business."

Businesses, or spaces to establish a business, were not sold in Boulder City. Instead, all businesses were leased to the people running the business. As Commissioner Elwood Mead pointed out, "With a sale you can enforce the law, but it would be better to have a lease system where a violator could be put out." Additionally, in a congressional hearing on May 19, 1930, Secretary Wilbur pointed out that it would be "more profitable to the government to sell the lots at the enhanced value" than to sell them then, "with no value except as a piece of desert." Leases were not to exceed twenty years and included an opportunity to renew the lease or for the lessee to purchase the property at the end of the lease. Each lease had a clause that gave the government full power to cancel the lease if it deemed the business or the lessee to be unsatisfactory. This was done specifically to prevent a business from trying to sell alcohol or engaging in gambling or prostitution. The lease would only, therefore, continue with the "good behavior" of the

tenant. Good behavior was defined, at least in part, as the observation of the rules and regulations, not subletting or assigning the lease and not storing explosives or inflammables on property.

BOULDER CITY BUSINESSES

Boulder City may be likened to a desert mirage that has become a reality.
—1935–36 Las Vegas, Boulder City, Overton phone directory

By early 1932, the building of Boulder City was in full swing. Close to one hundred permits were issued to businesses and individuals to construct buildings other than those erected either by the government or Six Companies. B.B. Thompson from Hobbs, New Mexico, had opened a shoe repair shop with "modern, electrically-operated machinery." Nevada Jewelry Company promised its new, complete stock of jewelry and silverware would "be sure

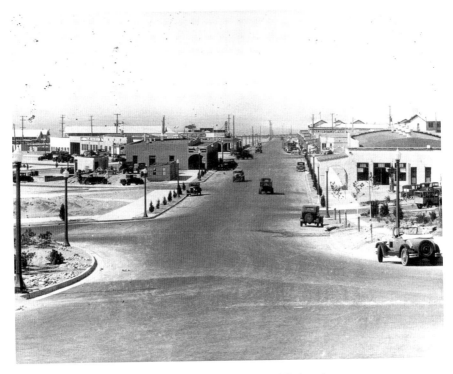

The business section of Boulder City. *Courtesy of Bureau of Reclamation.*

to please." Parson's Bar-B-Q was scheduled for opening on March 12, telling residents "You'll enjoy the delightful atmosphere of 'Bar-B-Q', Flowers, N'everything." And Boulder City Motors was inviting "Mr. Car Owner" to "make Boulder City [his] headquarters," promising a "modern, completely equipped plant." Marion Allen wrote of his first impression of a town under construction. "I thought 'in all my years I have never seen such a desolate and discouraging sight.' I now wonder, if I hadn't been broke, would I have stopped? I think I would have for there was a certain kind of excitement about all this action out in the middle of the desert."

To promote the town and its progress, the newspaper placed articles such as "Electrician Aids Building Boulder," in which was written:

> *C.E. Smith, electrician, points with pride to his achievements in the electrical field in rapidly-growing Boulder City. He has done complete electrical work for Roy Fairbanks's building, Laubach's clubroom, Thompson's shoe shop, Goodrich auto court, Parson's Bar-B-Q, Boulder City Builders Supply Store and the Troy Laundry office.*

Ida Browder's Café

One of the most famous of all the businesses in Boulder City was Ida Brower's Café. Ida M. Browder was born to noble blood on January 10, 1889, in Krunstadt, Austria-Hungary, a countess with a long family history and a name to match. "It is a very long name and very difficult to spell," she told a reporter in 1948. "And besides, this is America. Such things mean nothing here." Even from an early age Ida longed to see America, an inspiration gained from an American private tutor she had growing up. She made it to America before World War I, eventually marrying Marbus Dean Browder, a civil engineer, in Alexandria, Virginia. They had two children, Marbus Jr. and Ida Katherine.

When her husband died in 1930, Ida was left with little choice but to make her own way in life. As with everyone else in America, Ida heard about the dam and the little city being built to house its workers. Sensing an opportunity and feeling "it would be a good, safe place for the children," she moved to Boulder City from Salt Lake City, Utah, and got a permit to open a café at 552 Nevada Highway. While the building was under construction, she shipped an army tent she had in the home she kept in Salt Lake to

Ida Browder's Café under construction. Note the tent to the right of the building. *Courtesy of Bureau of Reclamation.*

Boulder City and set up camp on the lot where her business and home were being built. "The tent had been used by her son for scouting activities and boasted a wooden floor, walls made of boards, and a small stove," wrote Fran Haraway for *Nevada Women's History Project*.

"They were all so very nice to me," Ida said of the engineers who installed a pipe to give her water and strung a wire so she could have electricity. In December 1931, though the building was not yet complete, Ida decorated the place, set up a Christmas tree and held a dinner for some of the engineers on the project—cooking the food herself. That was the start of Ida Brower's Café, a business that never officially opened. "We had that first Christmas party, and they just kept coming from then on," she explained. While it wasn't official, the local newspaper did announce an opening, saying, "Home cooking and individual table service are the principle features of the new lunch room and café which has been opened by Mrs. Ida M. Browder on Nevada Boulevard near Ash Street. Mrs. Browder had her own building constructed for the café and has arranged every feature for convenience and good taste."

It didn't take long for Ida to become somewhat of a mother to the men working on the dam, so much so that she was often referred to as Mother

Browder and was routinely remembered by them on Mother's Day. Not only did Ida run one of the first businesses in town, but she was also a trusted safe keeper for many of the workers' earnings. "When the boys would come in after payday and want her to keep some of their money, she would put it under the mattress and keep it for them to keep them from going and drinking it down in Vegas," said Elton Garrett.

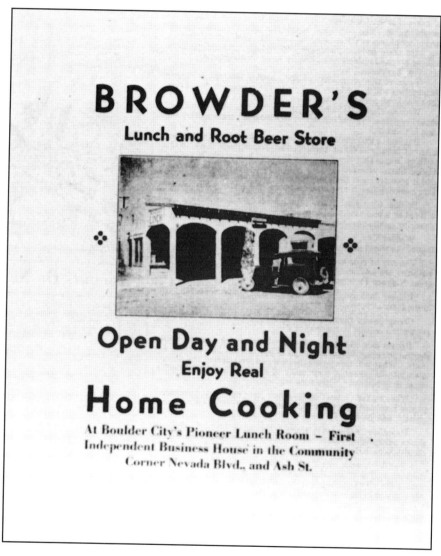

An advertisement for Ida Browder's Café in the local newspaper. *Courtesy of* Boulder City Journal.

Boulder City resident Erma O. Godbey recalled a time when a dance was being held downtown. "A bunch of ex-servicemen decided, 'We'll have a dance in Laubach's Recreation Hall.' They got the key. All that was there was just the cement floor, the bare building, and they did have a part of the bar built. But no chairs, no anything else in there. So we got some music and we had a dance." The recreation hall was across the street from Ida's Café, so she invited the revelers over for coffee and cake at midnight. While the couples were having fun inside, it began to rain outside. "It just rained cats and dogs," said Godbey. "Water was just running down this street and down [Avenue] B." The women really weren't dressed for the rain, so the men picked them up and carried them across the street to Ida's. "We all went over to Mrs. Browder's and had some coffee and cakes."

Ida had a setback in 1932 when her son Marbus contracted spinal meningitis at age thirteen. Though she rushed him to Salt Lake City and he received the best medical attention possible at the time, he died on June 24, 1932. It was a devastating loss. Ida took her young son's body and buried him next to his father in Sacramento, California. After the death, Ida returned to the town she loved, and just as she did when her husband died, she carried on—and then some. In memory of her son, Ida convinced Dr. Elwood Mead, the Bureau of Reclamation's commissioner, to get the Library of Congress to donate three thousand books to Boulder City. Ida used the books to supply the first library, which was named the Marbus Browder Memorial Library.

Ida eventually expanded her café to an entire building that started at 550 Nevada Highway and went to 558. A staunch Democrat, Ida often hosted discussions in her living room at the back of the café. "They were all welcome," Ida would say with a sly smile. "Even if some were Republicans." Ida would go on to become one of Boulder City's most prominent citizens. She helped organize an American Legion Auxiliary (in her living room), and was chairman for the first Mother's Day program held by the auxiliary. The first Parent Teacher Association (PTA) was formed at a meeting in Ida's café, and the Veterans of Foreign Wars (VFW) post was organized in her dining room.

She organized the first Clark County President's Birthday ball, the Girl Scouts, the Women's Club and the county unit of the March of Dimes for infant paralysis, which she headed for four years. Ida was a delegate to the Clark County Civic Service Federation. She was the first woman elected to the school board and was part of a committee that tried to get a college started in Boulder City. Ida helped start the high school and played a significant role

in establishing a music department in that school. She also helped found the Boulder City Chamber of Commerce and served as treasurer. She served on the Democratic county and state central committees and was on the Nevada committee for the New York World's Fair.

THE GREEN HUT CAFÉ

Ida Browder wasn't the only one to open a successful café. Clarence Newlin had one as well. "In those early days the Green Hut was considered a first-class restaurant with its dining area and its long, long counter and stools," said Madeline Knighten, whose husband worked at Green Hut. "When you came in the door, you were faced by a lovely potted palm. It was really classy for Boulder City in those days." The café's first-class status was no accident. Newlin bought the very best ingredients so he could make the very best food, and the café had something that in Boulder City made it very special. "The Green Hut was air-conditioned," said Hazel Allen, an employee.

"My manager's daughter, Jane, and I used to get up and wrap about a hundred and eighty sandwiches for the men who worked on the Edison Power line," said Allen. "Then, of course, we had our regular breakfast, and our lunch. I worked a 21-stool counter. And of course, we had a lot of the men come in at night for dinner. And families too." While the café was very successful, it did have a bit of a reputation, or rather its cooks had a bit of a reputation. "Every Sunday morning we passed the hat to get money enough to pay the fine to get [the] cook and his wife out of jail," said Allen. "They'd get drunk on beer; we would bail them out. But, you know, we always got our money back or they didn't get their checks."

THE THEATRE

Earl Brothers built the Boulder City Theatre, which opened its doors on May 14, 1934, at 1225 Arizona Street. "The only amusement there was the movie house," said Boulder City resident Alfred Baker. "Good Lord, they'd be four deep lined up a block long every show. Boy, that was a gold mine, that little theater." Brothers ran a theater catering to a twenty-four-hour town. "They had one [movie] in the morning for graveyard or swing; then they

had one in the afternoon and two at night," said Baker. "Mr. Brothers, who was the manager of the theater, started his shows at eleven in the morning so that the men who went to work at three in the afternoon could come in and watch a movie or sleep, whichever they would rather, until the time to go to work," said Boulder City resident Lillian Whalen.

Because the Brothers theater was cooled, it became an oasis in the hot summer. "Our summers were terribly, terribly hot, and we didn't have any way of cooling except by fan," said resident Edna French. "He had some sort of cooling system. It was nice and cool in there." Brothers was also well liked. "Earl was such a jolly fellow, and everybody liked him very, very much," said Erma Godbey. Brothers gained this affection by several of his actions, including allowing children into his theater in the hot summer months. "Mr. Brothers was so good to the children during the summers here," said French. "Mr. Brothers would open his theater in the afternoon and invite the children down there." Brothers also held raffles once a month on Saturday, giving away tickets to movies or sometimes even money, and he allowed the schools to hold graduations in his cooled theater.

Bud Bodell said:

> *I had only one felony in the time that I policed* [Boulder City] *for the government for two years. Two dam workers robbed the theater owner, taped and bound his wife when he came home, and stole his car....I got them*

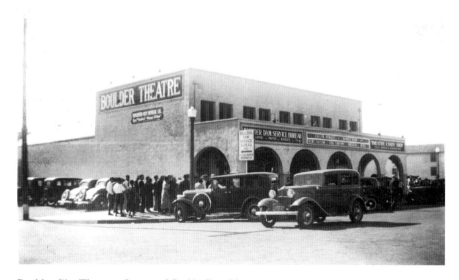

Boulder City Theatre. *Courtesy of Boulder Dam Museum.*

within an hour in Las Vegas. They'd see [Brothers] *carrying that sack of money home every night.*

But Brothers did more than just run the theater. "He took all kinds of responsibility off our hands," recalled Walker Young. "He was always a help, never a hindrance. His family, a nice family, we met all of them, he ran a good theatre." Brothers established the visitor's bureau. "Earl Brothers was one of the drivers who not only built a theater and operated it, but he got into publishing and visitor center business by designing and getting permission for the Visitor's Bureau where photos of the construction of the dam were shown in a little theater," said Boulder City resident and journalist Elton Garrett. Brothers also had an "establishment for selling films" down at the dam site.

Garrett also worked for Brothers for a time. "I was one of his guides taking parties from the Visitors' Bureau down to the point to look down and see where [the workers] were building the dam. It was fascinating…we'd walk over to the rail and look down and explain it to them." Brothers and his wife ran the theater and visitor's bureau "until they were divorced and she got the theater and he got the Visitor's Bureau," said Garrett. Brothers would also eventually have his hand in the establishment of Boulder City's first bank.

The Post Office

On April 15, 1931, a little sixteen-foot by twelve-foot, crudely built, pine-board shack was opened as a fourth-class post office. Less than a year later, it became the fastest-growing post office in the United States. "Boulder City's post office has had a phenomenal career probably never before even approached in history," reported the *Las Vegas Evening Review and Journal* in March 1932, "from a pine shanty to a fine permanent building in eleven months." Acting postmaster J.L. Finney started the post office with $250 worth of stamps and no stamp-canceling machine. The first mail he received consisted of a single small bundle.

By the end of the first month, the little post office had gone through all $250 in stamps and did $7,700 worth of money orders. By July, it had been upgraded from a fourth-class to a third-class post office. In September 1931, it was moved to the Boulder City Company office building. It was a fortuitous move, as Christmas 1931 brought ninety-five sacks of mail, all of which had to be distributed to the citizens of Boulder City.

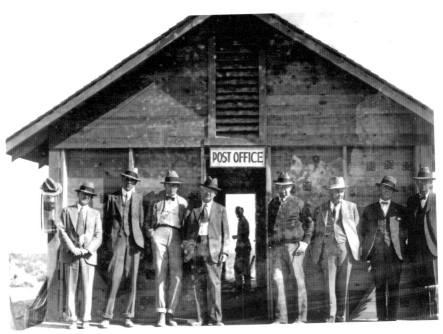

Secretary Wilbur (*second from left*) and other men standing outside the original Boulder City post office. *Courtesy of Bureau of Reclamation.*

Three months later, the post office moved for the third and final time, taking up residency in the newly constructed Municipal Building. With that move came the permanent appointment of Finney as the postmaster. "The new post office has roomy, well ventilated, cooled quarters," reported the *Las Vegas Evening Review and Journal* in March 1932. "There are nine sections of boxes containing 840 boxes, and Postmaster Finney estimated that 500 more could be used." By March 1932, nine clerks were handling $45,000 in money orders and $15,000 in stamps every month. They were handling three large letter pouches and twenty sacks of regular mail, and while mail was sent out from the post office once a day, it received mail coming to the town twice a day.

THE TERMINAL

Located near the junction of Nevada Way and Arizona Street was a terminal for the buses both coming to and leaving the town and the town's

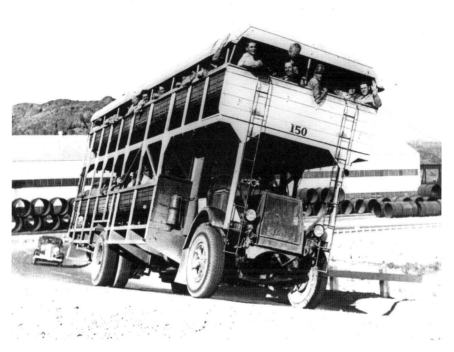

A full Big Bertha headed to the dam site. *Courtesy of Bureau of Reclamation.*

taxi services. But because Boulder City was designed to be easily accessed by its residents, most people just walked around town. While the railroad carried supplies to Boulder City and then to and from the dam site, there were no passenger services. For this reason, the railroad was located to the northwest of Boulder City—far from the center of town.

Workers were transported to and from the dam site not by train but in large, double-decker trucks designed specifically to carry men. Nicknamed "Big Bertha," the trucks were modified in Boulder City to carry 154 workers. The modifications made Big Bertha top-heavy, giving her a nasty habit of leaning mightily to the side when heading around corners, looking as if it would tip at any minute. Traveling down the tight, winding road to the dam site, a man almost had to be braver to ride the trucks than to work on the dam itself. "Of course the top was nicer riding," said Marion Allen. "You got the air."

THE BOULDER DAM HOTEL

*The national interest in the building of the dam should bring
large numbers to view the finished structure.*
—Las Vegas Evening Review and Journal

Secretary Wilbur had a vision of what Boulder City would become long before the first road was graded or the first brick was ever put in place. He envisioned his model city would eventually become a "sizable tourist town," and with a main transcontinental highway scheduled to come in from Arizona, Boulder City seemed poised to fulfill the secretary's vision. Additionally, Wilbur knew that dignitaries and government officials would be coming to Boulder City to see the modern marvel that would be the dam. However, if tourists were going to come to Wilbur's Boulder City, they were going to need a place to stay, and that meant a hotel.

In 1932, plans were made to build a seventy-four-room hotel to be placed in the heart of Boulder City. A permit for the hotel, which was slated to be called the Boulder Inn, was issued to W.F. Grey and his wife, Virginia Lamberson-Grey, on April 2 of that year. As plans for the hotel were announced, excitement in Boulder City heightened. The *Boulder City Age* reported:

> *Sounds too good to be true. A first-class hotel capable of caring for large parties of visitors has been the crying need of the community. The hotel, if built as planned at present, will be larger than the New Apache hotel in Las Vegas. Mr. and Mrs. Grey are to be commended for their initiation of this worth-while project.*

The Grays chose two potential sites to place the hotel. One was on the hill just to the left of the administration building, and the other was diagonally opposite the theater. The first site offered a view of the large lake that would be created when the dam was complete, as well as a panoramic view of Boulder City itself. On the other hand, the second site was practically in the center of the town, making it very convenient. For a while, it looked certain that the first site would be chosen. "Commanding an impressive view and overlooking what will be the greatest lake backed up by the Hoover Dam, the Boulder Inn will be built on the top of a hill just west of the government administration building," the *Boulder City Age* reported. The paper also reported that construction of the hotel would begin in about a

month and be finished by September 1932. Placing the hotel on a hill that overlooked the city may have seemed the perfect location; however, Boulder City manager Ely Sims had other ideas. In fact, he had already finalized the location. "The hotel site will occupy eleven lots, numbers eleven to seventeen inclusive, fronting on Wyoming Street," which was diagonally across from the theater.

The Greys, who were successful hotel owners out of Fresno, California, hired local architect L. Henry Smith to design a two-story, "fire-proof" hotel. Smith's hotel had a stucco exterior in the Spanish style. There was to be "a sumptuous lobby" complete with a "huge fireplace" that would "present a homelike atmosphere." The rooms were slated to be decorated by "a master interior decorator," and there were plans for a governor's suite. Steam baths, along with beauty and barbershops, were slated for the basement. There was also to be a patio and "wide driveways." The paper reported that "a large deal of money will be spent by the Greys in exterior and interior decorations."

While the town anticipated the building of the hotel and the local paper reported construction would "start soon," it never did. By August 1932, even the *Boulder City Age* was forced to finally give up hope and report the sad news that the hotel was not to be. "The lessees have just given us the unwelcome information that it is impossible to raise the required sum and that the enterprise must be abandoned." It seemed like the hotel would never get off the ground. In truth, the Boulder Inn never did rise—at least not that Boulder Inn.

A second attempt to build a hotel was made by Paul Stewart Webb, "Jim" to his friends. Webb, who had made a name for himself building expensive homes, came from California with the hopes of winning the government contract to build homes in Boulder City. Webb got the contract; on October 1, 1931, he was granted a permit to establish the Boulder City Builder's Supply on the outskirts of town. Seeing an opportunity, Webb applied for, and was granted, a permit from the Bureau of Reclamation to build an elegant hotel. But to do that, he needed investors. The first person he approached was Raymond Spilsbury. He chose Spilsbury because his family, which owned the Land and Livestock Company, had money. Webb met Spilsbury, who was a metallurgical engineer, in Peru when the two worked for the Cerro de Pasco Copper Corporation during World War I. According to Spilsbury's wife, "When Ray came up to Boulder City in 1933 to visit Jimmy they got together and decided to form this corporation with Jimmy in charge." She also stated that her husband was "heavily invested in it."

Once Spilsbury was on board, the two men brought in another investor they had worked with in Peru and formed the Hotel Holding Corporation. The three decided to abandon Smith's design and instead hired Mort Wagner, who designed a thirty-three-room, three-story Dutch Colonial hotel. Each room was to have an adjoining bath, and furniture was to be purchased from Baker Brothers, a well-established furniture company in California. Wagner designed the hotel with six massive columns at the front entrance and a spacious and impressive lobby, as well as heating and cooling systems. The hotel itself was to be constructed of the same stone used for the Arizona State Capitol building and was slated to cost $50,000 to construct.

Not only was the name of the hotel changed to the Boulder Dam Hotel, the location was also changed, but not to its position back up on the hill. Instead, the hotel was moved a block up and on the same side of the street as the theater, on the plot of land known as Cardenas Plaza. This placed the hotel a block away from the bus depot, shopping area and post office. Unlike the Greys' foray into the Nevada hotel business, Webb's attempt was much more successful. By September 1933, the hotel was nearly complete, and a Thanksgiving opening seemed likely. The *Boulder City Age* reported that Howard Doud was brought in as manager of the hotel from Maryland, where he was general manager of "one of the finest hostelries on the coast."

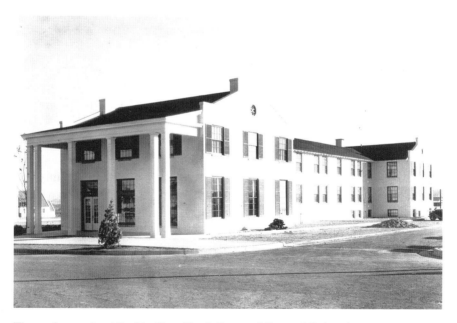

The newly completed Boulder Dam Hotel. *Courtesy of Bureau of Reclamation.*

While the Thanksgiving opening didn't happen, the Boulder Dam Hotel did open only a few weeks later, on December 15, 1933. As reported by the *Las Vegas Evening Review and Journal*, "Boulder City's new and beautiful hotel was opened today to the public for the first time. Howard Doud, manager of the Boulder Dam Hotel, and his staff were busy greeting the interested visitors as they came to inspect the perfection of the building and interior."

From the moment it opened, Webb's Boulder Dam Hotel was a huge success. Over the years, it was visited by the likes of Bette Davis, Will Rogers, James Cagney, Henry Fonda and Howard Hughes. In 1935, the hotel underwent renovations to the tune of $60,000. A restaurant was added to the side of the building, and the rooms were expanded from the original thirty-three to eighty-six. The renovations proved a success, as both the hotel and the restaurant were placed on the prestigious Duncan Hines Adventures in Good Eating and Adventures in Good Lodging national guides. It was also the location where Evelyn Grossman was pampered by the Los Angeles–based *Queen for a Day* radio show.

Six Companies Store

I owe my soul to the company store.
—Tennessee Ernie Ford

What better way to get the money back you just paid your workers than to open a store where they could spend that money? That is exactly what Six Companies did. Located in downtown Boulder City on a prominent corner, the Six Companies store had everything from clothing to fruit. It had a butcher shop and separate sections for groceries, hardware and clothing. The store even sold stoves, appliances, iceboxes and electrical fixtures. "In the construction days everyone shopped at the Six Companies store," said Boulder City resident Mary Eaton. "It was a department [store], you might say."

While Sims Ely made sure the company store had competition and that it didn't charge too much for its goods, there was one thing even Ely couldn't stop—scrip. Six Companies realized it couldn't stop its workers from shopping in other stores, so it decided to pay its employees in scrip, which is a certificate of a right to receive something. "Originally Six Companies scrip was just a little book that was stapled together," said Erma Godbey. "It had

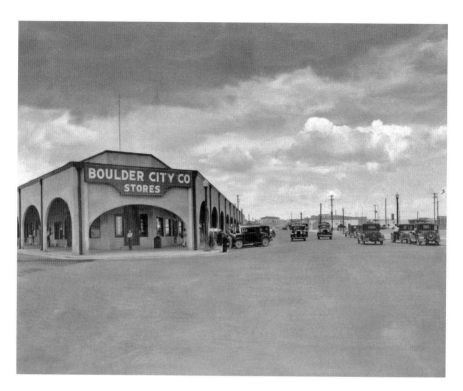

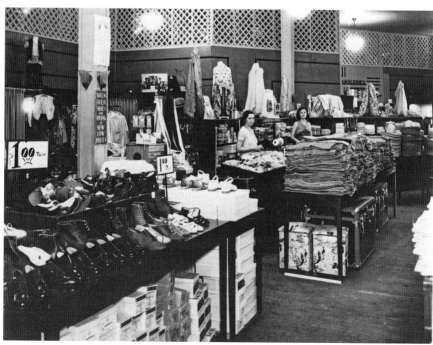

twenty-five [cent], fifty [cent] and dollar pages in it." Each "book" of scrip was worth five dollars in goods and could only be used at the Six Companies store. "The company store down here was one of the competitors, of course, with quite an advantage in use of scrip," said Elton Garrett. The advantage was that the scrip kept the workers' money firmly in Six Companies' pockets, and because five dollars' worth of goods didn't cost Six Companies five dollars, a five-dollar book of scrip wasn't worth the five dollars in cash the workers would have been given.

Scrip was worth even less when one considered the fact that many workers had to sell the scrip so they could get the money they needed for other items. For example, gas was not available at the Six Companies store. If a worker needed gas, he had to sell his five-dollar book to someone for actual cash. Of course, no one was going to offer him the full value for a five-dollar book of scrip, so he'd have to sell the scrip for four dollars or even less. But he needed the money for gas, so he had no choice. Now the five-dollar book he was given as part of his wages was worth even less. Of course, not everyone thought that way. "I never discounted. I never could—I wasn't built that way," said Erma Godbey about buying books of scrip. "I thought, well, if it buys five bucks worth of groceries for them, it would buy five bucks worth of groceries for me."

Six Companies would later change its paper scrip to coins, issuing pieces in values of five, ten, twenty-five and fifty cents and one dollar. A picture of the dam was engraved on the coin, as were the words "GOOD FOR TRADE ONLY AT BOULDER CITY CO. STORES." The scrip, both coins and paper, became so popular that the merchants of Boulder City complained to Sims Ely about the unfair advantage it created. After all, it was only good in the Six Companies store. Even if other stores wanted to accept it, they had no way of turning over the scrip for cash with the Six Companies, because Six Companies wouldn't exchange the scrip for

Right: The script issued to workers, redeemable only in the company store. *Courtesy of Boulder Dam Museum.*

Opposite, top: The Six Companies Store. *Courtesy of Bureau of Reclamation.*

Opposite, bottom: Inside the Six Companies Store. *Courtesy of Bureau of Reclamation.*

currency—only goods. Ely heard the city's merchants and threatened to close the store if Six Companies didn't stop issuing scrip. Faced with little choice, the company discontinued the issuance of scrip.

SIX COMPANIES RECREATION HALL

"Even Frank Crowe would come in there once in a while. We had a chummy sort of relationship all the way around. It was fun," said journalist and Boulder City resident Elton Garrett, speaking of the recreation hall Six Companies built to keep its employees entertained. The hall, which was positioned next to the company store, had pool tables, cigar and candy vending machines and even a soda fountain.

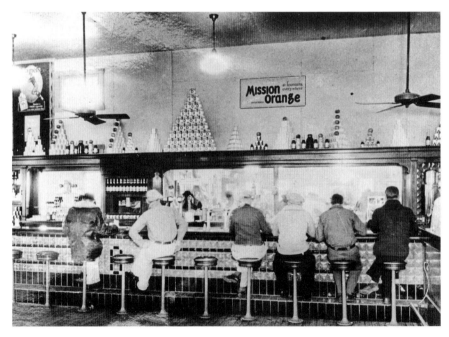

Patrons sitting at the counter of the soda fountain inside the Six Companies Recreation Hall. *Courtesy of Bureau of Reclamation.*

Six Companies Hospital

A hospital was built by Six Companies on the site that was initially earmarked for the hotel. The one-story hospital initially cost $20,000 and had a capacity of twenty beds. However, that soon expanded to two stories and a sixty-bed capacity as the need increased. The main problem with the hospital when it opened was that, because it was built by Six Companies, it was only available to that firm's employees. "At the time that it was built, that hospital was just for the men workers. There was not [*sic*] women allowed in the hospital as patients. No women [were] allowed for a good many years," recalled Mary Ann Merrill. "It was operated for the workers at the dam and was not available to the families of the dam workers, except in emergency," said Boulder City resident Lillian Whalen. This meant anyone who needed hospital care had no choice but to go to Las Vegas.

Residents who couldn't make the trip to Las Vegas had to settle for other accommodations. "Our first child was born on January 7, 1933, down on Seventh Street where we lived," said Mildred Kine. "He was born in our home. I had a nurse come in and help. It was either that or go to Las Vegas,

Inside a room in the Six Companies hospital. *Courtesy of Bureau of Reclamation.*

because the hospital up here was only for workmen and they didn't want to have maternity cases up there." Because of this, home births were a common occurrence in Boulder City.

DEALING WITH THE ELEMENTS

The climate swings from one extreme to the other, like luck at the gaming wheel.
—George A. Pettitt

Deserts are hot—everybody knows that. But deserts are also cold, and in some instances, the wind blows consistently. This was the case with Boulder City. If the summer's triple-digit heat wasn't bad enough, residents also had to deal with bitter cold in the winter and winds whipping up sand storms. Because most of Boulder City wasn't designed to last beyond the completion of the dam, no efforts were made to integrate trees, bushes, flowers or any other type of landscaping in most of the residential areas where the temporary homes were placed. "When we first came to Boulder City, it didn't look very good," said Helen Manx. "There was no grass or trees. There was dust, dust, dust everywhere." This left the residents exposed to the elements.

THE INTENSE HEAT

You don't have to spend too much time in Boulder City or at the Hoover Dam in the summer to realize it gets hot—unbearably hot. In the early days of the project, water was brought in by train. "Eighteen tank cars a day were necessary to meet the demand," wrote George A. Pettitt in *So Boulder Dam Was Built*, a book he authored for Six Companies. On the jobsite, canvas water bags were strategically placed, and "squads of water boys were kept on the go night and day," wrote Pettitt. Almost as soon as a water bag was put up, it disappeared, most likely taken by a worker to have at his tent or makeshift home. Before construction was completed, Six Companies would purchase close to 34,000 canvas water bags. "Where they disappeared to nobody seems to know," wrote Pettitt, "but it is a safe bet that they will fill the needs of people in all parts of the United States for years to come."

Engineer Walker Young recalled a time when he and his crew were building forms for the sedimentation tank that would supply water for

Boulder City. The forms were close to ten feet high. After they were erected, Young took a measurement on the shady side of the forms. "I went over in the shade and sat with my thermometer and watched the crew," he said. "It made a temperature of a hundred and forty degrees." The heat was so bad that the crew foreman had to keep a close eye on his workers to make sure no one became dehydrated. "He watched the men in his crew and when one of them staggered out, he told him to come over and sit down here for a while. He'd sit there fifteen minutes like those football and basketball players after they'd got accustomed a little bit to the heat spell, then they'd go to work again." In the book he wrote for the Six Companies in 1935, Pettitt described the Nevada weather thusly:

> *In summer, day after day, for months on end, the sun describes a blazing arc from one grotesquely sculptured horizon to the other. Under its careless prodigality the sand and rocks grow painful to the touch and the air becomes a quivering cellophane curtain behind which barren wastes seem at times lipid pools of water and again puddles of quicksilver into which the mountains melt and float away. Life declines in shriveling gasps. Black wings soar and plunge, and blinding dust buries the bleaching frameworks of what once were mortal things. Then comes the winter.*

The U.S. Weather Bureau recorded only one place in the United States that had temperatures hotter than those found at the dam site, and it was only a short distance away, at Greenland Ranch in Death Valley. "The heat became so intense toward the latter end of the summer that the Six Companies were strongly tempted to close up shop for a few months," wrote Pettitt. "On occasion the thermometer hovered between 125 and 130 degrees at three o'clock in the afternoon, and forgot to drop below 110 degrees at night." "When you went down from the top of the hill down to the river," recalled Helen Holmes, "you could feel the heat. Sometimes you'd feel like you couldn't get your breath. It just seemed like it was so terrible hot." "I didn't cope very well at first," said Boulder City resident Alice Hamilton. "I can remember the first time I tried to walk downtown. I finally became so hot that I sat down on the curb, and finally some person, I can't recall who, came along in a car and picked me up and took me home. I just couldn't make it; it was so terribly hot."

Workers on the dam who stayed in the dormitories were charged a flat fee of $1.60 per day. That fee covered their room—a large area they shared with other workers—and "hotel service," transportation to and from the

dam and their food—which, by the way, included all they could eat. When dinnertime came, mess hall tables were filled with platters of food. Men—many of whom had not had regular meals in quite some time—could not resist the temptation to overindulge. This often proved deadly when combined with the extreme temperatures and working conditions found on the dam site. "Many of them had been living on coffee and doughnuts or an equivalent diet for so many months," wrote Pettitt, "that their undernourished bodies were unable to stand the physiological upset brought on by the heat." Man after man collapsed in the hot sun. "A contributing factor to the number of deaths from heat prostration, it was suggested, was over eating," wrote Pettitt. "We lost 16 men the first year who died of heatstroke," said Young. "The people hadn't had a good meal in months; so they would gorge themselves in the cookhouse and then go out in the heat."

These unbearable conditions were such a factor that the government sent a man out to study the physiology of work in the heat. Dr. David Bruce Dill came to Boulder City and immediately got to work. He enlisted men from the "white collar gang" to play several sets of tennis in the heat. "They'd put an apparatus on their arms to collect all the perspiration so they could take it out later and measure it," said Young. "They'd play so many sets, so many minutes, so many times, then they'd measure the amount of water in that man's system that had to come out, or did come out anyway." These measurements were then compared to those taken of Six Companies workers after they finished their shifts. "They reported in every day after working their shift to get the same sort of measurements," said Young. Dr. Dill would then compare the two measurements to determine the effects of the heat on the workers at the dam. As a result of his research, the men were given salt tablets to help them retain moisture. "I believe that's the first time that salt tablets were used," said Young.

Of course, with a camp full of engineers and scientists, creative solutions to the heat are bound to be explored. "We got five-gallon oil cans, and took part of the top, part of the ends of them out," said U.S. Bureau of Reclamation hydrographer Leo Dunbar. "You cut a hole in the center and hang some towels in there, put a little bit of water in the bottom of what was left. We could rotate that thing a little bit and if we had a fan, we'd put it at the end of the five-gallon can and blow the water through there." Evaporative window coolers eventually came along, but if you were a scientist, you don't need to buy one. "You'd just build them when you'd see how they worked," said Dunbar.

It wasn't only the workers on the dam who suffered mightily from the heat; it also had to be dealt with by the residents of Boulder City. Residents who weren't resourceful enough to build their own coolers found other ways to keep the heat out. "I jumped out of bed and then took a shower before I even thought of starting breakfast," said Rose Lawson. "Then in the afternoon you'd have another shower. Then when you got ready to go to bed, you'd have another shower. Many times you'd never light the [water] heater at all. The water would be warm enough for a shower." Boulder City resident Helen H. Holmes had a makeshift cooler she learned about in Needles, California. "It was simply just burlap on the outside of the window, and you put a hose and you let it drip around and keep this wet," she recalled. "Then you had a fan in the window that circulated air into the house. I believe we had the first one in Boulder [City]."

Many workers on graveyard shift would simply run a water hose on their houses while they slept during the day to keep the heat at bay. The workers who stayed in the dorms would wet a sheet, strip down, wrap themselves in the wet sheet and then head down underneath the dormitory to sleep. "It was cooler under there than inside," recalled Jake Dielman. "In a couple of hours, your sheet would get warm, so you'd get up and wet it again." Others found a more creative way of beating the heat, taking a trip to nearby Railroad Pass for a quick drink. "The drinks weren't very potent," recalled Marion Allen, "but they had plenty of ice in them and this was what counted most after a hot day of work. One lady told me she hated to have to drink all that booze just to get the ice, but that's how important ice was in that extreme heat."

The Extreme Cold

It's easy to forget that winters can get very cold in the desert. Ironically, the town that was created to build a dam to supply electricity to millions of homes wasn't allowed to use electricity for heat during its construction. "All the electricity coming in here from Edison Company was being reserved for construction purposes," said hydrographer Leo Dunbar. But while the townsfolk weren't allowed to use electricity for heating, they could use it to cook. Each permanent house was equipped with a 110-volt electric range. "We would put rocks in the oven and heat those rocks during the day," Dunbar admitted. Then they would wrap the hot rocks in paper and place them in their beds. "It was uncomfortable," recalled Dunbar, "but it finally

warmed things up." Superflex oil heaters would later be brought in to heat many of the homes.

Like Dunbar, other residents used the desert to their advantage. "We had a potbellied stove that might have been 12 inches around at its biggest part and maybe three feet high," said Wilma Cooper.

So we'd go off across the desert and we'd pick up dead cactus, old sacks, dead twigs—whatever we could get—and bring 'em in and start a fire in that potbellied stove to heat water enough so we could have a cup of coffee. That old stove'd get red-hot. You was sure you was gonna burn the house down. But there wasn't anything for coals, so when the fire went out, it cooled off right away.

THE UNRELENTING WIND

"In the early days the sandstorms were really bad," recalled Boulder City resident Edna Ferguson. "There was so much sand because of all the activity and construction, street building and so forth." Edna recalled one day when the wind was particularly bad. "The sand was all stirred up and nothing could hold it down. It grew worse and worse. It was like a sand blizzard."

"We used to look down in where the Six Companies are and feel so sorry for the housewives down here," said Madeline Knighten. "They'd put their lovely washing out on the line and a sandstorm would come up. We'd look down and see their washing blowing in that wind, and we'd feel so sorry for them." Mary Eaton was one of those housewives, "I used to hang my diapers out on the line, and, with the wind, they would just twist around the line until they were worse off than when I put them out there." Teresa Jones Denning recalled her first night in a Six Companies home: "I'll never forget the first night we moved out there. There was no grass in Boulder City at that time. It was just sand piles. The first night it blew so hard when we got up in the morning we took a flat-bottomed shovel and actually shoveled the dirt out that had come in on the floor."

Before long, Ely and Young realized the sand wasn't going away any time soon and that the only way to control it was with landscaping. They decided to allow grass yards to be planted at all government houses. They even provided the seed. That didn't work too well initially. "The bad winds came from the south," recalled Edna Ferguson. "Our house, being at the north

end of the city and on a side hill, caught a lot of the sand that blew up that way. The government gardeners tried so hard to get the lawns started. These sandstorms would come along and cover up the new grass. One time they had to dig down a foot to find the grass level. They tried four times before the grass could hold its own against the elements." As always, the resourceful residents of Boulder City found ways to make it work. They placed one-inch-by-twelve-inch boards "around each yard to hold the sand in so the wind couldn't blow your yard away while they put in the grass seed," said Nadean Voss. "You were supposed to water every two hours until the lawn came up. Otherwise you were going to get fined for the seeds that were lost."

"Grass was very precious at that time," recalled Wilma Cooper.

> *We were trying so hard to keep our 15 or 20 sprigs of grass growing. One time after we got a pretty good stand of grass growing, we had a terrible sandstorm and it was just like a snowdrift across our lawn. We didn't have a shovel; we didn't have anything to do with. My brother was here visiting me, so he and I took pie tins and paper sacks and went out and loaded the sand and hauled it out to the alley. We saved our grass.*

To battle the sandstorms, the Bureau of Reclamation lowered the water rate, encouraging people to start and maintain a lawn. "The water rate was really great," said Mary Eaton. "I believe your water was $3 a month if you had a lawn, so most of us tried to have something. It wasn't much, but we had some grass out there." It was Steve Chubs's job to determine what rate people paid. "If you didn't have a lawn, you got the A rate. If you had a lawn, you got the B rate," he said. "If they had a lawn, I'd go back and tell the [Bureau] to cut the rate."

With grass being so hard to grow, some residents in temporary housing came up with a more creative, if not appropriate, solution. "A lot of people went out and brought in cactus," said Rose Lawson. "Cactus was a novelty to people from the Middle West and different parts of the country. So we brought in two or three small barrel cactuses, and I planted them right over next to the house so that no one would run into them and get hurt." Edna French and her husband took a unique approach to landscaping their lawn. They went down to the sewage disposal plant, paper bags in hand, and took back "little pieces of Bermuda grass," a strain of grass that is more apt to grow in the desert. "We started up a little lawn on our front yard, not very large, about eight by ten I suppose," said Edna. Then, to create a bit of shade, the Frenches planted castor beans around the house.

"Castor beans grow very quickly, and in just a few years' time they are almost treelike."

HOLIDAYS AND SOCIAL EVENTS

The desert wasn't blanketed in fresh-fallen snow, but Christmas still came to the residents of Boulder City. Crowds packed into the Anderson Brothers Mess Hall to watch a pageant celebrating the birth of Christ. "They wanted my littlest one, my Ila, to be a baby in the manger, but I knew she'd be scared," said longtime Boulder City resident Erma Godbey. "So they managed to get hold of a big doll to put in the manger scene. Then all the little kids that had been going to Sunday school sang 'Away in a Manger.'" New Mexico Construction Company workers played the shepherds and wise men. The company even supplied the frankincense and myrrh.

Ironically, the town was putting on a pageant celebrating the birth of Christ in weather conditions likely closer to the real thing than would be the case in other American cities, where snow was part of the equation. After the program, Anderson Brothers handed out goodie bags for the children. "As I remember, there was an apple and an orange each, and some candy," said Godbey.

Holding holidays in the mess hall became a routine occurrence. "Every holiday we'd go up to Anderson's," said Marion Allen. "Thanksgiving cost a whole 75 cents. The wife and I, 75 cents apiece; for the girl, it was free. So that cost us $1.50. You'd have turkey, roast beef, anything under the sun as long as you wanted." On January 27, 1932, the *Las Vegas Age*, which had a section of the paper dedicated to Boulder City, told of an upcoming dance. "The Boulder City American Legion will hold a valentine dance, which will take place February 12 in the Anderson mess hall. Arrangements for the affair have already started: The Venetian's eight-piece orchestra will probably furnish the music for the evening. Refreshments will be served as usual."

In a town full of working men, most of them single, it was good to be a young single woman. "It was great," said Dorothy Nunley. "There were so many men and not very many women. You didn't have to be pretty at all to get a date. You could be very plain and you would always get a

date." Mary Ann Merrill agreed, "It was pretty nice being a single girl, because there were a lot of fellows and they'd pay a lot of attention to you because there wasn't many girls in town. I think the ratio was at least 10 to 1."

CLUBS AND ORGANIZATIONS

As Boulder City became more and more of a community, it developed clubs and organizations. "Masons and Eastern Stars were two of the first fraternal organizations," said Mary Eaton. "We had what they called the Stray Elks Club, I guess chartered off the Las Vegas Elks," said resident Saul "Red" Wixson. "A lot of people belonged to the American Legion from World War I. They always had a lot of activities, dances," said Eaton. "The Legion Hall was the place for socializing in Boulder City at that time. It was a huge, big, spread-out, ranch-type wooden building," recalled Madeline Knighten. "It had a huge dance floor, a big dance floor. I didn't go to the dances, but they had the dances every Saturday night."

"We had a local band made up of musicians from all over the United States," said Wilma Cooper. "When we had the Sons of the Legion dances, the boys were afraid to dance for fear that somebody'd see them, so we used to have moonlight dances," said Erma Godbey. "Sims decided we couldn't have moonlight dances, because he thought the kids were all necking. Well, they weren't. It's that the boys wouldn't even get out on the dance floor unless it was dark so they couldn't see their feet and see the mistakes they made."

"I did belong to several card clubs at that time," recalled Boulder City resident Helen H. Holmes. "One had a lunch in the afternoon, but I'd always take my young son with me. We played option bridge at that time…and I'm not really a card player, but it was something for social, or to get acquainted."

SO HOOVER DAM WAS BUILT...NOW WHAT?

There certainly is a feeling of fraternalism in an operation such as the building of a large dam inasmuch as there is only one objective and that is to get the job done well.
—*Construction engineer Walker R. Young*

The "Tourist Guide" section of the 1935–36 Las Vegas, Boulder City, Overton phone directory described the best way to experience the three-year-old "miraculous creation of the stalwart men who are building Boulder Dam." It said:

> *To get the best view of the city, from high in the air, the tourist should drive to the top of Water Tank hill. The sight is one he will long remember. To adequately appreciate the achievement of the builders of this unusual city he should drive around its business districts, run out to its sporty nine-hole desert golf course, on the south-east rim of the city, near the Masonic hall, and, when this has been done, return to the main business section, park his car and visit the city's public buildings; the attractive stores, dine in its cafes and "rub elbows" with its citizenry.*

Secretary Wilbur would likely have been very pleased with the write-up his town received in the phone directory. For all intents and purposes, Boulder City was a huge success—even with all the changes that were necessary

along the way. Under the watchful eye of both Sims Ely and Walker Young, Boulder City developed into a fine, wholesome, first-rate town, something Secretary Wilbur's son noted when he said:

> *So far as the physical features are concerned, one would have to admit this municipal adventure in the heart of the Nevada desert was clearly a success. They prove that Boulder City was not the creature of whims or theories, but was born of sheer necessity.*

Finishing Up

It was the most gigantic engineering project ever undertaken, and it would certainly require the full time to finish.
—Boulder City Journal

On September 30, 1935, the headline of the *Boulder City Journal* read "Boulder Dam Job Completed 2 Years Ahead." The paper further reported, "Boulder Dam was originally scheduled to be completed on January 1, 1938. All the graphs and construction schedules were worked out on that basis. That was before Six Companies Incorporated took over the job of building the gigantic structure and assigned Frank T. Crowe to the task of seeing it through on schedule."

Crowe had proven to be the right man for the job. "He had built almost every dam of any consequence in the west," reported the *Boulder City Journal*. With a crew he claimed to be "the finest crew of men I ever had," Crowe "broke every record known to the construction world," reported the *Boulder City Journal* in September 1935. "They've established records that will stand as an eternal monument to Crowe and his men wherever the work of the master builder is of interest."

By the time the dam was completed, "every state in the union contributed to the construction of [Hoover] Dam with manpower," reported the *Boulder City Journal* in September 1935. Of the 21,374 men on the payroll during the construction of Hoover Dam, Nevada had the most with 5,522—nearly one-fourth of the total number of men on the project. It was followed closely by California, which had 5,055. Of the original seven states affected by the building of the dam, 1,165 men were from Utah, 643 were from Arizona, 457 were from Colorado, 161 were from Wyoming and 109 were from

New Mexico. Of the states outside the seven, Washington had the most men with 642 and Delaware the fewest with only 1. The average age of the men working on the dam was "around the 30-year mark from the start," as reported by the *Boulder City Journal*.

Though Boulder City was built quickly, it was built well. A testament to this fact is that some eighty years later, all 408 residences built in the first eleven years of the city's history are still in existence today. In fact, in December 1931, a special committee on public information about the Hoover Dam appointed by the Associated General Contractors of America and the American Engineering Council reported:

> *Yet, in less than eight months, this region has been so organized that every man who is properly engaged in any capacity in the work itself is well housed and better fed than the greater average of his fellows. In dormitories that are steam heated for the penetrating cold of the desert winters, ventilated with conditioned air, cooled and moistened to produce maximum comfort in the summer's heat, these men are supplied with individual rooms, comfortable beds, clean linen, electric lights, janitor service, modern toilet and bathing facilities, in a way which marks the new "high" in the curve of construction camp accommodations. The dining room through a singularly fortunate concession, which is guarded by a contract which can be terminated on twenty-four hours' notice, is serving better food than the average American home enjoys.*

By the time Boulder City and the Hoover Dam were completed, Six Companies Inc. had spent an average of $230 per man employed for living conditions in Boulder City. That number, according to Ray L. Wilbur Jr., is "four or five times as much as that invested on any other project in history." By March 1932, the federal government had spent $1,600,000 of its estimated $1,808,092 on Boulder City. Much of this money went to permanent structures that would remain well after the dam was completed, unlike the housing built by Six Companies, which was, for the most part, taken down after construction on the dam was finished.

On Friday, March 11, 1932, three years before the dam was completed, the *Las Vegas Evening Review and Journal* lamented the future of Boulder City. "Boulder City's future, we can be assured, will be one of activity and improvement for the next five years while the dam and power plant are being constructed. Beyond that time its status is largely problematical. If the attraction to tourists and to manufacturers is sufficient the population

may rise above 3,000 persons." Like everyone else, the newspaper expected the population of the town to decrease after the dam was completed and some areas, like the contractor's area, to simply return to the desert. The newspaper even predicted the population—which at times was as high as 6,500—would eventually settle to around "534 to 645" men, women and children, with a "slight possibility" of it swelling to 1,600.

As Walker Young recalled, "It was anticipated that after the construction of the dam was completed and the powerhouse [was] in operation, Boulder City would then become simply a residential area for operators." However, as Young noted, "It hasn't worked out that way." The *Las Vegas Evening Review and Journal* did admit that "it is difficult to estimate the number of industries that will be drawn to Boulder City by the cheap power available after construction of the dam and power plant. By means of this cheap power, electro-chemical industries will be able to produce many products such as carbide, ammonia, hydrogen, nitrogen, oxygen, neon, calcium chloride, and other materials from available supplies directly at hand." The newspaper also admitted that "a considerable tourist business will probably develop and one or more large hotels might be required to accommodate these visitors."

The single-family dwellings built by Six Companies were intended to be temporary, which is why the designs were simple. Like Walker Young, the executives of Six Companies were expecting the workers to simply leave once construction of the dam was complete. When that didn't happen, the firm began selling its cottages to the workers who inhabited them, beginning in 1935. The homes not bought by the workers were torn down. More than 120 of these cottages remain, with many retaining their original architectural integrity. Because they were never intended to last, the houses were initially placed on foundations composed of timber sills and posts set on concrete footings. By 1939, many of these foundations had to be replaced with concrete block—the original foundations were deteriorating after only eight years.

Dedicating the Dam

On September 30, 1935, President Franklin D. Roosevelt dedicated the Hoover Dam. Twenty thousand people were expected to attend the ceremony, which was to occur on the top of the dam at eleven o'clock.

However, Walker Young, the man in charge of making sure everything was ready, got his time zones mixed and thought the ceremony was to be at two o'clock in the afternoon. Young went down to the train station to pick up Harold Ickes, who was secretary of interior at the time. "He told me to meet him at the train station, which I did," recalled Young. "On the way out [to the dam], he told me the ceremony would be at eleven o'clock. I'd been looking at the whole thing while planning it with the idea of starting at two o'clock." Young experienced a bit of a panic. It was bad enough that twenty thousand people would be vying for the best spot on the forty-foot-wide top of what would prove to be a very crowded dam; the ceremony was going to be three hours sooner than he had expected. He voiced his concern to Secretary Ickes, worried about the crowd that would gather. "We don't care about the twenty thousand people," Ickes said. "We're talking about the twenty million people who are going to listen to us on the radio."

Young managed to get word to the rangers and the two to three hundred soldiers who would be used to guide traffic to and from the dam. "We did the best we could," said Young. "We finally got them down there." Though Young had an important role in the planning of the event, he was soon given an even more important task—escort to the president and first lady. When a president comes to a town, it is common for politicians to try to align themselves with the president, even more so when the president is coming for a joyous event that attracts national attention. The dedication of the Hoover Dam was one such event. Governors and senators, from Nevada and other states, wanted to be the one to escort the president and his wife. As Young said, "A political situation arose." To solve it, Young was asked to be the escort, certainly much to the chagrin of the career politicians. "I couldn't understand that," Young said of his being asked to escort President and Mrs. Roosevelt to the dam. "But of course it didn't take long to realize that there was a situation that they didn't know who it was they were going to pick to ride with him [who was] politically popular—nobody!"

So Young, President and Mrs. Roosevelt, their chauffeur and a Secret Service agent all climbed in the car. Las Vegas resident Dean Pulsipher also had a connection to the president—his wife's uncle was the chauffeur. "He was driving a big open-air Cadillac for Roosevelt," said Pulsipher. "Everyone was excited and there was a lot of activity there." Young was placed directly in the middle of the president and the first lady. He talked about the construction of the dam and pointed out landmarks along the way. "We pointed out the reservoir, which was a beautiful sight," recalled Young. "Looking down from the top of Hemenway Wash—beautiful blue

Engineer Young driving President Roosevelt and first lady Eleanor Roosevelt to the dam dedication ceremony. *Courtesy of Boulder Dam Museum. Manis Collection.*

water. With the mountains, it was a beautiful sight and Mrs. Roosevelt was quite impressed with that."

Young wasn't the only one who got confused on the time. "A lot of people didn't get there at all," he recalled. "They were still on the way to Boulder City. Back in Washington, they had forgotten the three-hour differential between Eastern time and our time, so it upset everything." Luckily, it all went off without a hitch. President Roosevelt, in front of a large crowd, stood on a wooden platform and dedicated the Hoover Dam, ending once and for all the longstanding debate over the name of the mammoth structure.

To celebrate the event, the U.S. Post Office Department issued commemorative stamps picturing the Hoover Dam. The first day of issue was September 30, 1935, the same day President Roosevelt dedicated the dam. Everybody wanted the stamps, and they wanted the stamps postmarked by the Boulder City Post Office on the date of dedication. The post office expected to be busy—it even hired on additional personnel to handle the expected deluge. However, the amount of mail they received was far greater than anticipated. More than 200,000 pieces of mail—mainly postcards—came through the Boulder City Post Office that day. The mail was laid out on long wooden tables and each piece canceled, by hand. President Roosevelt was one of the people who sent a letter, as did King George V of England and King Fuad of Egypt.

Above: President Roosevelt dedicating the Hoover Dam. *Courtesy of Bureau of Reclamation.*

Left: Hoover Dam commemorative stamp. *Courtesy of Boulder Dam Museum.*

Post office employees handling the initial mailing of 200,000 Boulder Dam stamps through Boulder City Post Office. *Courtesy of Bureau of Reclamation.*

Handing Over the Keys

Government removed from the people becomes an irresponsible bureaucracy.
—Dale Pontius, activist and founding faculty member of Roosevelt University

"The present growth, bustle, and hum of activity in Boulder City are stimulating and are a source of comment by all who visit here," reported the *Las Vegas Evening Review and Journal* in March 1932. "The future for the next few years will be as the present, except that there will be many added improvements. The future, beyond the period of construction, will depend in great measure on the inhabitants at that time, for it is possible that the government will withdraw its parental authority following the construction period."

Boulder City was a unique town in that its origins weren't traced to mining, cattle or trade centers, which was common to western towns. Lewis Mumford's theory that "the thriving of towns has its origin in the agricultural improvement of the countryside" certainly did not apply to Boulder City. "Here was a thriving community which had arisen for reasons

entirely unrelated to those which usually contributed to city growth," wrote Lee E. Walker. In fact, Boulder City was less of a "western town" than many of its East Coast counterparts. "Neither expense, nor effort was spared to make Boulder City as attractive and comfortable as possible," wrote Walker. "Wide tree-lined streets and luxurious lawns make the city a unique oasis in the dry barren desert of southern Nevada."

The people who inhabited the city were government employees, contract workers, professionals and their families. And while Six Companies and the Bureau of Reclamation had, to a large extent, built the town, it was the people who lived there who had made the town their own. Now, with the Hoover Dam completed, it was a town they wanted to run. In 1932, the population of Boulder City was almost 2,500. Two years later, that number grew to more than 6,000. However, one year later, when the Hoover Dam was completed, in September 1935, the number of residents of Boulder City shrank to only 4,000—a little less than half the population of its neighbor to the west. By 1937, the number had again declined to 3,000, but this was still much larger than anyone had foreseen. Still, Boulder City was "no 'company' town," wrote Walker. "Here in the desert has arisen a model city possessing almost as much attraction as the Hoover Dam itself."

In 1941, city manager Sims Ely retired, and the responsibility for running the municipality transferred to the director of power for the Boulder Canyon Project. Though all the main players had pulled out, the residents of Boulder City still didn't have control over their own town. "No attempt was made to separate city functions from other operations of the project, and government for the city was provided as a part of the power operations," wrote Walker. This situation ensured that the people in charge of the town were more responsive to the will of Congress than to the citizenry. "If a democratic society is one where the power of government is responsible to the people governed," wrote Walker, "then the Boulder City government could hardly have been considered democratic."

While the government may or may not have been eager to hand over the keys to the city, the very nature of how Boulder City came to be created a substantial hurdle—the town had no money with which to support itself. Another problem was that Boulder City was officially on federal land, meaning no one in the town, resident or business owner, actually owned the real estate they occupied.

Interestingly enough, while Secretary Wilbur had made sure the town had been planned down to the placement of every last bush, neither he nor

any of his counterparts made any type of plan for turning the city over to its inhabitants once the construction of the dam was completed. It does make one wonder if the government ever had any intention of letting Boulder City go, or if it intended all along to keep it federally owned—something that would have been unprecedented but par for the course. U.S. senator Alan Bible did state in a 1955 hearing that some program to hand the city over to the citizenry had been under consideration as far back as the 1940s. But nearly fifteen years after the completion of Hoover Dam, Boulder City was no closer to its goal than when the dam was dedicated.

Part of the holdup came from Nevada itself. Senior senator Patrick A. McCarran said in a speech on the senate floor, "From the beginning Mr. President, I have been insistent that no steps be taken to change the status of Boulder City unless and until the citizens of that community have an opportunity to express themselves in an election as to which type of municipality they would favor."

There was also the question of what to do with McKeeversville. "Officially McKeeversville is not there at all," reported the *Boulder City News*. "Its denizens are squatters, pay no ground rents and hold no leases. Their houses stand on neither lot nor plat because the area was never laid out. Yet there are 50 houses in McKeeversville (or should we say, more suitably, 'habitations')." But McKeeversville was very much there and had even been given a new name: Lakeview Addition. Additionally, McKeeversville was older than Boulder City, and it didn't seem right to just ignore it. In 1948, the U.S. Bureau of Reclamation finally relented and announced plans to develop McKeeversville. "It does stand on one of the finest building sites in town," reported the *Boulder City News*. "It is fairly level and commands a magnificent view."

It was in the late 1940s, specifically October 14, 1949, that the ball finally got rolling when a dark-haired, nice-looking, bowtie-clad man of forty-two rolled into town. "Boulder City's doctor is here and already the city's pulse beats faster as news of his appointment and arrival spread through the town," wrote journalist Morry Zenoff for the *Boulder City News*. The headline read "Expert Arrives; Promises Unbiased Survey." Dr. Henry Reining Jr., professor of political science and public administration at the University of Southern California, graduate of both Akron University and Princeton University and director of a public management consulting service, came to Boulder City at the behest of the U.S. Department of Interior to conduct public hearings on the future of the government's model city. "I come here with an attitude of learning and listening," Reining told the *Boulder City News*,

"and with a completely open mind. Let me assure the people of Boulder City that all government officials I've been with at the Bureau today—all have leaned over backwards impressing me with the fact that they are as open minded about this entire problem as I am. They are making sure I see all the facts, figures and both sides of every story."

Reining wanted to make sure all the people of Boulder City understood he came to them with no preconceived notions. "I will need facts, data, statistics, cost figures—facts and more facts," he told the *Las Vegas Review-Journal*. "So far as possible these facts should be allowed to speak for themselves and to indicate a solution." Reining also wanted there to be no doubt that the process would be transparent. "Everything that is done in this survey should be done publicly, without secrets, without confidences, without withholding of any information by anyone from anyone else," he said.

The first woman to open a business in Boulder City, Ida M. Browder, gave Reining and his staff office space in her building. "Mrs. Ida Browder offered the use of her building at 552 Nevada highway and this is being furnished and equipped for the use of the expert and his staff," reported the *Las Vegas Review-Journal*. By November, Reining was ready to begin hearing from people. "I understand there are some 90 organizations in this city. I hope I'll hear from all 90 before this investigation is over," he said. "I'd like it clearly understood that every citizen here has a right to be heard. I will be glad to talk with anyone, either publicly or privately." Reining expected the process to take "a few months," after which the citizenry was promised a chance to vote on "important community points" before the report was sent to the secretary of interior. The first hearings were held at Earl Brothers' Boulder Theatre on November 17 in three sessions (10:00 a.m.–12:00 p.m., 2:00 p.m.–4:00 p.m. and 7:00 p.m.–9:00 p.m). Other hearings were held at the theater and in other places, such as the basement of the Masonic temple.

"This is an exceedingly complex situation," Reining told the *Boulder City News* regarding the hearings. "More complex than I thought. Yet, because I've been interested in Boulder City's problem for years, I feel that it can be handled." When asked why he wanted to conduct the public hearings, Reining answered simply, "I don't want to feel alone in a problem that belongs to all of us." True to his word, Reining did his best to hear everyone who had an opinion on the subject, collecting more than six hundred pages of testimony. Afterward, he concluded, "What we need now is a firm policy implemented by appropriate action and aimed at the objective of a permanent solution to the financing of non-project costs and the administration of Boulder City as a municipality."

In addition to the hearings, Reining ordered a census of Boulder City. The results amazed many. "One of the surprising byproducts of the study was the report that the community's population probably will surpass all previous optimistic guesses," reported the *Las Vegas Review-Journal*. When the count was completed, the population of Boulder City was close to sixty-five hundred, having more than doubled in ten years and close to its 1930s full-swing construction days.

Reining submitted his final report on May 18, 1950. In it, he suggested that income from the sale of utility services be available to the city and that unoccupied areas of the city be sold to generate additional income. He also suggested that the government either transfer all lands to the municipality for a nominal fee or sell the lands to the leaseholders or anyone else who may be interested. Reining gave four possible scenarios for the future management of the town, only one of which turned the town over to Nevada as a full incorporation. No matter which road was taken, Reining found that one thing was certain. "In accord with democratic traditions, the residents of Boulder City have repeatedly expressed the desire to take part in the governing of their municipality," he wrote in his report. "One citizen after another [has] made suggestions for citizen representation in the administration of the city."

Reining understood well the need and desire of Boulder City's citizens to govern themselves. His permanent solution to "Boulder City's problem" was always some type of incorporation that would provide local autonomy. In fact, Reining never seriously looked into any form—new or varied—that would permit the continued control of Boulder City by the federal government. "Rather, exclusive emphasis was given to the possibilities for home rule," wrote Walker, "and each of the various alternatives by which this might be operable was explored."

In his report, Reining stated:

> *Local autonomy is a basic tenant of American federalism. It is only through ultimate incorporation that the residents of Boulder City can exercise to full extent their rightful power to run their own local government. It is only with municipal incorporation and a more or less complete autonomy that the National Government can be relieved of the responsibilities of ruling this municipality. Therefore, in Boulder City now it appears to be necessary that the people be conditioned to self-government.*

However, like Senator McCarren, Reining strongly believed that it was up to Boulder City's citizens to decide the issue in an election, stating,

"Democracy is not only a goal in itself, but is also a method of solving problems." Nevada law agreed. In order for a town to become incorporated in the state of Nevada, action must originate from the residents of the town in the form of a petition to the state legislature, the district court or the board of county commissioners.

Public opinion, as always, varied. Some people, like Mr. and Mrs. R.C. Bello, requested that no change in administration be made. "Paul Dexter declared that he preferred to keep the community just as it is now," reported the *Boulder City News*. While others, such as Mr. and Mrs. P.J. Hidden—property owners—and Harry J. Sallee "urged that the community be divorced from government control."

Other organizations were more concerned with making sure some specific rules did not change, no matter which way the decision went. "A report from the Women's Club, by Mrs. Charles Hyde, president, said that a poll of the members showed 90 per cent [*sic*] in concord with the operations of the community while the entire membership urged regulations against liquor and gambling if a change is made," reported the *Boulder City News*.

An election was held. "In the face of fundamental community changes, the people of Boulder City demonstrated that their capacity for community action, long immobilized, was not entirely lost," wrote W. Darlington Denit, who added, "a committee of volunteer election workers performed with exceptional intelligence and diligence."

THE TRANSFER

"The Bureau of Reclamation and the Department were aware that they could not give Boulder City local self-sustaining government in one spasmodic gesture," wrote Denit. Instead, Reining proposed a three-phase process:

1. Complete administrative and financial segregation of municipal operations and the Boulder Canyon Project.
2. Incorporation under a federal charter, would be a period of developing substantial autonomy in municipal government.
3. Incorporation under the laws of the state of Nevada.

The first step in the process happened on July 27, 1951, when Secretary of Interior Oscar L. Chapman issued order number 2650, separating the administrative responsibilities of the Boulder Canyon Project from the Boulder City municipality, ordering the appointment of a city manager and creating an advisory council composed partly of citizen representatives. Seven years later, after the town had accomplished little to move itself toward autonomy, Congress took the bull by the horns, passing a bill called the Boulder City Act, which would "authorize the disposal of certain Federal property in that area in Clark County in the State of Nevada commonly known as Boulder City, now part of the Boulder Canyon Project, in order that the people of that area may enjoy local self-government and to facilitate the establishment by them of a municipal corporation under the laws of the State of Nevada."

Interestingly enough, the forces wanting an independent Boulder City seemed to wane a bit. Quite possibly, the residents of Boulder City had become accustomed to federal rule and liked it. Or, maybe the idea of independence was more appealing than the actual practice. Either way, in reaction to Congress's bill in 1957, the Boulder City Advisory Council sent a motion to Secretary of Interior Fred A. Seaton:

> *That the Secretary of interior be advised at once that it is the judgement of the Advisory Council that the majority of people in Boulder City are of the opinion that incorporation or separation of the city would not serve their best interests at this time. Therefore, the Council questions the merit of enacting such enabling legislation as long as this condition prevails.*

The council's motion held little weight. When positions on the council were up for election the following year, changes in the council switched support back to independence. The Boulder City Act, which was signed by President Dwight D. Eisenhower on September 2, 1958, all but forced the residents of Boulder City to finally take the action they had voted to take so long ago.

The Concerns

Probably the main reason the citizens of Boulder City took so long to take the reins of their own town was that they had it pretty good the way it was. They lived in a beautiful, law-abiding community that was an oasis in a state

with very liberal laws governing vices. Understandably, most residents were concerned that the standard of living they had established might change if the government moved out. While they may have wanted to govern themselves, they might have been just as happy with a say in how things were run instead of being in total control.

The majority of Boulder City's residents were worried that the vices so prevalent in their state would find their way to their model town. As far back as 1941, a petition was signed by over one thousand Boulder City residents opposing any change in the restrictions of the sale of alcohol. However, the town needed to make money, and as many Nevada towns had discovered, gambling and alcohol were big money makers.

In 1953, a legislative draft prepared by the Department of the Interior proposed to remove the "deed restrictions" on the sale of alcohol when the government sold the property. The proposal alarmed many residents who always saw the federal restrictions as a convenient method of keeping their town free from vice. So long as the federal government imposed the restrictions, there was little the state or local municipality could do. Even if they wanted to, they couldn't change the federal law. In a secret ballot, voters were asked if they favored "the use of deed restrictions as a means of prohibiting gambling and the sale of liquor in Boulder City if federal lands are sold." Of the people who voted, 959 favored the restrictions and 540 voted against them.

A major concern with keeping the restrictions was the banks. Several bank officials noted concern in cases "where a violation of any covenant would, by a reversion clause, give priority to any other person or agency than the holder of the encumbrance." Their concern was that if the person who made the loan violated the provisions established by the federal government, the government could, by provision, seize their property, and then who would repay the loan? With this legitimate worry, banks would be less likely to give out loans.

Understanding the residents' concern, the Boulder City Act actually allowed the restrictions to survive the transfer of the property to the individual for a period of twenty-five years. Whoever bought the land from the government would not be able to allow gambling, prostitution or the sale of alcohol on that property for twenty-five years. A violation would result in the reversion of the property to the United States. This only reinforced the banks' fears. However, as with so many things in life, it came down to the money handlers. The Bureau of the Budget did not agree with the provision, stating "While we appreciate the substantial Federal interest in

a stable community environment in Boulder City, we do not agree that this interest should override the rights of the community, once it becomes self-governing, to determine its future course." The bureau recommended that the restrictions expire when Boulder City becomes incorporated. A compromise was reached when the wording was changed to allow the restrictions for a period of three years after incorporation, after which it would be up to the residents to vote to "dispense with all the aforesaid conditions simultaneously."

Fears of vice ruining the town were further alleviated when the Nevada State Legislature passed a bill giving the local residents control over whether they did or did not want gambling and alcohol in their town. While residents would eventually approve the sale of alcohol, to this day, gambling is not allowed in Boulder City.

Concerns were further alleviated when the Department of Interior reminded residents that

> *The government is, and is likely to remain, the largest industry in the town. Federal installations will occupy more land within the city limits than any private or even municipal operation. As the principal beneficiary of a wholesome and attractive community, the Federal Government has an obligation to augment municipal income from normal taxes by a contribution large enough so that the city can maintain present standards of services and operations.*

Getting the Deeds

From almost the minute the Boulder City Act was signed, the Federal Housing Authority arrived in Boulder City to begin a pre-appraisal survey. A total of 1,004 residential and 129 nonresidential lots were appraised, along with 165 federally owned houses, apartments, duplexes and garages. Appraisals varied on lots from $900 to $3,750 and on homes from $41,000 to $15,500. Commercial structures and residences that were privately owned were not appraised. People were given sixty days to file a notice of purchase and another sixty days to conclude the purchase.

When the federal government released the land to the incorporated Boulder City, business owners finally achieved what some had been waiting decades for—own their own businesses. Ida M. Browder "was presented the

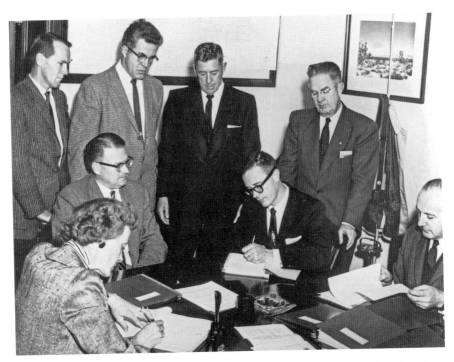

The official title of transfer of contracts and deeds from the United States to Boulder City.
Courtesy of Bureau of Reclamation.

first deed for a lot in Boulder City when incorporation made lot sales possible, buying the lot on which her business stands," wrote journalist Elton Garrett. Others followed, and starting in 1960, Boulder City began the long-awaited transformation from a federal reservation to a typical American town.

APPENDIX

VISITING DIGNITARIES AND CELEBRITIES

Wearing blue shantung suspender shorts, a white satin polka-dotted blouse, blue bobby socks, blue rubber-soled sandals and curls tied with blue ribbons, Shirley Temple walked into a Boulder City classroom in 1938 and attended school for the first time in her nine years. "She sat in my desk because I wasn't there," said Alice Dodge Brumage, whose mother had kept her home from school because she wasn't feeling well. According to the child star's mother, Temple had "never before attended a regular school, but has her own private class on the MGM lot in Hollywood." As part of the obvious publicity stunt, while she was there, Temple "visited each class in session at the Boulder City schools as a guest of Principal Robert O. Weede," reported the *Las Vegas Evening Review and Journal*.

Shirley Temple. *Courtesy of Boulder Dam Museum.*

America's Sweetheart wasn't the only person to visit Boulder City. Construction superintendent Frank T. Crowe was having lunch in the Six Companies' mess hall with humorist Will Rogers when Rogers asked Crowe how many people he had working on the dam. "About half," answered Crowe, to which Rogers replied, "Mr. Crowe, I'm supposed to be the comedian." Many famous people have visited Boulder City both during and after construction of the dam. Some of them came to see the dam, while others came to the Boulder Dam Hotel to establish residency in order to get a divorce. The following is just a partial list provided by the Hoover Dam Museum.

Richard Barthelmess and Ronald Colman, popular actors and poker kings.

His Excellency Celâl Bayar, president of Turkey.

George Beckley Jr., heir to the Wrigley Gum fortune; married in the hotel.

Wallace Beery, actor.

Rex Bell, cowboy star and lieutenant governor of Nevada in the 1950s.

Dr. Joel T. Boone, White House physician to Presidents Harding, Coolidge and Hoover.

Margaret Bourke-White, world-renowned photographer and traveler; married to novelist Erskine Caldwell; shot photos of Hoover Dam during construction.

James Cagney, actor.

Edward Cianelli, character-actor, portrayed a Nazi inquisitor in Alfred Hitchcock's *Foreign Correspondent*.

Bette Davis, American actress of film, television and theater.

Patricia Ellis, Hollywood character-actress, starred in the Warner Bros. romantic adventure *Boulder Dam*.

Henry Fonda, actor.

A.P. Gianinni, founder of Bank of America.

Mrs. Frederick Webster Gillet, lived at the hotel in order to establish residency in order to divorce her millionaire husband.

Ferde Grofé, composer of *Grand Canyon Suite*; stayed frequently at the Boulder Dam Hotel; established residency for a Nevada divorce; composed *Sunrise Over Lake Mead* while at the hotel; stayed at the hotel during concerts he performed in Las Vegas strip hotels.

Otto von Habsburg, crown prince of Austria.

Oskar J. Hansen, Norwegian artist and sculptor; designed the *Winged Figures of the Republic* and the star map terrazzos on the crest of Hoover Dam.

Sonja Henie, actress and figure skater.

Howard Hughes, entrepreneur; spent several days recuperating in the Boulder Dam Hotel after his Sikorsky S-43 crashed into Lake Mead.

Harold Ickes, secretary of interior after Ray Lyman Wilbur.

José Iturbi, actor and pianist; grounded in Boulder City when his airplane broke down. The hotel manager had a piano dragged up to Iturbi's suite so he could practice.

Boris Karloff, actor; lived at the hotel to establish residency for a divorce; remarried on April 11, 1946, in Boulder City.

Frances Lederer and Margo Albert (originally Margarita Guadalupe Teresa Estella Castilla Bolado y O'Donnell), matinee idol and the star of *Lost Horizons*, respectively. They stayed together at the hotel while Lederer awaited a divorce from his wife.

Harold Lloyd, Hollywood comedian and pinball wizard.

Fred MacMurray, actor.

Maharajah and Maharani of Indore, India, member of the Holkar dynasty of the Marathas; took full power of India in the 1930s.

Fibber McGee and Molly (Jim and Marian Jordan), radio stars.

Mrs. Raymond Moley, wife of the assistant secretary of state of the United States.

Crown Prince Olav and Crown Princess Martha of Norway.

Pascual Ortiz de Rubio, president of Mexico, and his family.

Cardinal Pacelli, later Pope Pius XII.

Shah Mohammed Reza Pahlavi, ruler of Iran.

George Palmer (G.P.) Putnam, millionaire publisher married on hotel's terrace.

George Pepperdine, president of Western Auto Supply and founder of Pepperdine University, and his family.

William Powell, actor.

Cast and crew of the RKO film *Silver Streak*, filmed in Boulder City and at the Hoover Dam site.

Will Rogers, film and Broadway star, writer and comedian; performed on the stage at the Boulder Theatre.

Admiral David Foote Sellers, commander of the Pacific Fleet, and his wife.

Prince J.M. and Princess K. Shrinagesh of Jahore, India.

Evangeline Brewster Johnson Stokowski, heiress to the Johnson & Johnson Pharmaceuticals fortune; married to conductor Leopold Stokowski. She lived at the Boulder Dam Hotel for several weeks to establish Nevada residency in order to divorce her spouse, who was traveling in Europe with Greta Garbo.

Milburn Stone, actor, portrayed Doc on the television series *Gunsmoke*; kept his boat moored at Lake Mead.

Senator Robert Taft, son of former President William Howard Taft.

Robert Taylor, actor.

Shirley Temple, actress and child star.

Sophie Tucker, comedian, singer and actress.

Mr. Cornelius Vanderbilt Jr., newspaper publisher, journalist, author and military officer, and his wife.

Duchess of Westminster.

William Woollett, famed architect and artist; his lithographs of Hoover Dam construction are reprinted today.

BIBLIOGRAPHY

Allen, Marion V. *Hoover Dam & Boulder City*. Redding CA: House of Steno, 2000.

Bell, Laura. "Boulder's Builders; This Week…Ida M. Browder." *Boulder City Journal*, 1948

Boulder City Historic District. Nomination to the National Register of Historic Places. Janus Associates Inc., Volume 1, April 1983.

Boulder City Journal. "Civic Survey Expert Due Today to Commence Studies." November 3, 1949.

———. "Every State in Union Sends Men to Dam Project." September 30, 1935.

———. "Project Originally Scheduled to Be Completed January '38, Builders Set Many Records." September 30, 1935.

Boulder City News. "Earl Brothers, Other Citizens Give Reports." Friday, November 25, 1949.

———. "Schedule Filled with Statements of Varied Points." November 27, 1949.

Carey, Roger, Kathy O'Neill and Dereck Segle. *A Report on Oral History Interviews About the Railroad Pass Squatters Camp for the Bureau of Reclamation*. May 9, 2001.

Colorado River Commission. *The Boulder Canyon Project: A Compilation of Data and Information Relative to the Colorado River Development*. Sacramento: California State Printing Office, 1930.

Denit, Darlington W. *Boulder City—Government Town Problem*; *Public Administration Review* 12, no. 2 (Spring 1952): 97–105.

"Draft of Proposed Boulder City Charter." Unofficial Charter Committee, Boulder City, Nevada, 1959.

Garrett, Elton, "City's First Business Lady Is Heart Victim," *Boulder City News*, January 19, 1961.

Las Vegas Evening Review-Journal. "Electrician Aids Building Boulder." March 11, 1932.

————. "Here's How." March 11, 1932.

————. "Laying Out of Park and Plazas, Planting of Trees Well Along Now." March 11, 1932.

————. "Nearly Twenty Miles of Paving Laid as Part of Boulder City's Construction Program of Year." March 11, 1932.

————. "Post Office at Boulder City Fastest Growing in Country." March 11, 1932.

————. "Three Churches Now Care for Boulder City Religious Needs." March 11, 1932.

Las Vegas Review-Journal. "Expert 'Wants Facts' in Boulder City Civic Survey." November 7, 1949.

————. "Initial Session to be at Theater Saturday; Downtown Office Obtained." November 1, 1949.

————. "Project Executive Discusses Future." March 11, 1932.

Leydecker, Mary, "Profile of a Marinite," *Independent-Journal* (San Rafael, CA), Saturday, June 7, 1975

Los Angeles Times. "Work on Dam to Start Soon." March 12, 1930.

McBride, Dennis, *In the Beginning...A History of Boulder City, Nevada.* Boulder City, NV: Boulder City Chamber of Commerce, 1981.

Official Charter, City of Boulder City. Boulder City, Nevada.

Pettitt, George A. *So Boulder Dam Was Built.* Berkley, CA: Six Companies Inc., 1935.

Pfaff, Christine E. *The Bureau of Reclamation's Architectural Legacy: 1902 to 1955.* Denver, CO: U.S. Department of the Interior, Bureau of Reclamation, October 2007.

Reining, Henry, Jr. *A Report as to Boulder City, Nev.* Printed as Senate Document No. 196; 81st Congress, 2nd Session, 1950.

Report on the Problems of the Colorado River Basin. Vol. I, *Summary of Problems.* Washington, DC: Department of the Interior, Bureau of Reclamation, February 1924.

Rowley, Rex J. *Becoming Las Vegas: Opportunity and Challenge with the Building of Boulder Dam, Nevada Historical Society Quarterly* 55, nos. 1–4 (2012).

Stevens, Joseph E. *Hoover Dam: An American Adventure.* Norman: University of Oklahoma Press, 1988.

U.S. Congress, Senate. *Committee on Interior and Insular Affairs, Hearings on s. 2675, Boulder City Act*, 85th Congress, 2nd Session (1958).

U.S. Congress, Senate. *Special Subcommittee of the Committee on Interior and Insular Affairs, Field Hearings on s. 514, Boulder City Act*, 84th Congress, 1st Session (1955).

U.S. Congressional Record, 81st Congress, 2nd Session (1950), XCVI, Part 7, 8613.

Young, Walker R. "Hoover Dam: Purposes, Plans, and Progress of Construction." *Scientific American* (September & October 1932).

————. Letter to John F. Calhan, July 31, 1975.

Walker, Lee E. "The Transition of Boulder City, Nevada, from Status as a Federal Municipality to a Municipal Corporation with Home Rule." January 16, 1961.

Wilbur, Ray Lyman. "The Memoirs of Ray Lyman Wilbur, 1875–1949." Stanford, CA: Stanford University Press, 1960.

Wilbur, Ray L., Jr. "Boulder City: A Survey of its Legal Background, its City Plan and its Administration." PhD Diss., Syracuse University, 1935.

Zenoff, Morry. "Dr. Henry Reining, Jr. Selected for Our Probe." *Boulder City News*, October 14, 1949.

———. "Public Meeting Will Explain Step by Step." *Boulder City News*, November 4, 1949.

Oral Histories

Banks, Louis Edward, interview by Kathy O'Neill, March 27, 2001, "Oral History Interviews about the Railroad Pass Squatters Camp for the Bureau of Reclamation," Boulder Dam Museum collection, Boulder City, Nevada.

Czerwonka, Frank, interview by Kathy O'Neill, March 20, 2001, "Oral History Interviews about the Railroad Pass Squatters Camp for the Bureau of Reclamation," Boulder Dam Museum collection, Boulder City, Nevada.

Dunbar, Leo, interview by Jim Maxon, May 28, 1985, "Hoover Dam Oral History Collection," Boulder City Library, Boulder City, Nevada.

———, interview by Dennis McBride, June 16, 1986, "Hoover Dam Oral History Collection," Boulder City Library, Boulder City, Nevada.

Emery, Murl, interview by R.C. Turner, "Hoover Dam Oral History Collection," Boulder City Library, Boulder City, Nevada.

Garrett, Elton, interview by Dennis McBride, November 10 and 11, 1986, "Hoover Dam Oral History Collection," Boulder Dam Museum collection, Boulder City, Nevada.

Godbey, Erma O., interview by Dennis McBride, November 7 and 8, 1986, "Hoover Dam Oral History Collection," Boulder City Library, Boulder City, Nevada.

Holmes, Helen H., interview by Marilyn Swanson, February 12, 1975, "Hoover Dam Oral History Collection," Boulder City Library, Boulder City, Nevada.

Holmes, Neil H., interview by Laura Bell, February 12, 1975, "Hoover Dam Oral History Collection," Boulder City Library, Boulder City, Nevada.

Pulsipher, Dean, interview by Dennis McBride, August 19, 1986, "Hoover Dam Oral History Collection," Boulder City Library, Boulder City, Nevada.

Walker, Young R., interview by Elton Garrett and Virginia "Teddy" Fenton, June 23, 1975, "Hoover Dam Oral History Collection," Boulder Dam Museum collection, Boulder City, Nevada.

ABOUT THE AUTHOR

Paul W. Papa is a full-time writer who has lived in Las Vegas for close to thirty years. He developed a fascination with the area, and all its wonders, while working for nearly fifteen years at several Las Vegas casinos. In his role as a security officer, Paul was the person who shut and locked the doors of the Sands Hotel and Casino for the final time. He eventually became a hotel investigator for a major Strip casino, during which time he developed a love for writing true stories about uncommon events. He now owns a business that concentrates on nonfiction, technical and commercial writing. Paul is the author of several books, including *It Happened in Las Vegas: Remarkable Events that Shaped History*; *Haunted Las Vegas: Famous Phantoms, Creepy Casinos, and Gambling Ghosts*; and *Discovering Vintage Las Vegas: A Guide to the City's Timeless Shops, Restaurants, Casinos, & More*. When not at his keyboard, Paul can be found talking to tourists on Freemont Street, investigating some old building or sitting in a local diner hunting down his next story.